ABSTRACTION: Towards a New Art

ABSTRACTION:

Towards a New Art
Painting 1910-20

THE TATE GALLERY

ISBN O 905005 07 4 paper O 905005 12 0 cloth
Published by order of the Trustees 1980
for the exhibition of 6 February–13 April 1980
Copyright © 1980 The Tate Gallery

Published by the Tate Gallery Publications Department,
Millbank, London SW1P 4RG
Designed by Sue Fowler
Printed in Great Britain by Balding + Mansell, Wisbech, Cambs.

Contents

Note
The dimensions are given in inches followed by
centimetres in brackets; height precedes width.

The following works are not included in the exhibition –
cat. nos. 10, 28, 82, 248, 285, 288, 291, 294, 300,
307, 308, 309, 317, 326, 328, 329, 336, 341, 385.

Cover/jacket
K. Malevich 'Morning in the Village after Snowfall' 1913

Foreword

The exhibition which this catalogue accompanies is the first loan exhibition to be presented in the new extension galleries of the Tate. It was planned under my predecessor, Sir Norman Reid, who was also, of course, responsible more than anyone else for bringing these galleries into being. The exhibition makes use of the wide spaces and flexibility of the architecture to show how abstract painting sprang up everywhere, almost simultaneously, on the basis of innovations that had mainly taken place in Paris – then the hub of the art world.

My thanks are due, first of all to the private collectors and museums who, by their generosity with loans, have made this exhibition possible. I am sure the others will not mind if I single out from these the Stedelijk Museum in Amsterdam, for its paintings by Malevich; the Gemeentemuseum in the Hague for their paintings by Mondrian and the Lenbachhaus in Munich for its Kandinskys. These museums own large groups of works by some of the artists who must dominate the exhibition, especially the works between the years 1910 and 1920 in which abstract art, as we understand it, was born. The generosity of other lenders is testified to by the number of times their names occur in the catalogue lists; among these the Museum of Modern Art, New York, stands out on its own.

This catalogue is supported by a book *Towards a New Art: essays on the background to abstract painting 1910–20* which, as its title suggests, deals with the background of ideas from which abstract painting grew. It has flourished ever since and in many forms as one of the most characteristic phenomena of Western culture in this century. I am grateful to those who have conceived and selected the exhibition and who have written the material for the catalogue; their names appear on the contents page.

Alan Bowness
Director

Preface

The use of the term 'abstract', applied to painting and sculpture, has become accepted practice in the history and criticism of twentieth-century art. From early on, however, it has caused difficulty and dissatisfaction; not without reason. Jean Arp in particular hated the term, insisting that he made 'concrete' images, not abstract ones, and from Alfred Barr's *Cubism and Abstract Art* (1937) commentators have learned to tread carefully when using the term. Arp's irritation spot-lights the central difficulty in its use. He did not begin with a subject and then refine or simplify his image of it; he simply made images that represented nothing else. The verb 'to abstract' (taken literally) means to separate or withdraw something from something else, and so he could not think of his art as abstract. Strictly speaking, Arp was right, but other terms that have been used to the same purpose, 'non-figurative', 'non-objective', 'pure', suffer from the defect of applying only to art which is not abstracted, just as the term abstract art applies only to that which is abstracted. Since, through long and less than rigorous usage, the term abstract art has come to be understood generally as embracing both the 'non-objective' *and* the 'abstracted', we use it again here in this broad sense. Hopefully, the exhibition will be its own demonstration of the myriad ways in which artists arrived at 'abstract' images early in the century.

Introduction
Peter Vergo

We are taking *plastic emotion* back to its *physical and spontaneous* source: nature . . . Thus, although our creations represent an inner life entirely different from real life, our paintings and sculptures based on plastic analogies can be called painting and sculpture *d'après nature*.

Gino Severini, *The Plastic Analogies of Dynamism* (1913)*

In what is one painting representative and another non-representative? If a man is not representing people is he not representing clouds? . . . masses of bottles? . . . houses and masonry? Or is he not representing in his most seemingly abstract paintings, mixtures of these, or of something else? Always REPRESENTING, at all events?

Wyndham Lewis, 'A Review of Contemporary Art' (1915)†

The colours of nature cannot be reproduced on canvas. Instinctively, I felt that painting had to find a new way to express the beauty of nature.

Piet Mondrian, 'Towards the True Vision of Reality' (1942)‡

*Drudi Gambillo & Fiori (eds.) *Archivi del Futurismo*, Rome, 1958–62, vol.1, p.78.[1]
†Michel & Fox (eds.) *Wyndham Lewis on Art*, New York, 1969, p.68.
‡Piet Mondrian, *Plastic Art and Pure Plastic Art, 1937, & Other Essays 1941–1943*, New York, 1945, p.10.

This exhibition was originally to have been called *The Origins of Abstraction*, a title finally abandoned for several reasons. It had been used for other exhibitions and publications,[2] and we had no wish to complicate further the already confused domain of the history of modern art. More important, 'Origins of Abstraction' did not really express the scope of the present exhibition, nor what we meant to achieve. 'Origins' might suggest that the visitor was about to see works by important precursors of abstract art – a subject in its own right, and one at least touched on by the Royal Academy's *Post-Impressionism* show[3] – whereas we intended rigorously to exclude the 'pre-history of abstract art' from our exhibition.[4]

The present title, though less catchy, had in our opinion distinct advantages. It made clear that we were dealing with a very brief period, little more than a decade.[5] Just as we had excluded the precursors, so too we intended to exclude the 'followers', however innovative or significant their work might be. By 'followers' we understood those artists (El Lissitzky is a good example) who in reality were building upon the experiments and innovations of the first-generation abstractionists. Our exhibition concentrates in the main on the early evolution of abstract painting; and it stops at precisely the moment that evolution was

essentially complete, having its own, distinctive identity. The way in which the 'language of abstraction' was then employed by subsequent artists would be the subject for another, quite different exhibition.

One further point, though it might seem self-evident, requires to be both emphasised and explained. As our title makes clear (and as the previous title did not), this exhibition is concerned not with abstract art but with abstract *painting*. To have introduced other art forms would have been both to complicate and at the same time to obscure the fundamental issues we meant to address. Any serious account of the way abstract painting evolved entails an examination of the problems against which the first abstract painters pitted themselves. These problems were not, however, the same as those which confronted artists working in other media. It was only painters who, because of the supposedly lofty status of their art, were faced with quite such acute difficulties in creating and justifying a form of visual expression devoid of representational or narrative associations.

Painting's traditional claim to seriousness rested largely on the painter's ability to express noble (or at least worthwhile) ideas and sentiments. The expression of such sentiments was inextricably bound up with narrative, or allegories, or symbols. True, many painters had shown, by devoting themselves to 'low key' subjects – landscape, genre-painting, still life – that they were neither anxious nor willing to deal in such coin. The moral status of these subjects remained, however, open to doubt. This doubt was only made more acute by the rise of Impressionism (the first art movement to give quite so much attention to landscape and the urban environment, to the everyday and the downright banal) and the almost exactly contemporaneous invention of photography, which seemed set (allowing for a few technical imperfections) to usurp at least one of the time-honoured functions of painting, that of recording the external appearance of things.

Artists working in other media were far less prey to such concerns. No one had ever demanded, for example, that music should necessarily narrate or represent anything at all. Even sculpture, though often cast in an heroic role, had through its traditional association with architecture and architectural decoration far more excuse than painting to slip into abstract, or at least semi-abstract garb. Only the novel, poetry and drama seemed still bound to narrative concerns; and poetry too, from the Symbolist era onwards, had begun to lay far greater emphasis on its own 'abstract' elements – metre, rhyme, alliteration, assonance – than on the unfolding of some narrative. As for the applied arts, the problem of abstraction scarcely existed. Abstract ornament, abstract book and magazine covers, abstract end-papers, abstract designs for textiles – all these were commonplace long before the beginning of this century.

The existence of an abstract vocabulary of ornamental forms only serves to focus attention once again on the problems peculiar to painting. A work of applied art exists by virtue of its destination or purpose; strictly speaking, it requires no other justification. Painting, on the other hand, must be essentially complete, carrying with it its own *raison d'être*.[6] For those artists who flirted with abstraction, but who could devise no self-evident justification for abstract painting, it was far easier to couch their abstract experiments in the form of ornamental designs. Indeed, we can discern a pronounced ornamental tendency running through the

work of many artists who toyed with abstraction during this fretful decade. Even where ornamental intent is not immediately apparent, we may still find on turning the sheet that what had seemed to be an abstract watercolour or drawing is inscribed in the artist's own hand 'design for embroidery', or suchlike. Cases of this kind occur with relative frequency – for instance, in the work of both Franz Marc and August Macke.[7] The art historian can only view such examples with profound misgiving, since it is far from clear whether these works should be considered as experiments which contributed to the development of an abstract language of painting, especially when, as often happens, they closely resemble other drawings or watercolours bearing no such 'declaration of intent'.

Even if we can discover some satisfactory way of disposing of this question, there are a host of others jostling to take its place. If we find that a painting which seemed to us 'abstract', because we could see in it no trace of representational forms, was in fact given a 'representational' title (such as 'Mercury passing in front of the Sun'), does this mean that, in compiling the hagiography of abstract art, we must bar the work and its creator from the halls of fame? Conversely, had Balla kept to himself the fact that his painting was based on observations of Mercury passing in front of the sun as seen through a telescope, and simply called his painting 'Composition No. So-and-so', would it for this reason alone count as 'abstract'? What of seemingly abstract works which have no 'representational' title, but which are clearly based on the same compositional structure as one that does – something that occurs again and again in Kandinsky's *oeuvre?* Can *any* painting, strictly speaking, be defined as 'abstract', since even the most hard-edged form-and-colour composition indisputably bears some relation to aspects of our everyday visual experience?

These questions reveal, if nothing else, the need for a better definition of abstraction than we have been offered so far. In fact, historians have for the most part carefully avoided defining abstraction, preferring to deal with it as part of what one critic has called the '"ismatic" order of art-historical developments'[8] – as if it were a phenomenon comparable, say, to Cubism or Futurism. Various writers have traced the historical origins of the abstract 'movement', have described the works of the principal *dramatis personae* in terms of convenient notions such as 'influence' and 'style', without pausing to consider one important and obvious fact: that abstraction is not a *style*, but what Delaunay called a 'change of understanding', and hence that no stylistic definition, however broad, can encompass the work of painters as diverse as Kandinsky and Malevich, Mondrian and Kupka, Wyndham Lewis and Itten.

We, the organisers of the exhibition, have taken a different view. We have paid relatively little attention to the question of influences, not least because it is far less relevant to the twentieth century than to earlier periods in the history of art. The growth and rapidity of communications, the proliferation of art magazines, each issue carrying a wealth of information and images, the comparative cheapness of photographic reproductions – all this means there is no longer any point in asking whether X might possibly have seen a certain painting by Y in this or that exhibition. Nor is it possible to account for the evolution of abstract painting solely in such terms. If, as we believe, abstraction really did

reflect a 'change in understanding' – in other words, a philosophical change – then a new approach to the subject is needed. If we are to begin to grasp the nature of abstraction, its impetus and momentum, then we must examine the *process* by which artists gradually evolved a vocabulary of abstract form – 'process', here, meaning not just method of working but also circumstances, intellectual interests, theoretical preoccupations as revealed by artists' own statements about their art. This has been the rationale behind the selection of works and of secondary documents, behind the arrangement of the exhibition (although the layout is also, to a large extent, geographical), behind the topics raised both in this catalogue and in the accompanying volume of essays, *Towards a New Art*. To arrive at something other than a merely subjective understanding of abstract painting – this is what we hoped to achieve.

One should not, of course, degrade the works of art themselves to the status of mere 'documents' of their creators' development. The works shown here have been chosen as much for their quality as for the fact that they 'fit in with' or 'complete' a particular group of paintings, water-colours and drawings.[9] None the less, it is important to look at the pictures not just for their own sake, but also for what they tell us about the artists' intentions; for if we *are* to achieve something more than merely subjective understanding, then we must try to see the world through the artists' eyes, to envisage their goal, how they conceived it, how they hoped to attain it, and their doubts and hesitations about doing so. This is particularly important in the case of those artists who said virtually nothing about their experiments with abstraction, either at the time or later.

If, moreover, one accepts the idea that abstract art reflects a philosophical change, then to understand the nature of that change, it is necessary to ask what are essentially philosophical questions, the most important being: Why create an abstract art at all? What was the need for a kind of painting without objects? But if one is prepared to accept that there was such a need, then a second question follows hard on the heels of the first. Why did artists themselves find it so hard to envisage an object-less art and, having envisaged it, to justify it? For scarcely one of the major pioneers of abstract painting attained the final goal without the gravest doubts, the most profound soul-searching. They were not, in general, especially worried by the questions to which art-historians have devoted most attention, such as that of style. Style was largely irrelevant. The first 'Blue Rider' exhibition, organised by Kandinsky and Franz Marc in Munich in December 1911, did not aim to propagate any particular stylistic tendency. Rather, it was supposed to show the diversity of modern work, the variety of different 'styles' which co-existed quite amicably at this and other early exhibitions of 'abstract' and 'not-so-abstract' art.

Painters were, on the other hand, deeply concerned by the same questions that trouble audiences today. For, admit it or not, art lovers still find abstract painting puzzling, for a variety of reasons. In what language, or in what tone of voice, is one being addressed? Are these works serious statements, comparable to the great masterpieces of the past? In which case, what has become of representation, previously regarded as an indispensable element of painting? In Kandinsky's worried phrase, 'what is to replace the missing object?'[10] Are colours and

forms, divorced from any representational aim, capable of communicating significant truths about man – his thoughts and feelings, his relationship to the world? What about structure? Are colours and forms structurally self-sufficient, as the sole elements of a composition? Are they, as Kandinsky put it, 'compositionally fitted for survival'?[10] What is the relation between abstract painting and ornament, which also seemed to offer an example of an abstract or near-abstract visual language?

As to what was the 'need' for abstract art, the answer to this question has both its positive and its negative aspect. In positive terms, painters – and writers and critics – felt that visual art should capitalise on its own resources. They could not see why the 'pure' elements of painting, principally colour and form, should not constitute just as sound a structural foundation, and at the same time just as rich an expressive vocabulary, as the 'pure' tones of music, itself the perfect example of an 'abstract' art which was both undeniably expressive and at the same time a model of organisation. Comparisons and analogies between painting and music occupied a good deal of artists' attention throughout the later nineteenth and early twentieth century.[12]

In negative terms, the artists of the avant-garde – even those who did not 'go abstract' – were also in fairly general agreement as to the kind of painting they did *not* want. They did *not* want what Gleizes and Metzinger called 'secular idealism'.[13] They did *not* want painting to depend for its worth on moral or didactic subjects, nor on allegories or emblems, nor indeed on any kind of narrative. They did *not* want the resources intrinsic to painting 'diluted', as Léger put it, 'by the need to tell a story.'[14] By the nineteenth century, there already existed a school of thought which held that it was not, in any case, for painters to concern themselves with those kinds of aims at all. The artist should not preoccupy himself with concepts, nor with narrative, nor even with the meticulous observation of nature. If he did, there was a danger of ruling out aesthetic response altogether, of jolting the viewer out of a state of pure, aesthetic contemplation and back into his normal, everyday manner of looking at the world. This view found elegant, forceful expression as early as 1818 in Schopenhauer's treatise, *The World as Will and Idea*.

Another, quite unexceptionable argument was that painting had too long been the handmaiden of other disciplines. For too long, painters had attempted to perform tasks which really belonged to the poet, the historian or the moralist. Again, this state of affairs had been brought about by painting's subservience to narrative. Now at last it was time to turn away from narrative. Painting should, as one critic put it, 'offer nothing but its own merchandize'.[15] This remark was made against the background of the rising tide of Impressionism; and artists in the early twentieth century gave due credit to the Impressionists for dispensing with conventional subject matter – though in fact Manet, Courbet and the landscapists of the Barbizon school could well claim priority in this respect. The Impressionists had also tried to define better what the 'merchandize' peculiar to painting was by studying elements of colour theory, psycho-physics and perceptual psychology; and again, these concerns were taken up by twentieth-century artists, in an attempt fully to understand the resources from which the visual artist creates. Signac, through his treatise *D'Eugène Delacroix au Néo-impressionisme*,[16] had popularised some of the colour theories important to both the Impression-

ists and Neo-Impressionists, especially the researches of Chevreul; and in many cases, twentieth-century painters turned to the same sources for confirmation of their own ideas. Delaunay happily acknowledged his debt to Chevreul, whom he termed a 'genius'.[17] The title he gave to some of his most 'abstract' paintings, 'Simultaneous Contrasts', also recalls that of Chevreul's most influential treatise, *On the Law of the Simultaneous Contrast of Colours*.[18]

Even artists not much given to theoretical speculation immersed themselves in colour theory – not only in the writings of Chevreul, but also in treatises by authors such as Helmholtz and Rood. That they did so indicates how much they desired to find a *systematic* basis for a kind of art in which subject matter, even the depiction of nature, was coming to play an increasingly muted part. The visitor to the exhibition will be able easily to distinguish a number of works which scarcely merit consideration as abstract compositions in their own right, but which quite clearly relate to diagrams and charts of the kind found in scientific treatises on colour (see in particular nos. 198, 263).

Marc, too, had read Chevreul, as well as treatises on colour by Brücke, Wauwermanns and Bezold, though he confessed to Macke that his 'own few superstitious ideas' were of more service to him than 'all these theories'.[19] None the less, he wrote of his attempt to 'organise' colours, and about his conviction that there was no 'doing as you like', since in that way 'one would lose the entire effect. On the contrary, one has to think of the *systematic* aspect . . .'[20] Macke was equally preoccupied with the idea of organising colours, dreaming of the 'superhuman power one would wield' if one succeeded in doing so.[21] In December 1910 he wrote to Marc about the 'colour circle' he had made, adding that he was at the moment 'much preoccupied with theory . . . I think it extremely important to get to the bottom of all the laws of painting.'[22] 'Laws' was a favourite word with Delaunay: in February 1913 he described to Macke his observations as to the movement of colours, their 'complementary and simultaneous contrasts . . . it is only there I find laws'.[23]

However, researches into the scientific basis of painting could lead rapidly into perilous straits. Schopenhauer had taught that the aims of science and of art were incompatible. The Symbolists had likewise affected a lofty disdain for science, because of its obsession with what Aurier called the 'warts of nature'.[24] Artists in the early twentieth century were heir to much that was characteristic of Symbolist thought. As far as science was concerned, they were prepared to be carried away by almost anything that turned the 'traditional' picture of the world on its head: quantum theory, four-dimensional geometry, the 'fringe mathematics' of Princet. But they were to some extent distrustful of conventional scientific theories – even colour theories – partly because they seemed to leave little room for inspiration, the irrational element in art. It is perhaps for this reason that Goethe's *Theory of Colours* enjoyed such widespread popularity during the first years of this century; for Goethe had proposed a specifically 'anti-Newtonian' (and in this sense quite 'unscientific') view of colour – not only its physical properties, but also what he termed its 'moral' (in other words metaphorical or allusive) effect. Overlaid with Rudolf Steiner's later interpretations, these theories took on a mystical tinge which only served to make them all the more attractive.[25]

Another difficulty was that, although there had been a good deal of theorizing about both the physiological effects of colours and forms, and their communicative potential – colours corresponding to particular emotions, lines indicative of certain states of mind – much of it had been in connection with the applied arts and ornament. Even Chevreul's ideas evolved partly as a result of observations made while attempting to improve techniques of dyeing. Of his two most influential treatises, the earlier, *On the Law of Simultaneous Contrasts* was, as its title makes clear,[26] conceived for the benefit of painters; but the later, *Colours and their Applications to the Industrial Arts, assisted by Chromatic Circles*[27] was aimed equally specifically at the applied arts. And in other, similar cases, theories which might have provided a firm foundation on which to start building a 'scientific' justification for abstract painting penetrated the consciousness of 'fine' artists far less deeply than one might suppose, precisely because they had been formulated for the benefit of the 'applied', not the 'fine' arts.

Brücke's *Physiology of Colours* had been written, as its title states explicitly, with the applied arts in mind;[28] and while it can be shown that both Marc and Kupka read Brücke's treatise,[29] little trace of its influence can be found in the remarks made by either artist on the subject of colour. Some of the *Jugendstil* designers like van de Velde and Endell made detailed studies of how, and in what sense, different types of line can be considered 'expressive', van de Velde even categorising them under different headings: 'emotive line', 'communicative line' and so on.[30] Kandinsky, we know, was interested in the Belgian designer's theories.[31] There is also a marked resemblance between Kandinsky's writings and Endell's. Sometimes, reading Endell, one might almost imagine one was hearing Kandinsky's voice. Yet Endell's famous statement in which he envisaged a 'kind of art with forms which mean nothing and represent nothing . . . yet which move our souls as profoundly, as powerfully as only music has hitherto been capable of doing'[32] was made as part of an extended argument about *decorative* art, whereas Kandinsky remained profoundly suspicious of abstract ornament, even warning against the dangers of a kind of painting that would signify little more than a tie or a carpet.[33] This distrust stems in part from a desire to preserve the traditionally elevated status of painting as distinct from the applied arts; and although Kandinsky himself made a number of ornamental designs, they are markedly different from his other drawings, and occupy a relatively unimportant place within his *oeuvre* as a whole.

Kandinsky was also the only major artist of the period to remain immune to the otherwise pervasive influence of Cubism. (To Kandinsky's name might also be added those of small number of German and Austrian artists, like Adolf Hoelzel, whose art has its origins in the ornamental abstractions of *Jugendstil*, or of Hoelzel's pupil, the Swiss painter Johannes Itten.) He admired Picasso's work, devoting some space to an account of the Spanish artist's latest paintings in *On the Spiritual in Art*, and reproducing one important Cubist work by Picasso – though only one – in a prominent position in the *Blaue Reiter Almanac*.[34] But just as the Cubists had criticised Impressionism for what they considered its lack of intellectual control, so too Kandinsky distanced himself from what seemed to him the excessively formal preoccupations of Cubism. He was also perhaps aware that, despite the highly abstract appearance of many

Cubist canvases, Cubism did not lead towards abstraction, but remained rooted in external reality – remained, as the Cubists themselves insisted, at bottom an art of realism.

What the Cubists had done was to create a new image of reality, influenced to some extent by the radical theories of the French philosopher Henri Bergson. Rejecting any conception of painting as a kind of 'window on the world', they broke decisively with the post-Renaissance convention of depicting objects as if seen from a single viewpoint, employing instead what Metzinger called 'mobile perspective'[35] – moving round objects, simultaneously recording not only different images of the same object, but also the near and the far, the seen and the remembered. The more radical also analysed, probed, destroyed objects in order to reconstruct them, enhancing the emphasis given to the surface plane of the picture while at the same time progressively blurring the separation between the motif (figure, object, etc.) and its environment. In so doing, they engendered a new formal vocabulary having an undreamed-of potential for abstraction; and while the Cubists themselves remained, for the most part, fairly close to the realities of perception, others were to explore much further the abstract possibilities of this new visual language.

Cubism exerted an extraordinary influence on painters both within France and abroad, not least on those who, like Malevich, were ultimately to develop a coherent language of abstract form. Even among those artists who experimented only fitfully with abstraction, few remained untouched by developments in Paris. The Italian Futurists, the Russian Cubo-Futurists, the Rhenish Expressionists, the American Synchromists, the English Vorticists – all responded in quite specific ways to the impact of Cubist painting. The 'rayist' style of painting developed by Larionov and Goncharova during 1912 seems to have derived its momentum more from Italian Futurism than from Parisian Cubism; but 'Rayism', too, remains unthinkable without the pictorial innovations of the Cubists. It is for this reason that a small number of important Cubist paintings occupy such an important place in the first room of the exhibition, through which the visitor, symbolically, must pass in order to reach the other historical and geographical sections.

Yet Cubism itself did not become an abstract art. On the contrary, it remained stubbornly rooted in the world of natural appearances, seeking to attain an equilibrium, it has been suggested, between the 'reality' of experience and the 'abstract beauty' of ideas.[36] In some respects, the further development of Cubism even represents a turn away from the possibility of abstraction. Certainly, Picasso and Braque seem consciously to have rejected the idea that the painter should push the analysis of form beyond the furthest limits of recognisability. By mid-1912, both had reintroduced into their work far more easily 'legible' elements, still drawn mainly from the repertoire of still life. In the course of the same year, they also began to include fragments from the real world – collage and *papier collé* – thus further emphasising the identity of their paintings as objects in their own right.

As for the other Cubists, as late as autumn 1912 Gleizes and Metzinger were still stressing the essentially realistic intent of Cubist painting, asserting – evidently with the possibility of abstraction in mind – that art 'cannot be raised all at once to the level of pure effusion'.[37] Though

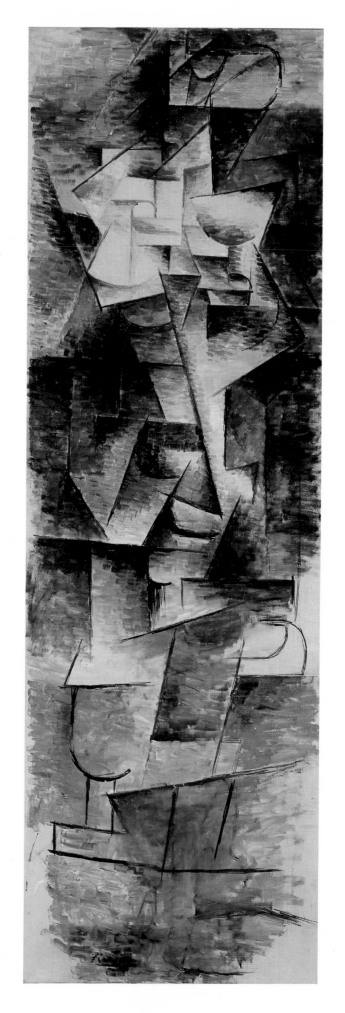

Cat.no. I
Picasso Female Nude

Cat.no.29
Delaunay Three-part Windows

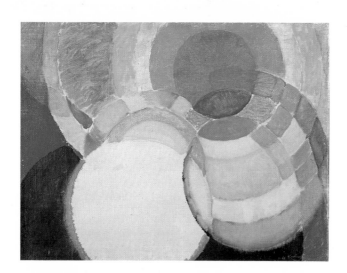

Cat.no.15
Kupka Disks of Newton

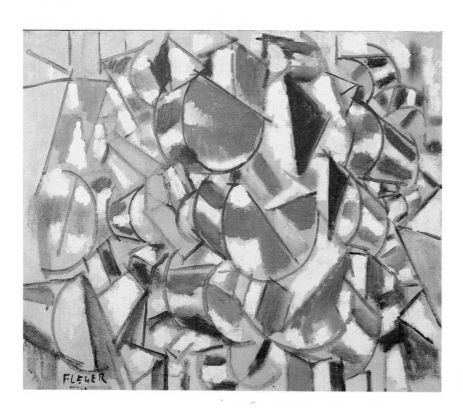

Cat.no.39
Léger Formal Variation

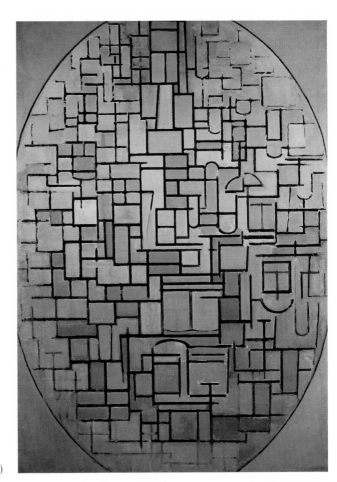

Cat.no.77
Mondrian
Composition no.3 (Oval Composition)

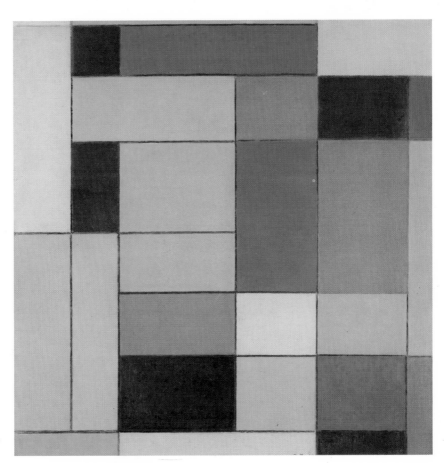

Cat.no.85
Mondrian Composition in Grey,
Red, Yellow and Blue

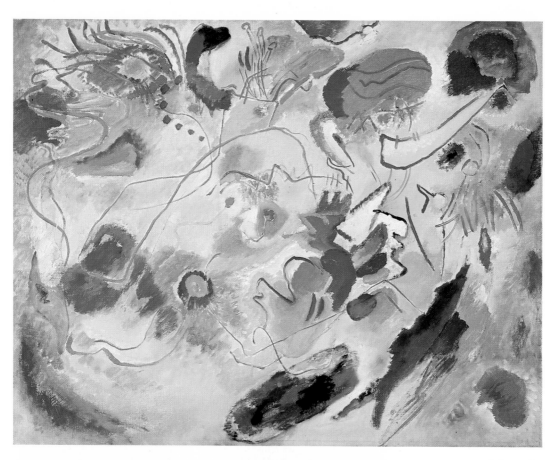

Cat.no.182
Kandinsky Picture No. 183
(Study for Composition 7)

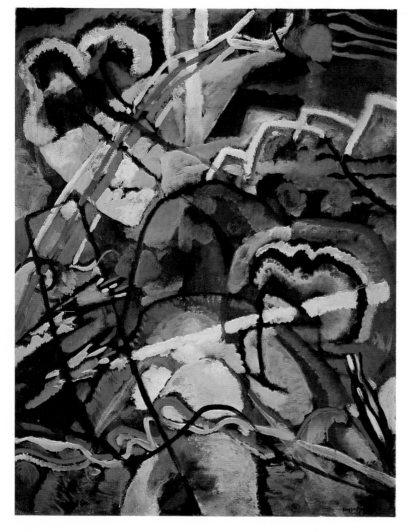

Cat.no.168
Kandinsky Oil Study for Painting with White Border

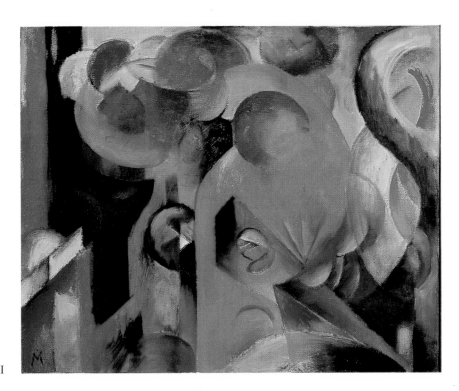

Cat.no.224
Marc Small Composition III

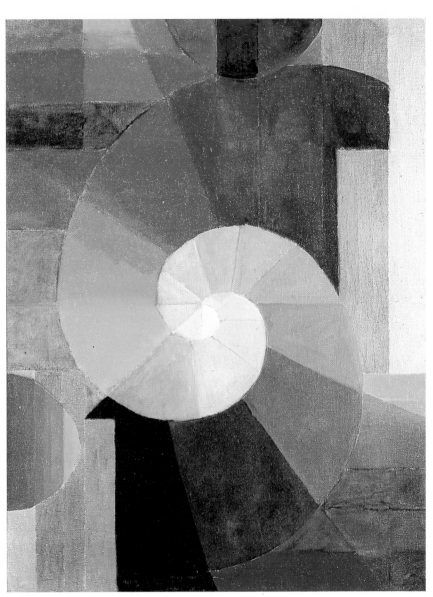

Cat.no.264
Itten Meeting

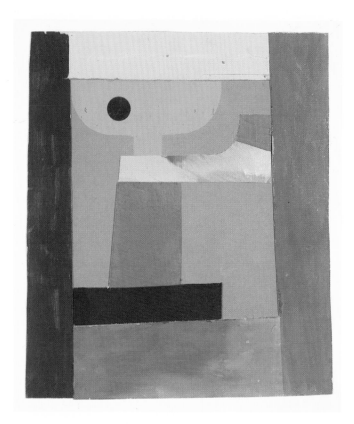

Cat.no.144
Arp Collage

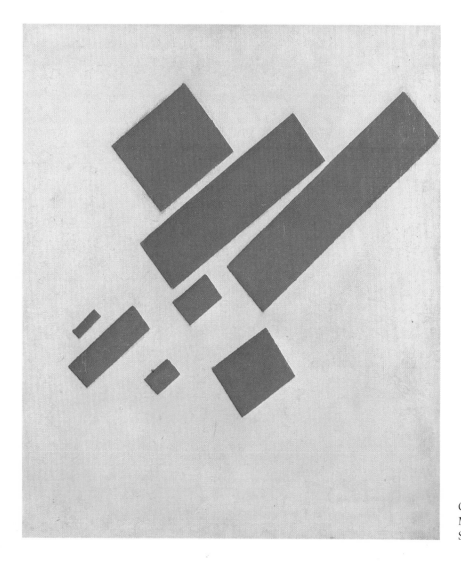

Cat.no.320
Malevich
Suprematist Painting, Eight Red Rectangles

Cat.no.311
Malevich An Englishman in Moscow

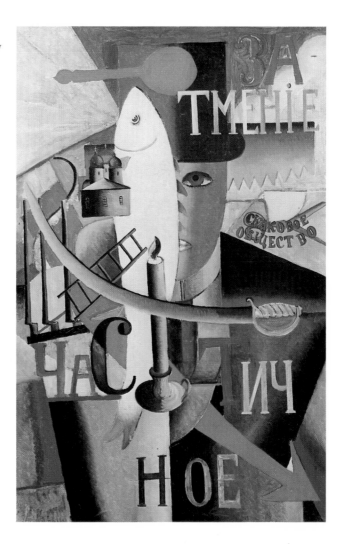

Cat.no.369
Balla
Abstract Speed The Car has Passed

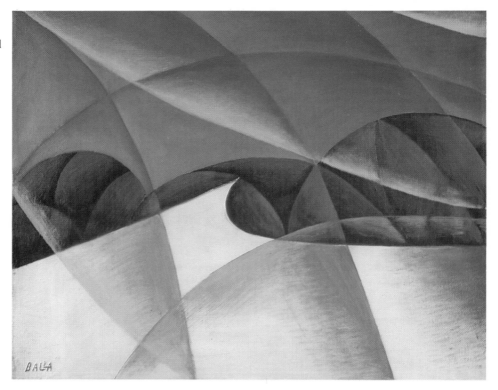

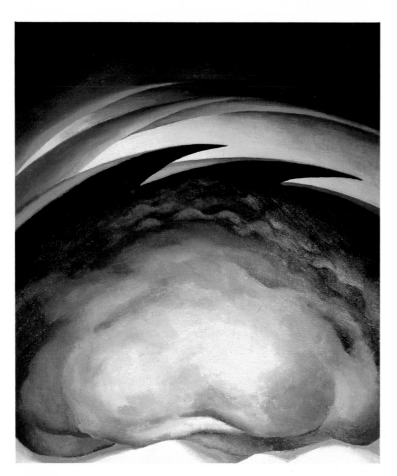

Cat.no.413
Russell
Study for Synchromie en Bleu Violacé

Cat.no.437
O'Keeffe From the Plains

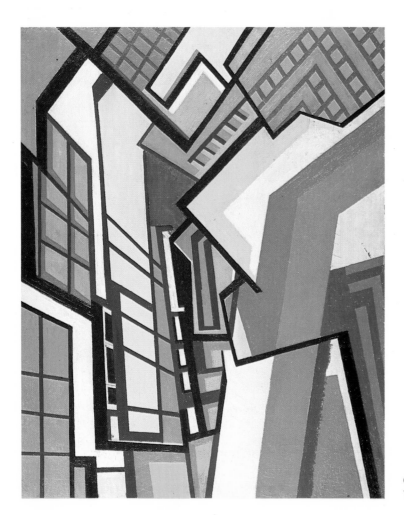

Cat.no.381
Wyndham Lewis Workshop

Delaunay (whose colourful version of Cubism Apollinaire had christened 'Orphism') and Léger both gave highly 'abstract' definitions of what they understood by 'realism', making important excursions into the realms of abstract colour and form, neither sustained – not coherently, nor for any length of time – a real commitment to abstraction. In Delaunay's case, it is not clear whether any of his paintings can properly be termed abstract, since even some of his 'Discs' and 'Simultaneous Contrasts' of 1913–14 were based, as his wife Sonia recalled,[38] on prolonged and painful observations of sunlight – in other words, of a natural phenomenon occurring in the real world. Moreover, even his most 'abstract' paintings (or 'pure' paintings, as Apollinaire termed them) were interspersed with other pictures like the 'City of Paris' (1910–12) which deliberately introduce 'impure' elements – in the case of the 'City of Paris' the Eiffel Tower, the Three Graces, a 'quotation' from a self-portrait by Douanier Rousseau. 'The Cardiff Team', eulogised by Apollinaire in his review of the 1913 Salon des Indépendants as the 'most modern painting in the Salon',[39] also contains 'impure' motifs, with the Eiffel Tower and the Great Wheel of the Champ de Mars prominently displayed. In fact, the 1913 Salon was greeted with something not far from a sigh of relief by Apollinaire, who announced: 'The subject has come back into painting, and I am more than a little proud to have foreseen what constitutes the very basis of pictorial art.'[40] By the end of 1914, both Delaunay and Léger had turned decisively away from the possibilities offered by pure abstraction and towards the depiction of the world of visible reality.

The fact that the Cubists failed – at least in the eyes of a whole-hearted abstractionist like Mondrian – to draw the logical conclusions from their own discoveries should not surprise us unduly. For the philosophies on which Cubism rested – in particular, that of Bergson – had mainly to do with the interpretation of sense data, and with man's relationship to the phenomenal world. They contained nothing of that 'other-worldliness', that mystical tendency that might have led artists to turn their back on immanent reality. Nor were they much concerned with the expression of individual psychological states – another important source for non-representational painting. They remained primarily concerned with men and with objects – with external, visible reality and with the structuring faculties of the mind – and so too did most of Parisian painting in the first years of this century.

In order to sustain abstraction, a quite different conception of reality, and of the function of art, was necessary. In some cases, this conception of reality – what might be termed 'higher reality' – took the form of mystical belief. In an interview published as early as 1909, Mondrian stated his conviction that

> conscious spiritual knowledge will have an increasing influence on the work of painters . . . Should the painter so far evolve that he attains concrete first-hand knowledge of the higher regions through development of his finer senses – then his art will become incomprehensible for humanity which is not yet familiar with these higher regions.[41]

Mondrian's is a particularly interesting case. Of all the pioneers of abstraction, he was the most directly influenced by Cubism, whose later stages (from 1912) he witnessed in Paris at first hand. He was im-

mediately drawn to the Cubists, especially Picasso and Léger, acknowledging 'without embarrassment' the debt he owed the former, though pointing out, in case we had failed to notice, that he was 'quite different from Picasso'.[42] He also observed in the linear patterns formed by the meeting of different planes, which the Cubists utilised as a vehicle for formal analysis, a structural order which came to play a vital role in his own art from 1912 onwards.

Gradually, however, he became aware that Cubism was not fulfilling its potential for abstraction, that it was not, as he put it, 'developing abstraction towards its ultimate goal, the expression of pure reality'.[43] This reproach may surprise us, since the Cubists, too, claimed that theirs was an art of reality. Mondrian, though, believed the task of art was not merely to analyse the perceptual act, the way we construe visual information, but to investigate the very essence of reality itself: what he called 'pure reality'.

This conception, and Mondrian's dissatisfaction with representing the appearance of objects, almost certainly derived from his reading of Theosophical and other mystical literature, which convinced him that natural creation arose from the conflict of polar opposites: male and female, black and white, vertical and horizontal. In 'natural reality', one of these elements inevitably predominated over its opposite, giving rise to the unbalanced, capricious and constantly shifting appearance of the phenomenal world. In 'pure' or 'abstract' reality, on the other hand, these polar opposites co-existed in perfect equilibrium. To reveal that equilibrium, or what Mondrian called the 'universal', was the highest function of art. 'Naturalistic painting', he wrote, 'gives too much prominence to the particular. The universal is what all art seeks to represent.'[44] Liberated from any descriptive function, the verticals and horizontals which play such an important part in Mondrian's painting after 1914, and which might be thought to derive from the formal vocabulary of Cubism, in fact have a profound cosmological significance. These 'pure pictorial elements' not only provided the basis for a ready-made language of abstract form; juxtaposed to create the right-angle and the cross, they could also serve as universal symbols, signifying that underlying order concealed from us by the inconstant forms of natural appearances.

Kandinsky, too, was drawn to Theosophy and occultism, though it was only for a comparatively brief period, around 1908–10, that they exerted any serious influence on his thinking.[45] None the less, Theosophical notions of the existence of a 'higher world', invisible save to the adept, peopled not only by astral bodies but also by colours and shapes (technically known as 'thought forms') which acted as signifiers of precise states of mind, may well have played a part in helping to 'discredit the object as an indispensable element in a painting'.[46] More important, however, for Kandinsky's own theory of art was the belief he shared with his Expressionist contemporaries in the primacy of *inner* experience, and that the task of art was to communicate not images of the external world, but 'events of an inner character'.[47] Reality was not to be confused with the external appearance of nature, nor with the perceptual act; truth was to be found not outside but within the artist.

The Expressionists, like the Cubists, criticised Impressionism, but not for the same reasons. It was not the Impressionists' 'lack of intellectual

control' which Expressionist artists and critics found distasteful, but the fact that they seemed to conceive of no higher function for art than to serve as the 'gramophone of nature', their paintings resembling 'wax impressions' of external stimuli.[48] The Expressionist artist – poet, painter, composer – strove instead to give voice to inner stirrings. 'Art', declared Herwarth Walden, whose journal *Der Sturm* provided Expressionist artists with both a forum and a mouthpiece, 'is production, not reproduction.'[49] This saying, together with Schoenberg's dictum 'Art comes from necessity, not from ability',[50] served as a slogan for the Expressionist movement as a whole. Not that the Expressionists were the first to give primacy to the internal at the expense of the external. As early as 1886, the year of Moréas' 'symbolist manifesto', Gustave Kahn, writing in *L'Evénement*, had declared: 'the essential aim of our art is to objectify the subjective (externalisation of the Idea), instead of subjectifying the objective (Nature seen through a temperament).'[51]

The shadow of Symbolism lay perhaps more heavily on the Expressionists than on any other twentieth-century 'movement'. The Expressionists voiced the same distrust of science, and in particular of nineteenth-century positivism. Franz Marc, in the journal *Pan*, wrote of how 'nineteenth-century art succumbed to the superior force of its powerful accomplice, science, whose help it had enlisted, and which set the course for the nineteenth-century spirit. Folk art and artists' art was carried to its grave in a little coffin: the camera.'[52] He also described in scathing terms the 'bright daylight appeal' of naturalistic art, which 'frightened away the mysterious and abstract images of inner life'.[53] But 'resistance to naturalistic form', Marc stressed, was 'not the product of caprice or a mania for originality'; rather, it derived from a 'much deeper desire which permeates our generation: the urge to fathom metaphysical laws, known until now, in practical terms, only to philosophy'.[54]

Kandinsky went much further than any of his Expressionist contemporaries in exploring the potential for painting of the 'abstract images of inner life' to which Marc referred. Like Marc – indeed, like most artists of his generation – Kandinsky was greatly interested in primitive and folk art, though not for its abstract, ornamental tendency. It was the expressive force of primitive images that mattered, a directness and immediacy which had become dulled in conventional (and especially academic) representation. Kandinsky took primitive, for the most part religious images as his starting point, progressively stripping away layers of representation, dissolving the external forms of objects so that their 'inner sound' might be heard all the more powerfully.[55] The original emotive force of the images he employed evidently mattered greatly to Kandinsky – especially those associated with themes such as apocalypse and the Last Judgement which dominate his paintings of the immediately pre-war years. He remained, however, uncertain whether the artist could abandon representational forms entirely and still communicate with his audience. In a statement written as late as January 1914, he still lays stress on the importance of recognition, and writes of his own inability to 'experience purely abstract form' without 'bridging the gap' by means of objects;[56] and in fact, his paintings of this period still reveal on close examination remnants of recognisable imagery, albeit in highly abstracted guise.

Forced to return home at the outbreak of war, it took Kandinsky some

time to come to terms with the latest developments of the Russian avant-garde. He must have been particularly astonished if he saw the unprecedented array of apparently abstract, geometrical works shown by Malevich at the exhibition *0.10* in Petrograd in December 1915.[57] Up until then, Kandinsky probably knew next to nothing about the change that had taken place in Malevich's paintings since 1913, Kandinsky himself having had no direct contact with Russia since his visit to Moscow in the summer of that year. At that point, Malevich was painting in a style termed 'Cubo-Futurist', which describes exactly what it was: a synthesis of elements borrowed from French Cubism and Italian Futurism. In itself, it is highly unlikely that either of these pictorial influences would have been sufficiently potent to motivate his development towards abstraction. Far more important in this respect were the theoretical and poetic notions of his Russian Futurist friends.[58]

In the course of that same year, 1913, Malevich had become closely associated with the more radical of the Russian Futurist poets, usurping the role of illustrator of their published anthologies and poems, a role previously played by artists such as Larionov and Goncharova. The writer Aleksei Kruchenykh and the composer Mikhail Matyushin (married to the poetess Elena Guro) exerted a particularly significant effect on Malevich's own thinking. It was Matyushin who published a long commentary on Gleizes and Metzinger's essay 'Du Cubisme' in the third number of the periodical *Union of Youth* (March 1913).[59] His analysis goes, however, far beyond anything one might have deduced from the original text, since Matyushin brings into the discussion not only four-dimensional geometry but also the mystical notions of the Russian writer Petr Uspensky.

Gleizes and Metzinger had referred only in passing to 'non-Euclidean scientists' and, rather vaguely, to 'certain of Riemann's theorems';[60] and although it can be shown that the French Cubists were interested in the notion of four-dimensionality, they did not attach to it the mystical associations it held for Uspensky and, following Uspensky, for the Russian Futurists. To the Russians, the fourth dimension was not really a mathematical concept at all: it was a symbol of a form of expanded consciousness, transcending our normal consciousness of everyday things. Uspensky, who referred repeatedly to treatises on four-dimensionality in his book *Tertium Organum*, divided 'psychic life' into four units: sensation, perception, conception, '. . . and there is beginning to form a fourth unit "higher intuition"'.[61] Kruchenykh in turn quoted this passage from Uspensky in his article of autumn 1913, 'New Ways of the Word'.[62]

Malevich was very close to both Matyushin and Kruchenykh during the latter part of 1913, since all three were busy preparing for their remarkable joint venture, the staging of the Futurist opera *Victory over the Sun*, given at the Luna Park theatre in Petersburg in December that year.[63] He would certainly have been familiar with Kruchenykh's poetic ideas, for example the notion of the 'word broader than sense', also announced in 'New Ways of the Word'. By the 'word broader than sense' Kruchenkykh meant the use of pure sound-patterns, puns, made-up and nonsense words and a whole host of other 'poetic' devices whose purpose was to liberate language from what the poet Benedikt Livshits called 'the sad necessity of expressing the logical connection of ideas',[64] conjuring up in the mind resonances other than the 'conventional' meanings

usually attached to words as signs. Malevich can scarcely have found it difficult to apply this notion to painting, since Gleizes and Metzinger had written in very similar terms about the symbolic as opposed to narrative significance of forms, and of the way in which 'the crowd long remains the slave of the painted image, and persists in seeing the world only through the adopted sign'.[65]

Even more important, however, was the experience of *Victory* itself, with libretto by Kruchenykh, music by Matyushin and sets and costumes by Malevich.[44] Kruchenykh's punning, at times near-nonsense text and Matyushin's microtonal music were intended to translate the audience to an elevated plane of consciousness. But what was the visual equivalent? How was Malevich to convey the 'higher intuition', turning the sets and costumes into something analogous to the experiments of poet and composer? His surviving designs, together with contemporary photographs and descriptions of the staging of the opera, reveal something of the remarkable solution he devised.[67] His cardboard and metal costumes were painted in flat colours, each part a different colour, and divided the actors' bodies into geometric shapes. The theatre in which the piece was performed was one of the first houses in Europe with a modern lighting console, enabling complex colour changes to be orchestrated rapidly and effectively.[68] Witnesses recalled the constant changing of the backdrop and curtains and the 'blinding light from the projectors'[69] as the actors in their geometric costumes moved or paused against the white or coloured background. The audience, already bemused by the 'shouts and war-like cries',[70] the pistol shots, the discordant sounds from the orchestra, must have been confronted by the extraordinary spectacle of apparently abstract, geometrical planes of colour suspended in space, floating, moving, appearing and disappearing in time to (or out of time with) the music.

It is difficult to escape the conclusion that the première of *Victory* produced a profound effect not only on the first-night audience, but also on Malevich himself. Certainly, recalling the event, he wrote to Matyushin in 1915: 'All the many things which I put into your opera *Victory over the Sun* in 1913 gave me a lot of innovations except that nobody noticed them.'[71] There is also a direct link between the opera and some of Malevich's Suprematist compositions shown at *0.10*, such as 'Lady. Colour masses of the fourth and second dimension'. In these paintings, Malevich not only divided his figures up into geometrical shapes as he had done on the stage but, deprived of movement and the possibility of causing parts of figures to disappear by means of the lighting, he had found a pictorial equivalent by simply omitting certain dimensions. In terms of conventional representations the effect is, of course, one of total illegibility. None the less, Malevich continued to give 'representational' titles to what appeared to be entirely abstract geometric paintings: 'Aeroplane Flying', 'Football Match', 'House under Construction'.[72] How many of his other, untitled Suprematist works were also based, at least in the artist's mind, on figurative motifs can only be a matter of pure conjecture.

If it were thought that abstract painting was a kind of art having no meaning beyond itself – a kind of art to which one need 'only relate' – then none of the three artists discussed in detail above – Kandinsky, Mondrian and Malevich – can be deemed to have reached the goal of

'pure abstraction'. It was because they did *not* conceive of abstraction in this way that they found their self-imposed task – one might almost say 'mission' – so difficult to achieve. For the same reason, they deserve – and have been given – a special place in this exhibition.[73] None of them was content to let his art rest on what were essentially negative arguments, nor even on justifications such as the 'self-sufficiency' of the abstract resources of painting. Each believed in a higher function for art, seeking, for this reason, justifications at least as morally and theoretically elevated as those on which painting had traditionally depended. And because they conceived of their art in this way, they all engaged in an intense intellectual and spiritual effort, reflected both in their art itself and in their statements about it – a struggle made all the harder because its outcome was so uncertain.

Yet equally deserving of our admiration are those artists who remained essentially indifferent to the moral status of abstract painting, and for whom abstraction constituted only one of a number of possibilities. For there were many different paths leading to abstraction – something else this exhibition is designed to show – and not all the artists who set foot on one or other of these paths envisaged abstraction as an exclusive goal. One might well argue that the exclusiveness of Malevich's approach to art in his latter years led directly to the death of painting, whereas an infinite variety, and a constant sense of wonder in the face of nature constitute the perennial appeal of Klee's work, alas so thinly represented here. Klee's paintings, perhaps more than any others, constitute perfect proof that 'abstract' and 'representational' form can co-exist in harmony – despite the hostility abstract art provoked, and continues to provoke. As late as 1935, when one might have thought the battles over abstraction had long since been fought and forgotten, Kandinsky was still trying to convince his readers that the painter has at his disposal 'purely pictorial means in which to "clothe" his impressions of morning without painting a rooster', and wondering, rather plaintively, why it was that he, an 'abstract' painter, should be crying 'Long live the rooster!' while his opponents were still shouting 'Death to the triangle!'[74] We should perhaps ask ourselves the same question.[75]

NOTES

1. All translations from foreign languages are my own unless stated. Even where I have used some secondary source, I have occasionally made improvements for the sake of meaning or style.

2. See for example the catalogue of the exhibition *Origini dell' Astrattismo, verso altri orizzonti del reale* (Milan, Palazzo Reale) 1979–80.

3. See the catalogue *Post-Impressionism. Cross-Currents in European Painting* (London Royal Academy of Arts) 1979–80.

4. It is, none the less, an important subject in its own right. It is dealt with, for example, in the valuable monograph by Otto Stelzer, *Die Vorgeschichte der abstrakten Kunst* (Munich) 1964.

5. Although 'officially' the exhibition covers the years 1910–20, we have occasionally included works that are either earlier or later, where it is important to show the beginnings or the continuation of a particular artist's development.

6. 'The decorative work exists only by virtue of its *destination* . . . Essentially dependent, necessarily incomplete, it must in the first place satisfy the mind so as not to distract it from the display which justifies and completes it.' Gleizes & Metzinger, *Cubism* (1912), translated in Robert L. Herbert (ed.), *Modern Artists on Art* (Englewood Cliffs) 1964, p.5 (volume hereafter cited as 'Herbert 1964').

7. See for example nos.209, 234 in the present exhibition.

8. William Feaver, 'Putting People First', *Observer Magazine*, 18 November 1979, p.72.

9. This exhibition was originally conceived as having an unashamedly didactic purpose; but like all didactic shows it proved to be vulnerable. If a group of works is meant to demonstrate the process by which an artist arrived at, or worked towards the solution to a particular problem, then the presence of each link in the chain is crucial. Unfortunately, the right loans were not always forthcoming. Other organisers of other exhibitions in other places had already tried the patience of public museums and private collectors. This, coupled with the natural reluctance of museums and collectors to allow their fragile treasures to travel at all, has meant that in many cases we have after all been forced to seek for substitutes. As far as Russian painting is concerned, the refusal of the Soviet government to co-operate with us in any way has also undermined the didactic function of the show at several crucial points.

10. Kandinsky, 'Reminiscences' (1913), in Herbert 1964, p.32.

11. Kandinsky, 'Malerei als reine Kunst', *Der Sturm* IV, Nos.178–9 (September 1913) p.98.

12. For a detailed discussion of this topic, see Peter Vergo, 'Music and Abstract Painting', in *Towards a New Art* (London) 1980.

13. Gleizes & Metzinger, *Cubism*, in Herbert 1964, p.3.

14. Fernand Léger, *Functions of Painting* (New York) 1973, p.14. The quotation is from Léger's 1914 lecture 'Contemporary Achievements in Painting'.

15. P.G. Hamerton, *Contemporary French Painting* (London) 1868, p.37; quoted after E.H. Gombrich, 'The Vogue of Abstract Art', *Meditations on a Hobby Horse and Other Essays on the Theory of Art* (London) 1963, p.147.

16. The complete text of Signac's treatise was originally published in Paris in 1899. See now the excellent modern edition by Françoise Cachin (Paris) 1964, rééd. 1978.

17. R. Delaunay, *Du Cubisme à l'Art abstrait. Documents inédits publiés par P. Francastel* (Paris) 1957, p.113.

18. See note 26 below.

19. *August Macke – Franz Marc. Briefwechsel* (Cologne) 1964, p.45 (letter dated 14 February 1911).

20. *Ibid.*

21. August Macke, letter dated Kandern, 14 July 1907 to Elisabeth Gerhardt; see Städtische Galerie im Lenbachhaus München, *Sammlungskatalog 1: Der Blaue Reiter* (Munich) ²1966, p.89.

22. *August Macke – Franz Marc. Briefwechsel* (Cologne) 1964, p.25.

23. Quoted after the catalogue of the exhibition *Paris-Berlin* (Paris, Centre Georges Pompidou) 1978, p.113.

24. G.A. Aurier, *Oeuvres posthumes* (Paris) 1893, p.294.

25. Steiner provided an introduction and notes for the edition of Goethe's *Farbenlehre* published as part of the series *Kürschners Deutsche Nationalliteratur: Goethes Werke* XXV (*Naturwissenschaftliche Schriften* III [1891]); see John Gage, 'The Psychological Background to Early Modern Colour', in *Towards a New Art* (London) 1980, and note 3; also Sixten Ringbom, *The Sounding Cosmos. A Study in the Spiritualism of Kandinsky and the Genesis of Abstract Painting* (Abo) 1970, especially p.78ff.

26. The exact title is *De la loi du contraste simultané des couleurs et de l'assortiment des objets colorés, considérés d'après cette loi dans ses rapports avec la peinture . . .* (Paris) 1839.

27. *Des couleurs et de leurs applications aux arts industriels, à l'aide des cercles chromatiques* (Paris) 1864.

28. Ernst Wilhelm von Bruecke, *Die Physiologie der Farben für die Zwecke der Kunstgewerbe...* (Leipzig) 1866.

29. Re Marc see note 19 above; re Kupka, see Meda Mladek, 'Central European Influences', in the catalogue *František Kupka 1871 – 1957. A Retrospective* (New York, The Solomon R. Guggenheim Museum) 1975, p.19, where the reference is, however, incorrectly given as *Die Psychologie der Farben . . .*

30. 'Die Linie', first published in *Die Zukunft* (Berlin) 6 September 1902; see Henry van de Velde, *Zum neuen Stil. Aus seinen Schriften ausgewählt und eingeleitet von Hans Curjel* (Munich) 1955, p.184.

31. The title of van de Velde's essay 'Die Linie' was noted by Kandinsky in a sketchbook in use during 1907–8 (Munich, Städtische Galerie im Lenbachhaus, GMS 335); the name van de Velde also occurs in the sketchbook GMS 333 of 1905–6. See Erika Hanfstaengl, *Wassily Kandinsky. Zeichnungen und Aquarelle. Katalog der Sammlung in der Städtischen Galerie München* (Munich) 1974, pp.155–6 re the dating of these two sketchbooks.

32. August Endell, 'Formenschönheit und dekorative Kunst', *Dekorative Kunst* I (1898) No.1, p.75.

33. Kandinsky, *Über das Geistige in der Kunst* (Munich) ²1912, p.98.

34. Kandinsky and Franz Marc (eds.) *Der Blaue Reiter* (Munich) 1912, following p.4. The title of the painting is given as 'La femme à la mandoline au piano'.

35. Jean Metzinger, 'Note sur la peinture', *Pan* (Paris) October–November 1910; quoted after Edward F. Fry, *Cubism* (London) 1966, p.60.

36. Christopher Green, *Léger and the Avant-Garde* (New Haven & London) 1976, p.12f.

37. Gleizes & Metzinger, *Cubism*, in Herbert 1964, p.7.

38. Sonia Delaunay, *Nous irons jusqu'au soleil* (Paris) 1978, p.44. Similar reservations also apply to Balla's *Compenetrazioni iridiscenti*, likewise apparently based on intensive studies of light.

39. Guillaume Apollinaire, 'Through the Salon des Indépendants', in *Apollinaire on Art: Essays and Reviews 1902–1918* (London) 1972, p.291.

40. *Ibid.*, p.292.

41. I. Querido, "Een Schilders-studie: Piet Mondriaan", *de Controleur*, 23 October 1909; quoted after Robert P. Welsh, *Piet Mondrian's Early Career. The "Naturalistic" Periods* (New York & London) 1977, p.160.

42. Letter dated 29 January 1914 to H.P. Bremner; quoted after Joop Joostens, 'Mondrian: Between Cubism and Abstraction', in the catalogue *Piet Mondrian 1872–1944. Centennial Exhibition* (New York, The Solomon R. Guggenheim Museum) 1971, p.61.

43. 'Towards the True Vision of Reality', in Piet Mondrian, *Plastic Art and Pure Plastic Art, 1937, and Other Essays 1941–1943* (New York) 1945, p.10.

44. Piet Mondrian, 'A Dialogue on Neoplasticism', *De Stijl*, Vol.II, No.5 (February 1919); quoted after Hans L.C. Jaffé, *De Stijl* (London) 1970, p.122.

45. Much stress has been laid on Kandinsky's interest in Theosophy, in particular by Sixten Ringbom in *The Sounding Cosmos* (see note 25 above). However, in all Kandinsky's published writings, voluminous though they are, he makes specific reference to Theosophy in only two places: his treatise *On the Spiritual in Art*, the substance of which was finished by the summer of 1909, and in his article 'Where is the "New" Art Going?', published in the Russian newspaper *Odesskie Novosti* on 9 February 1911; this article is little more than a re-working of parts of *On the Spiritual*. Significantly, there are no references to Theosophy in *Der Blaue Reiter*, which can be regarded as a summing-up of Kandinsky's intellectual position by mid-1912.

46. Kandinsky, 'Reminiscences', in Herbert 1964, p.26.

47. Part of Kandinsky's definition of his aim in painting his 'Improvisations'; see *Über das Geistige in der Kunst* (Munich) ²1912, p.124.

48. 'Impressionist ist der zum Grammophon der äußeren Welt erniedrigte Mensch.' (Hermann Bahr, *Expressionismus* [Munich] 1916, p.112); 'Wenigstens erscheinen uns jene Ästheten, die nur zu reagieren verstehen, die nur Wachsplatten für Eindrücke sind . . . als ehrlich inferior.' (Kurt Hiller, 'Literatur und Wissenschaft', *Heidelberger Zeitung*, July 1911; quoted after Paul Raabe, *Expressionismus: Kampf um eine literarische Bewegung* [Munich] 1965, p.296.) Hiller's remark, originally made in the context of literature, could equally well be applied to Impressionist painting.

49. This utterance was much quoted, both at the time and later. See e.g. Herman George Scheffauer, *The New Vision in the German Arts* (London) 1924, p.9.

50. Again, a phrase much bandied about by Expressionist artists, not all of whom agreed with it. See, for example, Macke's reactions to Schoenberg as expressed to Marc, in *August Macke – Franz Marc. Briefwechsel* (Cologne) 1964, p.97ff.

51. G. Kahn, 'Réponse des Symbolistes', *L'Evénement*, 28 September 1886; quoted after John Rewald, *Post-Impressionism from Van Gogh to Gauguin* (New York) 1956, p.148. Kahn's definition applied primarily to literary Symbolism.

52. Franz Marc, 'Die konstruktiven Ideen der neuen Malerei', *Pan* II, No.18 (21 March 1912); in Klaus Lankheit, *Franz Marc. Schriften* (Cologne) 1978, p.105.

53. *Ibid.*

54. *Loc.cit.*, p.106.

55. For a more detailed account of this 'dissolving' process see Peter Vergo, 'Kandinsky: Art Nouveau to Abstraction', in the catalogue *Kandinsky. The Munich Years 1900–14* (Edinburgh International Festival) 1979, p.4ff.

56. Statement published in part by Johannes Eichner in *Kandinsky und Gabriele Münter. Von Ursprüngen moderner Kunst* (Munich) [1957], p.109ff.

57. Kandinsky may well have seen the exhibition, since he travelled from Moscow to Stockholm around 20–23 December 1915 (see Eichner, *op. cit.*, p.210). In wartime, the only practicable route would have been via Petrograd. The *vernissage* of *0.10* was on 19 December.

58. The paragraphs on Malevich and the Russian Futurists which follow are based on numerous discussions with Susan Compton, who has also dealt in detail with

Malevich's progress towards abstraction in two important articles, 'Malevich and the Fourth Dimension', *Studio International* Vol.187 No.965 (April 1974), p.190ff, and 'Malevich's Suprematism – The Higher Intuition', *Burlington Magazine* Vol.CXVIII, No.881 (August 1976), p.577ff (cited hereafter as 'Compton 1976'). See also Susan P. Compton, *The World Backwards. Russian Futurist Books 1912–16* (London) 1978.

59. *Soyuz Molodezhi* No.3 (March 1913), p.25ff.

60. Gleizes & Metzinger, *Cubism*, in Herbert 1964, p.8.

61. P. Uspensky, *Tertium Organum* (St Petersburg) 1911; quoted after Compton 1976, p.579.

62. A. Kruchenykh, 'Novye puti slova', *Troe* (St Petersburg) 1913; for bibliographic details see Compton 1976, pp.578–9 and *The World Backwards* (London) 1978, p.125.

63. See the English version of the text published in *TDR/The Drama Review* Vol.15, No.4 (autumn 1971) p.107ff; also Charlotte Douglas, 'Birth of a "Royal Infant"; Malevich and "Victory over the Sun"', *Art in America*, March/April 1974, p.45ff.

64. B. Livshits, 'Osvobozhdenie slova' in *Dokhlaya Luna* (Moscow) 1913; quoted after Compton 1976, p.578.

65. Gleizes & Metzinger, *Cubism*, in Herbert 1964, p.6.

66. Malevich's costume designs are reproduced in black and white in Camilla Gray, *The Great Experiment: Russian Art 1863–1922* (London) 1962, p.163; three are reproduced in colour in the catalogue of the exhibition *Paris–Moscou 1900–1930* (Paris, Centre Georges Pompidou) 1979, pp.383, 396.

67. Two descriptions, one from Kruchenykh's unpublished memoirs, the other from an interview given by Malevich and Matyushin, are published in Camilla Gray, *op. cit.*, p.308 (note 6 to Chapter V).

68. See Compton 1976, p.580f.

69. Gray, *loc. cit.* (see note 67 above).

70. *Ibid.*

71. Quoted after Compton 1976, p.585.

72. Catalogue of paintings and drawings, Nos. 49, 51, 59, in Troels Andersen, *Malevich* (Amsterdam, Stedelijk Museum) 1970, pp.93, 94, 96.

73. It remains arguable whether Kupka should have been given a comparable place as one of the first theorists and creators of abstract painting. Unfortunately, his major treatise *Tvořeni v uměni výtvarném* (Prague, 1923) is available only in Czech; and while drafts for this work date back to the period before the First World War, they exist in different versions, the exact dating of which is still something of a problem. All of this makes a precise, objective evaluation of his theoretical contribution difficult. As far as his pictorial work is concerned, Kupka also differs from all the other principal creators of abstract art in that even his least recognisable subjects derive from studies of *movement*, either as observed in reality or as simulated by optical toys such as the zoëtrope.

74. Kandinsky, response to a questionnaire, in *Cahiers d'Art*, Vol.X (1935), Nos.1–4, p.54.

75. I am indebted to my fellow exhibition-organisers, both the staff of the Tate Gallery and my academic colleagues, for their assistance with specific queries and for their support and encouragement while preparing this essay. They are not to be held responsible for any of the ideas or, unless specifically acknowledged, interpretations contained therein. I am also particularly grateful to Dawn Ades who read the final draft of the essay at top speed, to Michael Compton and Ruth Rattenbury who edited it, and to Sara Selwood, who patiently read innumerable earlier drafts and also generously shared with me the fruits of her own researches.

'Pure Painting': Paris 1910-22
Christopher Green

Cubism was made up of many Cubisms. It was a cluster of fast-moving styles which shared very general principles. Most important among these principles was the rejection of painting as the counterfeit of nature and the assertion of painting as independent from nature – its infinite scope as a field for invention, in a word, its purity. Most central of all Parisian Cubisms between 1910 and 1914 was that of Picasso and Braque; it was central because it was the Cubism of the first Cubists and because all the others continued to draw from it.

Protected from the need to play to large audiences by their dealer D-H. Kahnweiler, Picasso and Braque pursued their Cubism as a near private and very personal exploration. Between 1910 and 1912 they produced paintings whose tipping angular planes never relate in any simple way to the subjects of their titles (nos.1, 4, 5 and 6). But they are paintings replete with suggestions of those subjects and, though their planar structure and tactile paint surfaces (by summer 1912 often coarsened by the admixture of sand) constantly reaffirm the flatness of the picture-surface, these works hint too at shadowy depths. The artist always invents his structures and their space with a subject in mind: still-life, landscape, the human-figure.

The Cubism of Picasso and Braque was known to the other Cubists through Kahnweiler's little gallery in Montmartre. The others lived in Montparnasse and the suburbs of Paris, and not all artists thus distant from Montmartre knew where to find the work of the first Cubists, since Kahnweiler did not advertise and his artists did not show at the Salons. An essential intermediary was the poet Guillaume Apollinaire, friend both of Picasso and Braque and of most who learned from them. He was the interpreter of the many Cubisms too and it was he who, in February 1912, announced the emergence from Cubism of a new art in which the subject would count no longer. He called it 'pure painting' and by the end of 1912 he had identified the painters involved and given them a name: Orphic Cubists or Orphists. Oddly, Picasso was named among them; otherwise they were identified as Robert Delaunay, Fernand Léger, Marcel Duchamp and Francis Picabia. In Paris before the Great War these four last named were indeed the painters who, guided by the Cubism of Picasso and Braque, came closest to abandoning the subject in painting, but Apollinaire could with reason have added another name, that of the Czech artist František Kupka, who, though furthest from Cubism as such, came closest of all the Paris-based artists to this kind of purity.

Kupka's achievement between 1909 and 1914 is remarkable, and most remarkable of all is the fact that it happened in Paris. As one of the Blaue Reiter group in Munich he might have fitted well enough; in Paris, as friend of the Duchamp brothers, he fits hardly at all, and he himself always insisted on his distance from Cubism. Born in 1871, trained in the Prague and Vienna of the 1890s, immersed in Idealist philosophy and theosophy, active as a medium, he was older than the Cubists and the Orphists and his ideas were strikingly foreign to theirs.

Isolated Kupka might have been, but he was not a private painter. He exhibited regularly in the Salons, and it was in the *Salon d'Automne* of 1912 that he made his mark as a 'pure painter', showing two large works without any specific subject-matter, 'Amorpha, Fugue in two colours' and 'Amorpha, Warm Chromatics'. The former's size is the measure of its public purpose: avant-gardism made spectacular, even glamorous. These paintings appeared at the very moment when Apollinaire first used the term 'Orphist', but behind them lay a development away from the subject which anticipated his earliest thoughts on 'pure painting' and which would almost certainly have occurred even had Picasso and Braque never existed. 'The First Step' (no.14), 'Little Girl with a Ball' (no.9), and 'The Disks of Newton' (no.15) series are all stages in this development, showing how a process, on the one hand of abstraction from nature ('Little Girl with a Ball'), and on the other of linear and chromatic experimentation ('The Disks of Newton') led to these results, unprecedented anywhere in Europe at that date. Kupka worked for images whose rhythms and whose luminosity he believed could convey the essential character of all life, a metaphysical ideal sharply at odds with those of Apollinaire's named Orphists but not with those of Kandinsky. Very different from the 'Amorpha' paintings, but an image also founded on abstracting processes and pure experimentation, was Kupka's contribution to the *Salon des Indépendants* of 1913, 'Vertical Planes III' (no.24). However 'expressionist' his intentions, he was capable of a cool and clean-cut geometry alongside the vivid interlace of the 'Amorphas'.

Kupka, then, was working single-mindedly towards 'pure painting' even before 1912. It was only in the spring of 1912 that the first of Apollinaire's named Orphists began to work in a comparable direction; these were Robert Delaunay and Marcel Duchamp.

In 1912 Duchamp combined a Mallarméan love of the suggestively obscure with a growing feeling

for themes that brought together the sexual and the mechanistic. From at least 1911 he had been aware of Picasso's and Braque's cubism, and the elusive ambiguity of their art set him off towards 'The Bride' (no.42) by way, 'en route', of the still recognisably figurative drawing, 'Virgin no.1' (no.41). Duchamp's brief excursion into the borderland between figuration and 'pure painting' was, however, far more an excursion into poetry as painting than was either Picasso's or Braque's. His unexpected fusions of visceral and mechanical form act like metaphors, creating conflicting associations around the ideas fixed by his titles.

Duchamp was quick to leave 'pure painting' behind (he had done so by the end of 1912); Delaunay was not, and his initial move in this direction was altogether more determined. Unlike Kupka, Delaunay was directly in touch with several of the *Blaue Reiter* painters, but his art was profoundly different. He spent the spring and summer of 1912 near Paris painting a series called 'The Windows'. Their starting-point was an earlier series based on a post-card view across Paris to the Eiffel Tower from the Arc de Triomphe ('The City, First Study' and 'The City no.2 (nos.25 and 26)). This earlier series registers a progressive move away from the 'chiaroscuro' articulation of solid form towards the suffusion of the entire picture-surface by Neo-Impressionist touches of contrasting colour. With the 'Window' series (no.27–29), keeping just a few reminiscences of the original post-card view, Delaunay allowed planes of prismatic colour, knowingly yet intuitively dispersed across the canvas, to take control. The planar structure of these paintings looks to that of Picasso's and Braque's slightly earlier cubism, but their colour declares a new content, specified with poetic intensity by the painter himself in his statement of January 1913, 'La Lumière'. The content is neither Paris nor the Eiffel Tower, but light alone. Working with the colour theory of Eugène Chevreul (so admired by the Neo-Impressionists) in mind, he aimed to use the way that colours enhance one another in simultaneous contrast and change as their relationships change to create paintings of compelling vibrancy, capable of thrilling the eye to movement. Colour as the vehicle of indefinable emotions – colour as Kandinsky conceived it – was not for Delaunay: in light alone, he believed, there could be experienced a dynamism consonant with the dynamism of life. Perhaps it could not have been otherwise for an artist raised in Impressionism and Neo-Impressionism.

1913 was the year when 'pure painting' had its biggest chance in Paris. Duchamp might have taken leave of painting altogether, but this was the moment when both Francis Picabia and Fernand Léger joined in the pursuit of 'purity', and early in the year Apollinaire expended many words in defence above all of Delaunay's simultaneous contrasts.

Léger made his intentions clear in May 1913 with a lecture published in the avant-garde periodical *Montjoie!* Like Delaunay, to whom he had been close, Léger declared that painting should be concerned with contrasts alone, but contrasts not simply of colours but also of line and form. He did not see the content of his painting as the dynamism of light, but rather as the dissonance and the dynamism of life under the impact of mechanisation, and these qualities, he believed, could most fully be achieved pictorially by the use of all pictorial elements set in opposition one against another. Just before the *Montjoie!* lecture, he had shown 'The Nude Model in a Studio' (no.37) at the *Indépendants*, but, though his subject here is so far transformed as hardly to be recognisable, it was not until the series called 'Contrasting Forms' (nos.38 and 39) begun in the spring or early summer of 1913, that his ideas took him close to 'pure painting'. Neither 'The Nude Model' nor the 'Contrasting Forms' are the result of a simple process of abstracting from nature; in both Léger transforms his initial subject-matter by imposing upon it an alien vocabulary of forms – in the former the figure is seen in terms of smoke forms, in the latter landscape is seen in terms of geometric solids more akin to the figure. Always the aim is to arrive at a combination of contrasting lines, forms and colours with its own force and mobility detached from any specific reference to subject-matter. Yet, just as Delaunay's real content, light, keeps his art in contact with the everyday experience of things, so Léger's real content, 'modern life', keeps in touch with the immediate and thus sets itself apart from either the abstraction of Kupka or the abstraction of Mondrian, Kandinsky or Malevich.

Delaunay's major contribution to 'pure painting' in 1913 was the 'Circular Forms' series. For both Léger and Delaunay, movement was the essence of reality, and here Delaunay's ultimate aim was to communicate not only the movement of light in space but also in time, for, working from separate studies of sun and moon light, he arrived at paintings which brought together both ('Circular Forms', 'Sun and Moon' (no.32), 'Simultaneous Contrasts: Sun and Moon' (no.33)); they are renderings of the cycle of day and night. Part of this series is the 'First Disk' (no.30), which has traditionally been dated 1912, but which could well have been completed in 1913. It is possible that this could relate to the electric light disks painted by both Robert and Sonia Delaunay in 1914, but its autonomy – a simple target disk freed from any context – sets it apart as Delaunay's purest Orphic painting.

Delaunay and Léger form a contrasting but, nonetheless, related pair; Picabia and Duchamp form another very different one. As Duchamp had in 1912, Picabia in 1913 approached 'pure painting' concerned with much more than the immediate sensations created by light and 'modern life'. The fluent stream of watercolours which he produced in New York from early 1913 as preface to the oils

painted in Paris later that year and through 1914, were attempts to generate associations of a musical, sometimes urban, usually sexual kind. In 'Negro Song' no.1 (no.44) and 'New York' (no.44a), as in 'Physical Culture' (no.45), his was an expressive approach, but he worked intuitively without a clearly thought out theory of colour and form to guide him, and totally without that conviction in the existence of an 'inner' reality characteristic of Kupka. His vocabulary was Duchamp's writ large and given a swagger unmistakably Picabian, and, like the Duchamp of 1912, his titles are there to fix a starting-point for the spectator's imagination.

When war was declared in August 1914 'pure painting' in Paris was already on the wane. Picabia and Kupka might have continued, but both Léger and Delaunay had not: the moment, so propitious in 1913, had passed. Through the years of the Great War into the early twenties Paris proved infertile ground for the sustained development of painting without a recognisable subject-matter. Kupka's faith in the ideas that had led him to the 'Amorpha'

paintings remained unbroken, but, as we have seen, he was a solitary figure; Picabia returned at times to abstraction, even from within Dada, but always with a sense of irony alien to the direct expressiveness of his art in 1913 and 1914. Otherwise, as Cubism continued to produce new Cubisms around the nucleus of Picasso, Braque and Gris, especially between 1917 and 1921, Paris saw no more than a few isolated excursions into abstraction. Pierre Albert-Birot's 'War' (no.46) of 1916, with its echoes of Balla and Depero, is perhaps the oddest and the most isolated. Herbin's compositions of 1920–1, ornamental in intention and effect, (no.50) coupled with Villon's highly sophisticated abstractions from such themes as the horse at a gallop are perhaps the most striking and original (nos.51–53).

Mondrian arrived back in Paris from Holland in 1919, and it was there that he evolved his mature abstract style. A final comment on the hostility of advanced Parisian art to abstraction by this date is the fact that his achievement went almost unnoticed in the French capital for half a decade.

PABLO PICASSO 1881–1975

Painted in the summer of 1910, 'Female Nude' (no.1) points towards a new phase in Picasso's Cubism. Behind it lie drawings done in Paris (not in the exhibition) either from a model or with a model in mind, drawings which retain the organic shaping of features like buttocks and calves. Here, however, Picasso has completely transformed the figure into a schematic scaffold of vertical and horizontal lines, which he has elaborated and opened up into its setting. From this point until 1912, the accent in his work lay on invention rather than representation, and, though they always referred to a figure or landscape or still life, his paintings suggested for many the possibility of an art of total invention.

1 **Female Nude** 1910
 Oil on canvas, $73\frac{5}{8} \times 24 (187 \times 61)$
 National Gallery of Art, Washington, Alisa Mellon
 Bruce Fund 1972

2 **The Fan** 1911
 Ink and sepia, $11\frac{3}{8} \times 8\frac{7}{8} (29 \times 22.5)$
 Private Collection

3 **Man's Head** 1911–12
 Charcoal on paper, $24\frac{1}{2} \times 19 (62.2 \times 48.2)$
 Metropolitan Museum of Art, New York,
 Alfred Stieglitz Collection

'Ma Jolie' (no.4) is one of the culminating paintings of the period in Picasso's art following 'Female Nude' (no.1). Almost certainly elaborated from schematic beginnings where the figure was easier to see, it has become a shadowy, near impenetrable image which only gradually offers clues of the figure's presence – a breast, the possibility of a shoulder, or of a columnar neck. On the left

a still life has been added, whose bottle at least is more quickly seen, acting as an intermediary, inviting the onlooker to explore the more difficult regions of the painting. The words 'Ma Jolie' also act as an invitation, hinting at the possible existence in the shadows of a pretty subject. One is caught between an immediate realisation of the grandness yet variety of this complex arrangement of tilting surfaces and a slowly growing curiosity to find 'Ma Jolie' within it.

4 **Ma Jolie** 1911–12
 Oil on canvas, $39\frac{3}{8} \times 25\frac{3}{4} (100 \times 65.5)$
 Museum of Modern Art, New York, acquired
 through the Lillie P. Bliss Bequest 1945

GEORGES BRAQUE 1882–1963

Braque's 'Mandolin' (no.5) is the result of the coming together of a still life and an abstract structure of partly slanting, partly upright planes. It is according to the directional lines of the abstract structure that the surfaces of mandolin and water-jug are facetted and opened up into surrounding space, so that the appearance is given of a structure imposed upon the objects. But Braque worked unsystematically and the process was almost certainly a subtly integrated one. The image produced (in advance of comparable Picassos) is elusive, only fleetingly referring to the presence of the still life, but Braque needed the example of works like Picasso's 'Female Nude' (no.1) before he could achieve the degree of openness and elusiveness arrived at in 'Clarinet and Bottle of Rum on a Mantelpiece' (no.6). Here, like Picasso at this time, Braque works with schematic and partial representations of objects, combining them more flexibly than in 1910 with an abstract planar structure, itself only partially defined. Again, the result is to create for the spectator a sense both

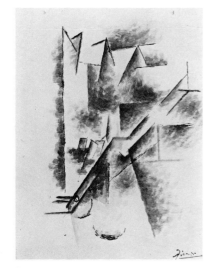

2

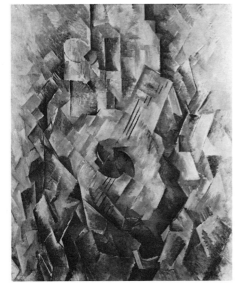

5

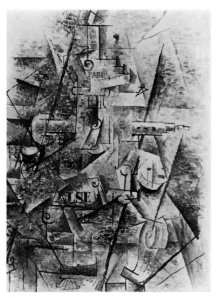

6

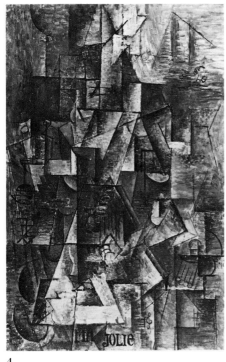

4

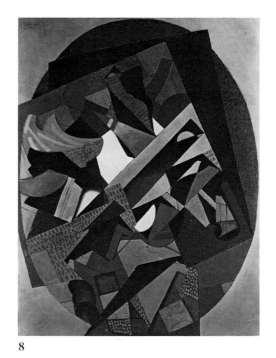

8

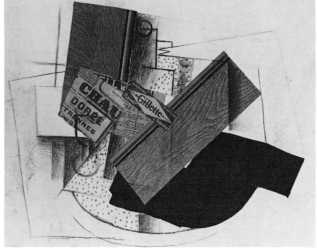

7

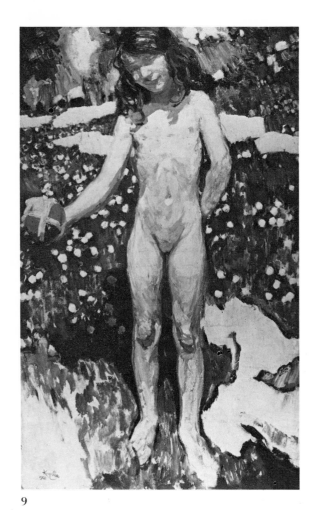

9

10

13

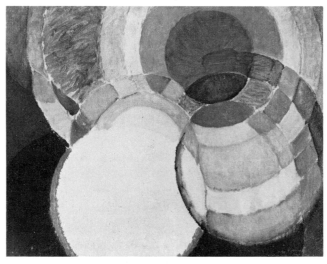

15

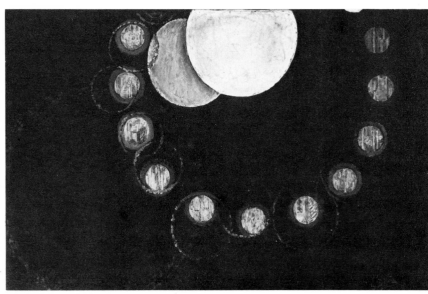

14

of the poised complexity of the pictorial edifice in its own right, and of the hints it carries of another, represented arrangement combining real objects in real space. A fluctuating awareness of the subject is still deliberately stimulated.

5 **The Mandolin** 1909–10
Oil on canvas, $28\frac{1}{2} \times 23\frac{1}{2}(72.5 \times 59.5)$
Tate Gallery (T.833)

6 **Clarinet and Bottle of Rum on a Mantelpiece** 1911
Oil on canvas, $31\frac{7}{8} \times 23\frac{5}{8}(81 \times 60)$
Tate Gallery (T.2318)

In the autumn of 1912, at Sorgues near Avignon, Braque made the first *papier collé*. The significance of this discovery both for him and for Picasso was enormous. Since the paper shapes cut out by Braque were abstract and were only sometimes shaped to refer to objects, they led him to a kind of composition that was even freer than before of subject-matter.

At the same time this new practice both simplified Cubist pictorial elements and made possible a new kind of unperspectival spatial illusionism where depth was evoked by the overlapping of cut-out shapes. The floating planes of these early *papiers collés* made possible the measureless spaces of Malevich's Suprematism and all that this, in turn, was to lead to.

7 **Still Life on a Table** 1913
Cut paper on canvas, $18\frac{1}{2} \times 24\frac{3}{8}(47 \times 62)$
Mr and Madame Claude Laurens

JUAN GRIS 1887–1927

Before 1914 Gris never achieved the appearance of near abstraction found in Picasso's and Braque's paintings of 1910–12. However, now and again after 1914 his practice of working from arrangements of flat planes which at the outset were not obviously related in their shaping to his subject-matter led to apparently highly abstract results. This 'Still Life' (no.8), painted in June 1915, is perhaps the most extreme case. In fact, here it is likely that he *did* have a specific arrangement of still life objects in mind from the start (including a bottle and a fruit-bowl with bananas), but the painting has been left at a stage in its development when their identity is yet to be plainly displayed for us. Gris's method of working must constantly have confronted him with the possibility of abstraction; that he never took it up is a measure of Cubism's built-in resistance to such a conclusion.

8 **Still Life** 1915
Oil on canvas, $45\frac{5}{8} \times 35\frac{1}{2}(116 \times 90)$
Staatliche Museen Preussischer Kulturbesitz,
Nationalgalerie, Berlin

FRANTIŠEK KUPKA 1871–1957

Behind the large painting 'Amorpha, Fugue in Two Colours', which was completed early in 1912, lay many earlier studies in which Kupka tried to intuit the chromatic and linear dynamics of things seen in life. Most important are the drawings (nos.11–13) made after the painting 'Little Girl with a Ball' (no.9), which attempt to capture the movement of both girl and ball in play. More loosely

connected is 'The First Step' (no.14), which seems in part to reflect the artist's fascination with images of the planets and their orbits.

Kupka combined the lessons drawn from such studies and paintings with the experience gained in altogether purer experiments with colour, 'The Disks of Newton' (no.15), to arrive at his conception of 'Amorpha, Fugue', but the number of studies (nos.16–20) that lead up to the painting (a selection only is on exhibition) show that even after so long and full a preparation, the final steps were taken with taxing deliberation. Though ultimately rooted in studies from life, the sheer variety of routes that led Kupka to this idea, including as they did studies independent of any specific subject-matter, makes it inadequate to understand it merely as the result of a process of abstracting. An image of startling simplicity and verve emerges from origins of unexpected complexity.

9 **Little Girl with a Ball** 1908
Oil on canvas, $44\frac{7}{8} \times 27\frac{1}{2}(114 \times 70)$
Musée National d'Art Moderne, Centre Georges
Pompidou, Paris (AM.3464P)

10 **Sketch for an Illustration**
Pencil, $12\frac{1}{2} \times 9\frac{5}{8}(31.8 \times 24.4)$
Národní Galerie, Prague

11 **Three studies after Little Girl with a Ball** 1908–9
(mounted together)
a. Pencil, $8\frac{1}{8} \times 5\frac{1}{4}(20.6 \times 13.3)$
b. Pencil, $10\frac{3}{4} \times 7\frac{3}{8}(27.3 \times 18.7)$
c. Coloured crayons, $8\frac{3}{8} \times 5\frac{1}{2}(21.2 \times 14)$
Museum of Modern Art, New York, Gift of Mr and Mrs
František Kupka (568.56, 4-5-2)

12 **Three studies after Little Girl with a Ball** 1908–9
(mounted together)
a. Coloured crayons, $10\frac{5}{8} \times 8\frac{1}{4}(27 \times 21)$
b. Coloured crayons, $8\frac{1}{4} \times 7\frac{1}{2}(20.8 \times 19)$
c. Coloured crayons, $7\frac{5}{8} \times 6(16.8 \times 15)$
Museum of Modern Art, New York, Gift of Mr and Mrs
František Kupka (568.56.8-3-1)

13 **Study after Little Girl with a Ball** 1909
Coloured crayons, $8\frac{1}{4} \times 5\frac{1}{4}(21.2 \times 13.5)$
Private Collection, New York

14 **The First Step** 1909–13
Oil on canvas, $32\frac{3}{4} \times 51(83.2 \times 129.6)$
Museum of Modern Art, New York,
Hillman Periodical Fund 1956 (562.56)

15 **The Disks of Newton** 1911–12
Oil on canvas, $19\frac{1}{2} \times 25\frac{5}{8}(49.5 \times 65)$
Musée National d'Art Moderne, Centre Georges
Pompidou, Paris (AM.3635P)

16 **Study for Amorpha, Fugue in Two Colours**
1910–11
Oil on canvas, $44 \times 27(111.7 \times 68.5)$
Contemporary Collection of the Cleveland Museum
of Art

17 **Study for Amorpha, Fugue in Two Colours** 1912
Gouache, brush and ink, $8\frac{1}{8} \times 8\frac{1}{2}(20.6 \times 21.4)$
Museum of Modern Art, New York, Gift of Mr and Mrs
František Kupka (569.56.22)

18 **Study for Amorpha, Fugue in Two Colours** 1912
 Gouache, brush and ink, $11\frac{1}{2} \times 11\frac{5}{8}(29.2 \times 29.5)$
 Museum of Modern Art, New York, Gift of Mr and Mrs
 František Kupka (569.56.10)

19 **Study for Amorpha, Fugue in Two Colours** 1912
 Gouache, brush and ink, $8\frac{1}{2} \times 8\frac{7}{8}(21.8 \times 22.8)$
 Museum of Modern Art, New York, Gift of Mr and Mrs
 František Kupka (569.56.15)

20 **Study for Amorpha, Fugue in Two Colours** 1912
 Gouache, brush and ink, $8\frac{1}{2} \times 9(21.4 \times 22.8)$
 Museum of Modern Art, New York, Gift of Mr and Mrs
 František Kupka (569.56.13)

In 'The Piano Keys' (no.21) Kupka over-painted a view of a
lake and boat with a flat arrangement of colour planes,
whose relationship with musical arrangements of sounds
he made explicit. This was the starting-point for a series of
studies and paintings (nos.22 and 23) in which, at times
stimulated by reminiscences of reflections in water (no.23),
at times more purely, Kupka explored planar combinations
of colour, usually with the musical analogy in mind (the
title 'Nocturne' (no.23) is, of course, another obvious
reference to this). The combination of spinning rhythms
and vertical planes found in no.22 pulls together these
concerns with the concerns dominant in the 'Amorpha,
Fugue', but the ambitious outcome, 'Vertical Planes III'
(no.24) stands very much as an alternative.

21 **The Piano Keys** 1909
 Oil on canvas, $31\frac{1}{8} \times 28\frac{3}{8}(90 \times 73)$
 Národní Galerie, Prague

22 **'Copenetrations'** 1910–11
 Oil on canvas, $29\frac{3}{4} \times 32\frac{1}{2}(75.5 \times 82.5)$
 Private Collection, New York

23 **Nocturne** 1911
 Oil on canvas, $26 \times 26(66 \times 66)$
 Museum Moderner Kunst, Vienna

24 **Vertical Planes III** 1912–13
 Oil on canvas, $78\frac{3}{4} \times 46\frac{1}{2}(200 \times 118)$
 Národní Galerie, Prague

ROBERT DELAUNAY 1885–1941

In 1909 Robert Delaunay began a series of paintings based
on a postcard view across Paris to the Eiffel Tower (nos.25
and 26)

 In the later canvases of this series (no.26) he imposed
upon this view a facetted structure of planes, across which
he began to elaborate clusters of colour-dabs in the man-
ner of the Neo-Impressionists. These were the starting-
point for a further series of paintings executed in the spring
and summer of 1912 in the countryside outside Paris
(nos.27–29) in which the facets of the basic structure
already arrived at are coloured in contrasting prismatic
hues to create a vibrant, luminous sensation. Traces of the
original subject always remain in these 'Window' paint-
ings, but the subject is at the same time always sub-
ordinate.

25 **The City, First Study** 1909
 Oil on canvas, $34\frac{3}{4} \times 49(88.2 \times 124.5)$
 Tate Gallery (T.217)

26 **The City II** 1910–11
 Oil on canvas, $57\frac{1}{8} \times 44\frac{1}{2}(145 \times 113)$
 Solomon R. Guggenheim Museum, New York
 (FN.464)

27 **Windows open simultaneously, first part,
 third motif** 1912
 Oil on canvas, $18 \times 14\frac{3}{4}(45.7 \times 37.5)$
 Tate Gallery (T.920)

28 **Windows over the City, first part, second motif** 1912
 Oil on canvas, $15\frac{5}{8} \times 11\frac{5}{8}(39 \times 29.6)$
 Estate of Sonia Delaunay

The idea of fusing three subtly different 'Window' compo-
sitions is probably Bergsonian in inspiration, three kinds
of light interpenetrating to convey the continuity of
change between them through time. The French philos-
opher, Henri Bergson, a hugely influential figure in this
period, stressed the continuity of movement through time
in a way deeply sympathetic to such an intention on
Delaunay's part.

29 **Three-part Windows** 1912
 Oil on canvas, $13\frac{1}{2} \times 35(34.3 \times 88.8)$
 Philadelphia Museum of Art (52-61-13)

The 'Circular Forms' series (nos.30–33) comes of De-
launay's desire to find abstract (pure) equivalents for the
different kinds of light experienced in nature, sun and
moonlight. He is said to have based these paintings on the
direct observation of these phenomena.

30 **The First Disk** 1912, possibly 1913
 Oil on canvas, diameter $53(134.7)$
 Mr and Mrs Burton Tremaine, Meriden, Connecticut

31 **Circular Forms, Moon III** 1913
 Wax on canvas, $10\frac{1}{2} \times 8\frac{1}{2}(26 \times 21.5)$
 Charles Delaunay

32 **Circular Forms, Sun and Moon** 1913
 Oil on canvas, $25\frac{5}{8} \times 39\frac{3}{8}(65 \times 100)$
 Stedelijk Museum, Amsterdam (A.3438)

33 **Simultaneous Contrasts: Sun and Moon** 1913
 Oil on canvas, diameter $53(134.5)$
 Museum of Modern Art, New York, Mrs Simon
 Guggenheim Fund 1954

SONIA DELAUNAY 1885–1979

The wife of Robert, Sonia Delaunay evolved her ideas on
colour in concert with him. Highly original in her appli-
cation of them as a painter, she added a new dimension by
branching out into design. Her very recent death sadly
removes the last of the earliest generation of abstract
painters.

 This colour accompaniment to Blaise Cendrars's poem
'Prose on the Trans-Siberian Railway and on little Jehanne
of France' was one of her earliest such attempts. The
interpenetration of words and colour creates a very rich
sequence of analogies between the poetic and the pictorial,
which, in the end, underlines the continuing involvement
of both Robert and Sonia Delaunay in the direct experience
of life, since such an involvement manifestly provides

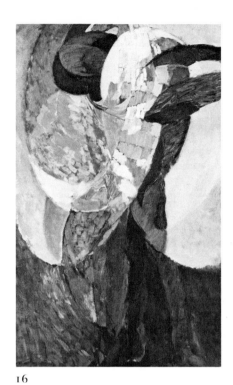

16

17

18

19

20

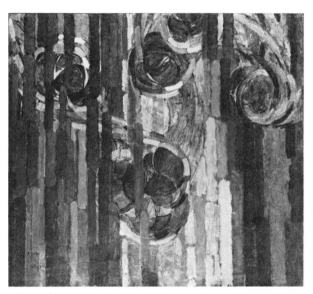

22

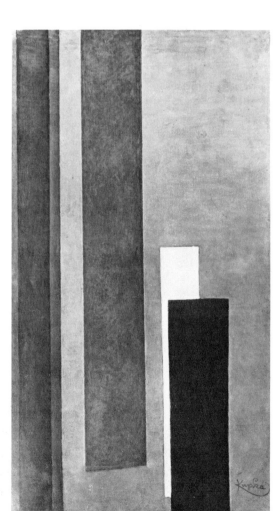

24

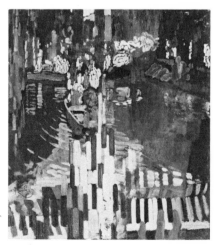

21

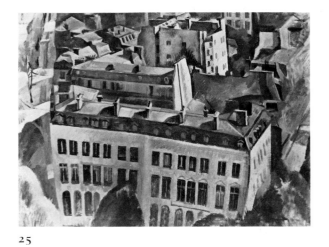

25

28

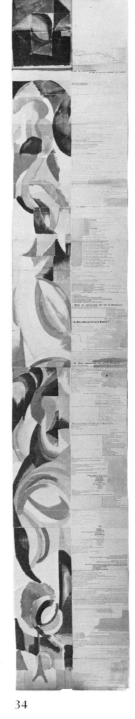

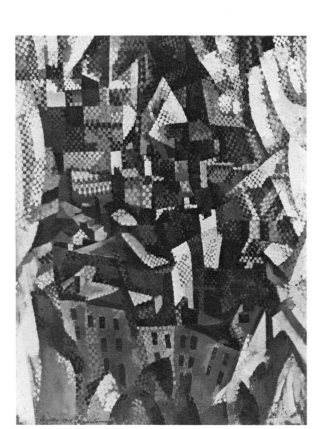

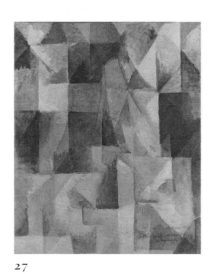

27

26

34

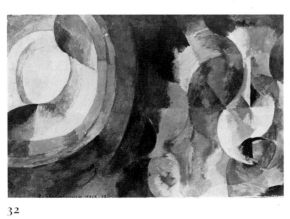

29 32

the impetus for Cendrars's poem. As well as their 'pure paintings' both the Delaunays produced paintings in 1913 and 1914 enlivened by instantly recognisable poetic images comparable often with Cendrars's.

34 Prose on the Trans-Siberian Railway and on little Jehanne of France 1913
Pochoir, $73\frac{3}{4} \times 13\frac{3}{4}(200 \times 35.5)$
Sims and Reed Limited

35 Composition 1913
Watercolour, $10\frac{1}{2} \times 7\frac{7}{8}(26.7 \times 20)$
Mr and Mrs Robert Lewin

FERNAND LÉGER 1881–1955

The hurried yet sure gouache, the 'Smokers' (no.36) takes as its major pictorial theme the confrontation between bracketing angular planes and upward rising curved surfaces. These latter rise from between two seated figures, still decipherable to the persistent spectator; the sinuous rhythms of this ascending central 'motif' derive from Léger's observations of smoke. It is in terms of just these curving surfaces, originally abstracted from smoke, that Léger transforms the figure in 'Nude Model in a Studio' (no.37) and the principle behind this transformation – the imposition on one subject of forms abstracted from another – is precisely the principle behind the evolution of the 'Contrasting Forms' of 1913–14 (no.38). In this case, Léger's initial treatment of landscape subjects was transformed by the imposition of cylindrical volumes which derive from his earlier geometricisations of the human figure. Here the process leads to the total negation of the landscape subject, but in 'Still life with Coloured Cylinders' (no.40), where volumes derived similarly from the cylindrification of the human figure are imposed upon a lamp, a 'compotier', a cup and saucer and other objects, Léger leaves his subject plainly legible. These paintings of 1913 and 1914 are about contrasts, as Léger's writings of the time make clear – contrasts of the curved against the straight, the flat against the volumetric, primary colour against black and white. Yet, in those canvases that almost achieve total abstraction (the 'Contrasting Forms') and those that declare an apparently traditional subject ('Still Life with Coloured Cylinders') the primary meaning is almost brutally stated (by way of the machine analogy) – Léger's forceful and dynamic view of mechanisation.

36 Smokers 1912
Ink and gouache, $25\frac{1}{2} \times 19\frac{1}{2}(64.9 \times 49.9)$
Stedelijk Museum, Amsterdam (A.6435)

37 Nude Model in a Studio 1913
Oil on canvas, $50\frac{3}{4} \times 37\frac{5}{8}(128 \times 95)$
Solomon R. Guggenheim Museum, New York (FN.1193)

38 Contrasting Forms 1913
Gouache, $17\frac{5}{8} \times 21\frac{3}{8}(44.7 \times 54)$
Rosengart Collection, Lucerne

39 Formal Variation 1913
Oil on canvas, $23\frac{1}{2} \times 28\frac{3}{4}(44.7 \times 54)$
Mr and Mrs Nathan Smooke

40 Still Life with Coloured Cylinders 1913
Oil on canvas, $35\frac{1}{2} \times 28\frac{1}{2}(90 \times 72.5)$
Galerie Beyeler, Basle

MARCEL DUCHAMP 1887–1968

The process of transformation behind 'The Bride' (no.42) cannot clearly be demonstrated by studies, since Duchamp worked away from the visible in a distinctly oblique way, inventing as much as he abstracted. Yet, there is no doubt that a rather whimsical selective and at the same time metamorphic study of the figure came first, as the drawing (no.41) makes clear.

41 Virgin I 1912
Pencil, $13\frac{1}{4} \times 19\frac{15}{16}(33.6 \times 25.2)$
Philadelphia Museum of Art, A.E. Gallatin Collection (52.61.24)

42 The Bride 1912
Oil on canvas, $35\frac{1}{8} \times 21\frac{3}{4}(89 \times 55.2)$
Philadelphia Museum of Art (50-134-65)

FRANCIS PICABIA 1879–1953

'Sad Figure' (no.43) is one of a group of works painted by Picabia in 1912, in which one can see the subject's identity clearly and can comprehend the process of cubification and simplification that has led to its pictorial interpretation. The example of Duchamp's evocative abstractions of 1912, including 'The Bride' (no.42), helped guide Picabia towards a far more freely expressive kind of painting in 1913 (nos.44–45). As far as possible, he worked without conscious control to produce these images, fusing the results of abstracting with pure flights of pictorial fancy. By this time, he was aware of Kandinsky's ideas on creation and expression. His aim was to create an emotional response in tune with the subject that lies obscurely behind his compositions, his titles guiding us to their identities since his painting so utterly refuses to do so. 'Negro Song' (no.44) is a reminder that he too was interested in the analogy between painting and music, an interest encouraged by his musician wife Gabrielle Buffet.

43 Sad Figure 1912
Oil on canvas, $46\frac{1}{2} \times 47(118 \times 119.3)$
Albright-Knox Art Gallery, Buffalo, Gift of
The Seymour H. Knox Foundation Inc. 1968

44 Negro Song I 1913
Watercolour, $26\frac{1}{8} \times 22(67.2 \times 56)$
Metropolitan Museum of Art, New York, Alfred
Stieglitz Collection, 1949 (49.70.15)

44a New York 1913
Watercolour, $21\frac{5}{8} \times 29\frac{1}{2}(55 \times 75)$
Art Institute of Chicago, Alfred Stieglitz Collection

45 Physical Culture 1913
Oil on canvas, $35\frac{1}{4} \times 46\frac{1}{8}(89.5 \times 117)$
Philadelphia Museum of Art (50-134-157)

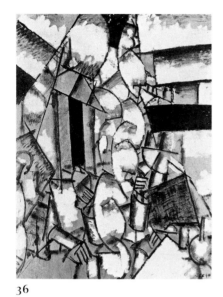

36

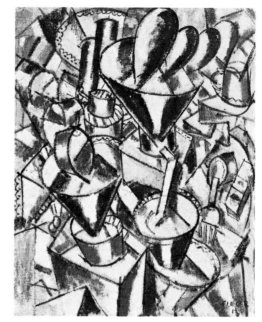

40

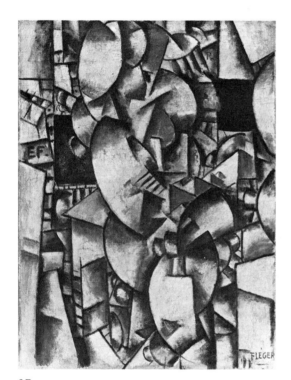

37

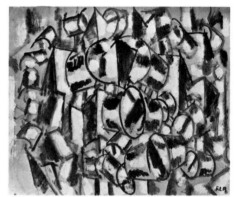

38

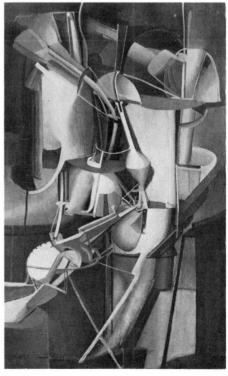

39 41 42

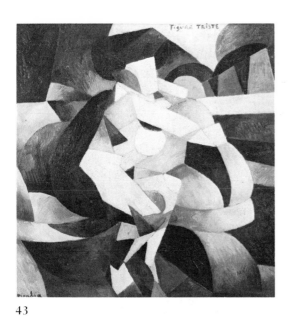

43

45

44

44a

50

46

47

48

PIERRE ALBERT-BIROT 1876–1967

Pierre Albert-Birot is remembered more as a poet and as editor of the influential Parisian avant-garde periodical *SIC*, than as a painter. His surprising flirtation with abstract painting came at a time when he was in close contact with the Futurist Severini, and an earlier study for *War* includes words in a loosely Futurist way to amplify the direct expressive message of forms and colours. His own writings in *SIC* during 1916 demonstrate that Albert-Birot saw this painting as an attempt at purely 'subjective' invention without reference to nature; using terminology reminiscent of Balla as well as Severini he called a graphic version of his painting 'the plastic expression "War".'

46 War 1916
Oil on canvas, $49\frac{3}{8} \times 46\frac{1}{2}(125.5 \times 118)$
Musée National d'Art Moderne, Centre Georges Pompidou, Paris (AM.1977.639)

AUGUSTE HERBIN 1882–1960

Auguste Herbin was one of the circle of artists around the dealer Léonce Rosenberg, which in 1919 and 1920 included Léger and Gris. The gouaches (nos.47 and 48) are clearly synthetic cubist treatments of still life subjects. Herbin uses flat coloured shapes glancingly to refer to objects, his range of shapes already prefiguring the overtly decorative vocabulary of the 'Composition' of 1919 (no.49). This latter, a remarkably original painting for its time, makes no secret of its subject, in this case landscape, but nonetheless shows how close to abstraction Herbin could get as a fine artist. Significantly, it was only when his intentions were specifically decorative, as in the 'Polychromatic Relief' (no.50), that he dared risk the appearance of total abstraction. Yet here almost always a subject lies behind his compositional ideas, in this case probably figurative.

47 Composition I *c.*1918
Watercolour on paper, $13\frac{5}{8} \times 10(34.8 \times 25.3)$
Musée d'Art Moderne de la Ville de Paris, Collection Henry Thomas No.56

48 Composition II *c.*1918
Watercolour on paper $13\frac{5}{8} \times 10(34.8 \times 25.3)$
Musée d'Art Moderne de la Ville de Paris, Collection Henry Thomas No.57

49 Composition 1919
Oil on canvas, $29 \times 35\frac{1}{2}(73.7 \times 90)$
Private Collection

50 Polychrome Relief 1920
Painted wood, $33\frac{1}{4} \times 26(84.5 \times 66)$
Musée d'Art Moderne de la Ville de Paris, Collection Henry Thomas No.58

JACQUES VILLON 1875–1963

After 1918, when the Cubists for the most part moved each in their own way towards more legible styles, Villon produced some of his most highly abstracted work. Ironically, where Cubists like Gris and the sculptor Lipchitz worked 'synthetically' from arrangements of abstract shapes *towards* their subject matter, Villon worked in a highly complex 'analytical' way, breaking down his subject-matter into flat planar configurations until it became all but unrecognisable. In this pair of studies (nos.51, 52), part of a series recently shown to have led to 'Colour Perspective' (no.53), the process is clearly visible, though so complicated as to be very difficult to unravel. It is symptomatic of the Cubist antipathy to abstract art that when Villon exhibited at the Galerie Povolozky in Paris in 1922, the Cubist-orientated critic Maurice Raynal found works like 'Colour-Perspective' too 'decorative' in their abstractness, using the term 'decorative' in a derogatory way.

51 Study for the Jockey No.4 1921
Pencil and watercolour on tracing paper,
$15\frac{3}{8} \times 21\frac{3}{4}(39 \times 55.2)$
Yale University Art Gallery. Gift of the Société Anonyme Collection (1941.751)

52 Study for the Jockey No.7 1921
Pen and ink on tracing paper, $10\frac{5}{8} \times 17\frac{3}{4}(27 \times 45)$
Yale University Art Gallery. Gift of the Société Anonyme Collection (1941.753)

53 Colour Perspective 1922
Oil on canvas, $23\frac{5}{8} \times 36\frac{1}{4}(60 \times 92)$
Yale University Art Gallery. Gift of the Société Anonyme Collection (1941.745)

The Netherlands
Jane Beckett

Accounts of the development of abstraction in the Netherlands between 1909 and 1919, are necessarily dominated by the work of Piet Mondrian, and inevitably by the development of the painters associated with the aesthetic of *De Stijl*. Such accounts however distort the wider issues within Dutch abstraction in these years, which emerged from a variety of complex, and often contradictory, issues and influences.

One important legacy was the involvement of Dutch painters in the Symbolist Movement at the turn of the century. Jan Toorop's close connection with 'Les XX', in Brussels, to which he was elected in 1884, had important repercussions in Holland. These were a concern with the relationship between the decorative and fine arts, theoretical discussion of the nature of the elements of line and colour and the concern with esoteric mysticism, spirituality and meaning.

The fusion in Brussels between an English Arts and Crafts tradition and the decorative concern of Parisian non-naturalistic painting opened the way for considerable debate in Holland on the relationship of art and society, and simultaneously for the exploration of arts and crafts and of monumental public art. The decorative murals and stained glass compositions of Anton der Kinderen (1859–1925) provided the model for Bart van der Leck's conception of monumental art as 'flat colour and the creation of space' (in 'Painting and Building' *De Stijl* I.4. (February) 1918. p.38) and ultimately for the *De Stijl* aesthetic of the unity of the arts within architecture. These factors blended in the collaboration between the architects J.J.P. Oud (1890–1963) and Jan Wils (1891–1976) with the painters Theo van Doesburg and Vilmos Huszar in the production of interior colour schemes enriched with stained glass windows. At *De Vonk*, Noordwijkerhout for example, Van Doesburg worked with Oud in 1918, in the creation of a monumental interior entrance hall, which he subsequently described as having transcended the decorative traditions of monumental wall painting. He characterised this change in conception as 'rejecting the illustrative and ornamental character' of monumental art, which he saw as 'wholly in conflict with its essence, which is to create through colour relationships, aesthetic space (extension) on the constructionally closed plane' (in 'Notes on Monumental Art'. *De Stijl* II.1. (November) 1918, p.1) Moreover the experience of working with the gridded structure of stained glass design was to prove fundamental in Van Doesburg's development

of geometric abstraction (see nos.108–110) While the artists of *De Stijl* pursued a rigorous collaboration with the architects, Otto and Adya van Rees pursued a similar interaction between the pure and decorative arts. In Paris in 1912, Adya van Rees based her silk embroideries on the contemporary canvases of Otto Freundlich, and subsequently in Zurich in 1915 made wool and silk embroideries based on paintings and collages by her husband and by Hans Arp. These works based on geometric configurations were exhibited together at the Galerie Tanner in Zurich in 1915.

Theoretical discussion of line and colour became interwoven temporarily with esoteric mystical concerns and with spirituality, and related to this, with interpretation of the theoretical writings of Wassily Kandinsky. Several artists in Holland, Piet Mondrian, Jacoba van Heemskerk and Adrianus de Winter, for example, were directly involved with Theosophic doctrine. While artists such as Theo van Doesburg, Johannes Tielens and Erich Wichman were concerned with a broader-based spirituality. The weekly review *Eenheid* (Unity), to which Van Doesburg regularly contributed between 1912 and 1919, was devoted to discussion of pacifist, ethical, and utopian socialist and religious views. These views are reflected in Van Doesburg's discussion of line in an article published in February 1914, in which he sees the 'curved line used predominantly for reasons of beauty (Phidias, Michelangelo, Rubens, Raphael); it has been used more and more economically for reasons of Truth (Millet, Monet, Cézanne) and it will end as the straight line for reasons of Love. This will enable the art of the future to create international form' (*De Avondpost*. 7 February 1914). Van Doesburg's original proposal to call the new periodical 'The Straight Line' was finally abandoned for the broader conception *De Stijl*.

In the association of line and colour with spirituality there are widely divergent approaches. The painters who exhibited their work as 'Absolute Painting', at the second *Onafhankelijken Exhibition* in Amsterdam in the autumn of 1913 – Jacob Bendien, Arnold Davids, Jan van Deene and Chris Hassoldt – described this abstract painting as 'emotion expressed through line and colour'. The work of this group of painters, the large proportion of whom lived and worked in Paris between c.1911–14, was focused initially on abstracted head and landscape motifs, yet by 1912, they had developed abstract – absolute painting – characterised by planes of bold colour, bound by undulating lines, partly dependant

on *Jugendstil* decorative arts and partly on the contemporary lyrical abstract canvases of the Czech painter František Kupka (nos. 15–20). The involvement of Piet Mondrian with Theosophic doctrine, with the writings of Rudolf Steiner and the Dutch Christosoph, Dr M.H. Schoenmaekers in particular has been widely discussed within the development of his emergent theory of abstraction (see below). Moreover it has been suggested that Mondrian's involvement with the Theosophic movement was fundamental in his subject preferences – windmills, seascapes, trees, church towers and building façades – in his gradual use of protogeometric elements, which resulted in close stylistic unity among works and also in his employment of a minimal number of compositional formats, principally the cruciform structure.[1] Broadly similar concerns are apparent in Jacoba van Heemskerk's painting. Her interest in 'the reality behind nature', and her suggestion that 'the teacher must try to point out the spiritual worth that lies behind the things that are optically perceptible' (in Marie Tak van Poortvleit *Jacoba van Heemskerk* Sturm Bilderbuch VII, Berlin 1926, p.16) derives philosophically from Theosophy.

One main theme of Dutch painting in the first two decades of the twentieth century was flower and tree motifs. Undoubtedly this can be linked to a nineteenth-century naturalist tradition, to *fin-de-siècle* flower symbolism, as well as to Theosophic meditational exercises. In Janus de Winter's oeuvre however, which consisted almost exclusively of flower (frequently orchids) and landscape motifs, there is little doubt of his mystical devotional interpretation of nature. He was specifically concerned with clairvoyant visions in which colour manifestations not apparent to the naked eye, but visible to Theosophic initiates, are manifest as aural shells surrounding objects. The titles of his work reflect this concern while his technique of isolating natural motifs in rich colour areas, stresses the conception.

Like Johannes Tielens, De Winter derived a theory of colour from Theosophy, although within Theosophic doctrine the attribution of specific meanings to tints and hues is very varied. However De Winter, Van Doesburg and Tielens appear to have followed, at least during 1916, C.W. Leadbetter and A. Besant's *Thought Forms* (published in a Dutch translation in 1903) in the ascription of spiritual and intellectual states to particular colours. By 1918, Van Doesburg had abandoned and indeed repudiated, his interest in Theosophy, and like Mondrian and Vilmos Huszar turned to the colour theories of Wilhelm Ostwald (e.g. *Die Farbenfibel*, 1917).

Also related to these broadly based mystical ideas was an interest in mathematic and geometric formulations. The analogy between proportional systems and harmonic spirituality as embodied in ideal forms has a long and chequered history. Interest in Holland focused on the publication in 1912 of J.H. de Groot's *Vormharmonie*, and Schoenmaekers

Beginselen der Beeldene Wijskunde (Principles of Plastic Mathematics), of 1916. Popular interest in conceptions of non-Euclidean geometry, and of the 'fourth dimension' must also be related to this. In an article on the 'fourth dimension', Tielens adopted a mystical interpretation (*Holland Express* 9, 1916). A year later Van Doesburg in an article on modern painting[2] partly influenced no doubt by Apollinaire's *Les Peintres Cubistes* adopted both the mystical view and saw the fourth dimension in terms of the possibilities of spatial measurement.

The final connection with 'Les XX' within the general background of the development of abstraction in The Netherlands was the introduction through the work of Jan Toorop of a Neo-Divisionist block-like stroke. For Mondrian in 1908–9 the adoption of this technique was important in the early stages of his development away from naturalistic subject matter. In a letter to the critic Israel Querido in response to the former's review of an exhibition of his work at the Stedelijk Museum in Amsterdam which included a room devoted to pointillist works, he writes that 'paint should be applied in pure colours set next to each other in a pointillist or diffuse manner'.[3] Dutch modernism was initially identified with this 'luminist' painting, an interpretation reinforced by the exhibition in January 1909 of Mondrian's painting with the recent Fauvist canvases of Jan Sluyters. The rich colour tonalities and mystic content of Mondrian's work was discussed by Israel Querido, while the heightened palette of Sluyters, characterised by anti-natural colours, linked Dutch painting with developments of a few years earlier in Paris and in Dresden.

The link between expressionist rich colouration and mysticism remained the basis of much critical writing on Dutch painting between 1909 and 1915 and in general terms influenced the development of abstraction in Holland during these years. However increasing contact with other European developments, through exhibitions and travel considerably broadened this conception between 1912 and 1914.

Dutch painters had travelled fairly regularly to the French capital. Toorop, for example, made regular journeys, and several of the artists who spent the summer months at Domburg, on the Zeeland Island of Walcheren, exhibited in Paris during the autumn. From c.1907–14 there was a considerable colony of Dutch artists living in Paris,[4] mainly in Montparnasse, and their contact with Parisian painters was chiefly among those who lived in the same arrondissements and frequented the same cafes. Thus Adya and Otto van Rees, Piet Mondrian, Petrus Alma and Lodewijk Schelfhout appear to have known Le Fauconnier, Léger, Gleizes, Metzinger and Severini.

The foundation of the Amsterdamse Kunstkring in 1910, by the critic Conrad Kikkert, Mondrian, Schelfhout and Toorop was clearly aimed at the introduction of modern European painting into the Netherlands. Knowledge of contemporary develop-

ments throughout Europe was accelerated during 1912–14, with the twice annual exhibitions of *De Onafhankelijken* (The Independants), the annual *Sint Lucas* and *Moderne Kunstkring* exhibitions in Amsterdam. The work of Dutch artists was shown in galleries and salon exhibitions in Berlin and Paris.

The first exhibition of the *Moderne Kunstkring*, held in October 1911 introduced the 1908–9 work of Picasso and Braque and more recent canvases by Herbin, Dufy, Vlaminck and Le Fauconnier. Moreover a whole room was devoted to twenty-eight canvases by Cézanne that belonged to the collector F.H. Hoogendijk. This exhibition brought about profound changes in Dutch painting and apparently stimulated Mondrian to depart for Paris by the end of the year. The following year Mondrian's earliest Cubist canvases were exhibited at the *Moderne Kunstkring* which again included work by Picasso, Braque and Le Fauconnier. By 1913, the last exhibition before the war, Cubist paintings had given way to recent canvases by Kandinsky and Franz Marc.

The exhibition of Futurist painters opened in August 1912 in The Hague (Gallery Biesing), in September it moved to Amsterdam (Gallery de Roos) and by October it was in Rotterdam (Gallery Oldenzeel). Recent painting from Germany was shown in a large retrospective exhibition of works 1902–10, by Kandinsky, selected by Herwarth Walden, at Gallery Oldenzeel in Rotterdam in 1912. Walden, moreover, established close contact with several Dutch painters and regularly exhibited work by Jacoba van Heemskerk in Berlin. Mondrian, the Van Reeses, and Erich Wichman were represented in the *Erster Deutscher Herbstsalon* in Berlin in the autumn of 1913.

Thus from this broad base of European modern painting the development of abstraction followed, stimulated both by the richness of the forms of painting and by the critical appraisal of them. Conrad Kikkert's knowledge of Montparnasse Cubism was undoubtedly instrumental in the influence of Léger and Le Fauconnier on Dutch painting. Cubism however was largely interpreted in Holland as Expressionist painting, although Kikkert's introduction to the catalogue of the first *Moderne Kunstkring* exhibition stressed its formal, austere elements. Generally the dynamism and excitable colour of Futurist painting had a larger influence than the strict control of Cubism. This was clearly not the case in Piet Mondrian's absorption of Cubism in Paris between 1912 and 1914. It is perhaps an irony that it was not Cubism, but the more melodic work of Otto Freundlich that stimulated the development of abstract painting among the large group of Dutch artists in Paris before the war.

The influence of Futurism was primarily in a temporary employment of fractured planes and modern subject matter. Although Louis Saalborn's interest in the synaesthetic fusion of sound and paint is clearly related to Futurist manifestos. His stress

on the importance of line, frequently linked with musical subject matter (nos.136, 137,) and the development of liberated, gestural line in numerous drawings of 1916 develops from this.

Formal and aesthetic links between line, colour and form were developed from Kandinsky's theoretical writings *On the Spiritual in Art* (1911–12), *The Blaue Reiter Almanac* (1912) and through the distribution of Walden's publication *Der Sturm*. The outbreak of war in the summer of 1914 and the consequent isolation of Holland until 1918 led to a curious fusion between the strands of pre-war exemplars, and a polarisation within Holland into small groups. This was undoubtedly linked to the nineteenth-century distinction between Amsterdam, Rotterdam and The Hague as artistic centres.

Erich Wichman discussed the relationship between Cubism, Futurism and Expressionism in the development of the conception of 'pure' and 'absolute' painting in a book published in 1914'.[5] The link between Cubism and Futurism is seen in overtly Expressionist terms. Similarly Van Doesburg's discussion of abstraction in the lectures he gave between 1915–16[6] on the development of modern painting is rooted in an expressionist theory of abstraction. In March 1916 Tielens, Wichman, Van Doesburg and Saalborn instituted the artists association 'De Anderern' (The Others) at the American Hotel in Amsterdam. This had only a short-lived existence with one exhibition in The Hague (Gallery d'Audretsch) and included work by the founders plus Vilmos Huszar and Laurens van Kuik.

In May 1916 Van Doesburg became involved in a Leiden group 'De Sphinx' that included architects among its members. This again appears to have been only a short-lived group. More fundamental was the agreement of Bart van der Leck and Piet Mondrian to join Van Doesburg in the publication of a review – *De Stijl* in May 1917. Contact with Bart van der Leck and Mondrian in Laren during 1916–17 led Van Doesburg gradually to abandon his overtly mystical conception of abstraction and to replace it with a more austere conception of geometric abstraction (nos.108–111) based upon the use of horizontal and vertical lines and primary colour. The dissemination of aesthetic and practice of this radical abstraction – Neo-Plasticism – followed in numerous articles and reproductions in the review *De Stijl*.

The development of abstraction in Holland between 1909 and 1916 was closely linked to an awareness of the developments of modern painting within other European countries, and is closely bound up with a broadly based mystical conception of the relationship between art and spirituality. It was from the fusion of these diverse elements that Dutch geometric abstraction developed among the painters of *De Stijl* and it is in their acceptance and rejection of the various models that much of the fascination of the processes by which these artists arrived at abstraction, lies.

NOTES

1. See R. Welsh and J.M. Joosten, *The Birth of De Stijl. Art Forum* XI April 1973.
2. *Eenheid* no. 392. 8 December 1917.
3. Quoted in full in R. Welsh and J.M. Joosten, *Two Mondrian Sketchbooks 1912–14* Amsterdam. 1969.
4. See M. Hoogendoorn, *Nederlanders in Parijs. Museum Journaal* serie 17.6. December 1972 pp. 247–253.
5. E. Wichman and E.L. Dake *Nieuwe richtingen in der Schilderkunst (cubisme, expressionisme, futurisme etc.)* Baarn. 1914.
6. Subsequently published as *Drie voordrachten over de nieuwe beeldene kunst.* Amsterdam 1919.

BIBLIOGRAPHY

Books

A.B. Loosjes-Terpstra, *Moderne Kunst in Nederland 1900–1914.* Utrecht. 1959.

H.L.C. Jaffé. *De Stijl 1917–31* London 1956.

H.L.C. Jaffé. *De Stijl.* London 1970.

Catalogues

'Het Nieuwe Wereldbeeld: het begin van de abstract kunst in Nederland 1910–25', *Museum Journaal* Serie 17.6. December 1972.

Kunstenaren der Idee. Exhibition catalogue The Hague 1979.

M. Seuphor, *Piet Mondrian.* n. d.

Piet Mondrian. Exhibition catalogue Toronto 1966.

Piet Mondrian. Exhibition catalogue Guggenheim Museum, New York 1971.

Cor Blok, *Piet Mondrian* a catalogue of the work in Dutch collections. 1974.

Bart van der Leck. Exhibition catalogue. Rijksmuseum Kröller Müller, Otterlo 1976.

Theo van Doesburg Exhibition catalogue. Basle 1968–9.

J. Baljeu, *Theo Van Doesburg.* London 1974.

Otto and Adya Van Rees Exhibition catalogue. The Hague 1975.

R. Welsh and J.M. Joosten, *Two Mondrian Sketchbooks 1912–14.* Amsterdam 1969.

R. Welsh and J.M. Joosten, 'The Birth of De Stijl; Part I' *Art Forum.* XI. (April) 1973.

J. Baljeu, *Sketsboekenperikleen. Museum Journaal* serie 16.6. December 1971.

PIET MONDRIAN 1872–1944

DOMBURG Strandgezicht

Uitg. Firma F. B. den Boer, Middelburg.

Fig. 1

Fig. 2

In September 1908 Piet Mondrian made what was to be the first (until 1914) of yearly visits to the small seaside village of Domburg on the island of Walcheren in Zeeland. (figs. 1, 2).[1] Jan Toorop, whom Mondrian probably met in Amsterdam earlier in 1908, had painted regularly (since 1903) at Domburg during the summer months, and at the time of Mondrian's arrival was the centre of an artistic milieu that included Jacoba van Heemskerk, Otto and Adja van Rees, Marie Tak van Poortvleit and Charley Toorop. The main subject matter of the Domburg painters was dunes and seascapes. It was not at Domburg but at Oele some months earlier that Mondrian had introduced the heightened and expressive colour of the Fauvist palette into his work and also a block-like structured stroke, possibly as a result of his close contact with Jan Sluyters, nevertheless at Domburg he explored these innovations.

Mondrian's work at Domburg was important in his move from naturalism to abstraction, and it is generally agreed that his interest in Theosophy played an important part in this process. Welsh has shown the importance of these ideas in Mondrian's work in Amsterdam, 1908–11, (R. Welsh in New York, Guggenheim Museum, *Piet Mondrian*, 1971, pp. 35–51.) While Mondrian's letter to the critic Israel Querido in response to the latter's review of the first major retrospective exhibition of his work, held with Jan Sluyters and Cornelius Spoor at the Stedeljk Museum, Amsterdam, in January 1909, reveals the importance of the Theosophical world view in his desire to stress the spiritual in preference to the material. (Quoted in full in R. Welsh and J.M. Joosten *Two Mondrian Sketchbooks 1912–14,* Amsterdam 1969). The letter concludes: 'For the present at least I shall restrict my work to the customary world of the senses, since that is the world in which we still live. But nevertheless art already can provide a transition to the finer regions, which I call the spiritual realm.'

These were surely important issues at Domburg where Mondrian concentrated on the same motif: church, lighthouse, tower and dune. These are subjected to a marked contrast in handling and colour exploration. Mondrian's insistence in his letter to Querido that 'colour and line can do much' to suppress materiality, and that 'it is precisely the essential lines of any object which I find fundamentally important, and also the colour', (R. Welsh and J.M. Joosten, op. cit. p. 10) is demonstrated in the Domburg

Fig. 3

paintings of 1909. In that year Mondrian painted the lighthouse at Westkapelle, the church at Domburg and the first of the dune and sea series. He worked both behind the dunes looking across the motif to the sea, as in the six canvases 'Dune I–VI', (nos. 54–55) and also took up a position on top of the dunes giving a lateral view along the beach. In the Dune series there are subtle colour tonalities and richly varied brush strokes, probably influenced by both Toorop's contemporary painting and the work of Jan Sluyters. These block-like strokes provide an armature for the dune motif and are an important step in Mondrian's development of abstraction. In 'Dune V', (identified by Blok as 'Summer, Dune in Zeeland', exhibited at the St. Lucas exhibition in Amsterdam in 1910), the brilliant luminosity of the earlier paintings is retained but not the structured block-like stroke. The spatial ambiguity of the earlier paintings also remains, and caused De Telegraaf's reviewer, C.L. Dake to observe that the painting 'must be studied I calculated today, from a distance of 38 metres. Then one actually perceives the luminous dune crescent with transcribed shadows and the ground in front.' (De Telegraaf, 6 May 1910). In the final painting in the dune series, 'Dunelandscape', (no. 56) worked by Mondrian in Amsterdam in the winter of 1910/11 and exhibited at the first Amsterdamse Kunstkring in 1911 the main pictorial elements in common with other works of this date, are rendered as triangulated geometric forms.

54 Dune II summer 1909
Oil on canvas, $14\frac{3}{4} \times 18\frac{3}{8}$ (37.5 × 46.5)
Gemeentemuseum, The Hague (134.1971)

55 Dune V 1909–early 1910
Oil on canvas, $25\frac{7}{8} \times 37\frac{7}{8}$ (65.5 × 96)
Gemeentemuseum, The Hague (83.1957)

56 Dunelandscape 1910–11
Oil on canvas, $55\frac{1}{2} \times 94\frac{3}{4}$ (141 × 239)
Gemeentemuseum, The Hague (149.1971)

In the paintings which followed Mondrian introduced the use of predominantly horizontal and vertical lines as the basis of the compositional structure. These are explored principally in a series of drawings and paintings on which Mondrian worked at the same time as the dune series, and which culminated in the major 'Composition No. 10: Pier and Ocean' of 1915. This series focuses on a lateral view of the Domburg beach and seascape, concentrating on the angular structure created by rows of wooden groins that jutt out into the sea, and the acute angle of the dune sloping down to the beach, and in some works on a direct frontal view of the sea (nos. 57–62). One of these paintings 'The Sea' (Private Collection, Switzerland. Fig. 3) was completed after Mondrian's arrival in Paris in early 1912. On his return from Paris in August 1914 Mondrian returned to Domburg and to the motif of the sea. A small sketchbook(no. 65), possibly executed at this time (although Welsh has argued for a slightly earlier date 1913/14) contains numerous drawings of the sea and the church at Domburg as well as careful notes which explore Theosophic principles, notably the horizontal/vertical polarities, within a general call for abstraction in art. *Sketchbook I* contains numerous drawings in which the wooden groin-piers and the sea at Domburg are depicted in sharply delineated drawings of contrasting horizontal and vertical lines. The drawings of the sea are tentative, and delicately trace the horizontal, but broken, lines of the waves. (nos. 57–60). Mondrian's use of horizontal and vertical lines as his primary pictorial means denotes the complex fusion in his work of a Cubist vocabulary, a Theosophic doctrine and his affirmation in 1918, in a letter to Theo van Doesburg, that these 'are to be seen everywhere in Nature'. (Letter quoted in J.M. Joosten and R. Welsh, *The Birth of De Stijl, Part I, Art Forum* XI (April 1973) 8, pp. 50–59.)

In the transposition in 1914–15, from the small note-book sketches of the groin-pier and sea motif executed on site at Domburg to increasingly large scale sketches in charcoal, indian ink and gouache Mondrian submits the horizontal, vertical, diagonal and curved lines to minute adjustments in the interests of pictorial logic. Finally he makes empirical adjustments with paint on the canvas of the 'Composition No. 10: Pier and Ocean' (no. 64) resulting in a system of free floating vertical and horizontal lines, and the total suppression of curved elements. The syncretic form of Mondrian's approach to nature in 1915 and his gradual abstraction can be clearly seen by comparing the early and late sketches of the motif (nos. 62, 63) and is borne out in his recollection in 1942 that 'Observing sea, sky and stars I sought to indicate their plastic function through a multiplicity of crossing verticals and horizontals.' (P. Mondrian. *Towards the true vision of reality*. New York. *The Documents of Modern Art*. ed. R. Motherwell. 1945. p. 13).

1. The periods Mondrian spent in Domburg seem to have been as follows:
 1908 September, (arrival listed in the *Domburg Badnieuws*, 12 September).
 1909 Part of June, (arrival listed in the *Domburg Badnieuws*, 26 June) and short visits in Autumn and Winter (according to Albert van den Briel).
 1910 End of August to October (*Domburg Badnieuws*, 27 August).
 1911 July in nearby Veere (*Middleburg Courant*, 26 July).
 1912 August (*Domburg Badnieuws*, 10 August).
 1913 Mondrian's intention to visit Domburg (of which he wrote to Lodewijk Schelfhout, 25 May 1913, 'In the summer I plan to visit Domburg for a couple of weeks like last year') may not have materialised. (Letter in Brieven van Piet Mondrian *Museum Journaal*, 13. 1968.
 1914 Mondrian returned from Paris to Holland in August and was certainly in Domburg at the end of September (letter to Ds H. van Assendelft in J.M. Joosten, Documentatie over Mondrian. (4) *Museum Journaal*, 18. no. 4 1973).

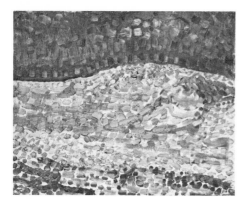

54

56

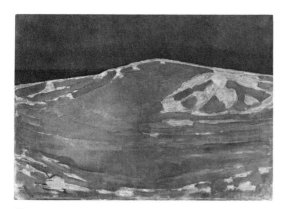

55

62

59

60

63

61

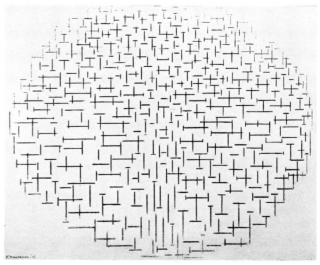

64

57 **Dunes and Sea**
Pencil, $4\frac{1}{4} \times 6\frac{1}{2}(10.5 \times 16.5)$
Marlborough Fine Art (London) Ltd, London

58 **Dunes and Sea**
Pencil, $4\frac{1}{4} \times 6\frac{3}{4}(10.5 \times 17.2)$
Marlborough Fine Art (London) Ltd, London

59 **Dunes and Sea**
Pencil, $4\frac{1}{4} \times 6\frac{3}{4}(10.5 \times 17.2)$
Marlborough Fine Art (London) Ltd, London

60 **Dunes and Sea**
Pencil, $4\frac{1}{4} \times 6\frac{3}{4}(10.5 \times 17.2)$
Marlborough Fine Art (London) Ltd, London

61 **Rough Sea**
Oil on canvas, $13\frac{1}{2} \times 19\frac{7}{8}(34.5 \times 50.5)$
Gemeentemuseum, The Hague (132.1971)

62 **Pier and Ocean** 1914
Pencil, $4\frac{1}{2} \times 6\frac{3}{4}(11.4 \times 15.9)$
Marlborough Fine Art (London) Ltd, London

63 **Pier and Ocean** late 1914
Charcoal, $20\frac{3}{4} \times 26(52.7 \times 66)$
Sidney Janis Gallery, New York

64 **Composition No.10: Pier and Ocean** 1915
Oil on canvas, $33\frac{1}{2} \times 42\frac{1}{2}(85 \times 108)$
Rijksmuseum Kröller Müller, Otterlo (532.15)

65 **Two Sketchbooks** *c.*1912–14
Facsimile
Private Collection

the verticality of the motif by the introduction of overlapping small rectangular planes.

The motif of the tree may be based on the synthetic fusion of several drawings, but in some instances at least, Mondrian could point to specific sources. Thus, 'Composition: Trees II' is based on a drawing of a pear tree and Mondrian identified the motif of 'Oval Composition with trees' (Stedelijk Museum, Amsterdam) to the original owner of the painting, Mr H.P. Bremmer, as a tree in the Luxembourg Gardens in Paris. (Terpstra, in *Moderne Kunst in Nederland 1900–1914*, p.160 note 3).

66 **Tree** 1911/12
Pencil, $7 \times 4\frac{7}{8}(17.8 \times 12.5)$
Marlborough Fine Art (London) Ltd, London

67 **Tree** 1911/12
Pencil, $4\frac{7}{8} \times 6\frac{7}{8}(12.5 \times 17.5)$
Marlborough Fine Art (London) Ltd, London

68 **Tree**
Pencil, $4\frac{7}{8} \times 6\frac{5}{8}(12.4 \times 16\cdot8)$
Marlborough Fine Art (London) Ltd, London

69 **Study of Trees** *c.*1912
Chalk, $25\frac{5}{8} \times 35(65 \times 89)$
Gemeentemuseum, The Hague (163.1958)

70 **Composition: Trees II**
Oil on canvas, $38\frac{5}{8} \times 25\frac{1}{2}(98 \times 65)$
Gemeentemuseum, The Hague

71 **Tree**
Oil on canvas, $39\frac{1}{2} \times 26\frac{1}{2}(100.2 \times 67.2)$
Tate Gallery, London (T.2211)

72 **Composition XIV**
Oil on canvas, $37 \times 25\frac{5}{8}(94 \times 65)$
Stedelijk van Abbemuseum, Eindhoven

Mondrian left Amsterdam for Paris in December 1911 on the advice of his friend the critic Conrad Kikkert. Two themes dominate Mondrian's work in Paris, initially tree motifs partially recalled from Domburg and partially those in his immediate surroundings, and then a series of works based on Parisian façades. The Dutch composer, Jacob van Domselaar, recalled visiting Mondrian in his studio in the rue du Depart in the winter of 1912–13 and seeing, 'Trees. Nothing but trees'. (Recalled in M. Seuphor. *Piet Mondrian* n.d. p.98) The loosely gridded structure and rounded contours of Mondrian's earliest (1911) Parisian canvases, such as 'Nude' and 'Landscape with trees', (both Gemeentemuseum, The Hague) link his work with other Dutch Cubists in Paris such as Petrus Alma and Lodewijk Schefhout. The curved and straight contours of the 1912–13 canvases are not present in 'Composition: Trees II', which is structured on a careful interplay of triangulated and oblong planes. The muted grey-green, black and white has given way in 'Tree' to the ochre and grey colours, broken brush strokes and sophisticated rhythms of the 1911–12 work of Picasso and Braque.

In the tree paintings the planes are set parallel to the picture surface, and often breaking into one another so that the ochre and grey colour patches are not contained by the plane. Moreover in the early 1912–13 tree paintings (nos.67–70) the strong verticality of the chosen motif dominates the pictorial structure. If Blok's suggestion that 'Composition XIV' (no.72) is based on 'Composition: Trees II' is correct then by early 1913 Mondrian has countered

In the latter part of 1913 Mondrian began a series of sketches of buildings within the immediate environment of his Montparnasse studio at 26, rue du Départ, and by the end of 1913 abandoned entirely the tree motif that had dominated his work of the previous eighteen months. While these sketches can be seen as a variation on the theme of the church at Domburg, they are in essence quite different. Some sketches (*Sketchbook II.* no.65) appear to be views out of his studio window and are all certainly city based motifs. They provoke comparison with the same theme in Robert Delaunay's four paintings, 'The City', 1910–11 (nos.25, 26) and Fernand Léger's 'Les Fumées sur les Toits' series of 1911.

Mondrian's adoption of an overtly city-based image, and in one case at least, a directly contemporary motif of advertising posters, sited at the corner of the rue du Départ and the avenue Edgar Quinet (no.75) suggests specifically modern subject matter. Indeed the titles of later works, such as 'Fox Trot', 'Broadway Boogie Woogie', and 'Trafalgar Square' suggest a recurrence of this concern with contemporaneity. The use of the bouillon cube advertisement – KUB – in the *c.*1913 drawing refers directly to Picasso's use of the same advertisement in the summer of 1912 at Sorgue in 'Paysage aux Affiches' (present whereabouts unknown.) Picasso employed the

66

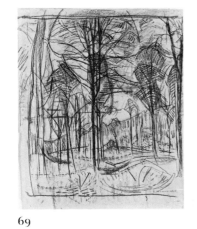

69

70

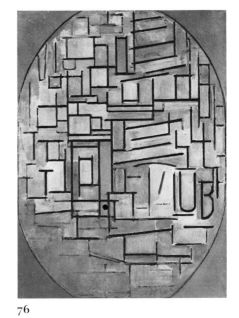

71

73

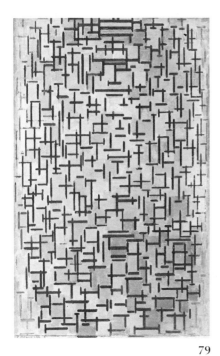

74

75

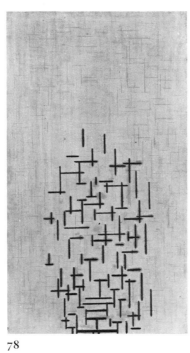

76

79

78

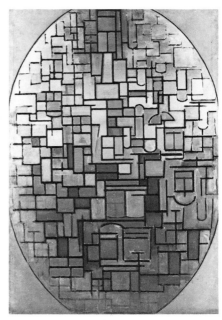

77

advertisement as a pun both on Cubism and on the diagrammatic drawing technique of the advertisement whereby the volumetric bouillon cube is transposed onto a two-dimensional surface. Later in 1912 Wyndham Lewis blasted 'Bouillon Kub for being a bad pun'. (*BLAST* No.1 1914, p.13).

In the transference of the fundamental elements of the drawing to paintings only residual traces remain. In 'Oval Composition' of 1914, the projecting staircase block, the 'UB' of KUB and the stepped roof line are contained within the overall horizontal vertical structure (nos.75, 76). Moreover the façade paintings are characterised by an equivalence between the image and the pictorial elements. Thus the disposition of rectangular elements can be related although very loosely, to doors, windows, rooflines and chimney pots. A drawing (no.74), of 1913–14, of the residual elements left following the demolition of a building is annotated with colour notes and provides the basis for 'Blue Façade' 1913–14 (Museum of Modern Art, New York.) The ochre/grey colours and broken brush-strokes of the tree series have now given way to an even application of paint in subtle blues and pinks. More striking still is the equilibriated disposition of the horizontal and vertical elements, often presented as adjacent rectangles bounding the colour patches.

A large group of the façade paintings was exhibited at the Gallery Walrecht in The Hague in June/July 1914. Joosten has argued that the absence of markings for this exhibition on three canvases of 1914, the 'Composition in an oval', 'Oval Composition Tableau III' (nos.76, 77) and 'Oval Composition with light colour planes' (Museum of Modern Art, New York) suggests that these works were the latest to be completed in Paris, and that Mondrian excluded them from the Hague exhibition in order not to destroy the 'unity of such a compact presentation'. (J.M. Joosten in New York, Guggenheim Museum. *Piet Mondrian*. 1971 pp.53–66).

Whether or not the three canvases are the last work Mondrian produced in Paris before the war (and were therefore left in his studio during the war years) they form a distinct group within the façade paintings in the predominant use of secondary hues, pink, blue, and ochre, and oval format in which the edges of the oval press beyond the picture plane, thus leaving open some of the main grid structures.

73 **Demolished buildings, Paris** c.1912
Pencil, $6\frac{3}{4} \times 4\frac{1}{8}$ (17.2 × 10.5)
Marlborough Fine Art (London) Ltd, London

74 **Buildings, Paris** 1912
Pencil, $6\frac{3}{4} \times 4\frac{1}{8}$ (17.2 × 10.5)
Marlborough Fine Art (London) Ltd, London

75 **Paris buildings** 1912–13
Crayon, $9\frac{1}{4} \times 6$ (23.6 × 15.5)
Sidney Janis Gallery, New York

76 **Composition in an oval** 1914
Oil on canvas, $44\frac{1}{2} \times 33\frac{1}{4}$ (113 × 84.5)
Gemeentemuseum, The Hague (160. 1971)

77 **Composition No.3 (Oval Composition)** 1914
Oil on canvas, $55\frac{1}{8} \times 39\frac{3}{4}$ (140 × 101)
Stedelijk Museum, Amsterdam (A.24589)

'Composition 1916' is the only major painting completed by Mondrian in that year and marks a return both to the Parisian façade motif and the colour explorations of 1913–14, but also extends the new strict horizontal/vertical use of line and geometric configurations of the previous year, while abandoning the oval centralised image. In the summer of 1915 Mondrian settled in Laren a small town east of Amsterdam, temporarily lodging with his friend, the composer Jacob van Domselaar. He remained in Laren until July 1919, when he returned to Paris. Contact in Laren with the Dutch Christosoph, Dr M.H.J. Schoenmaekers and with Bart van der Leck was to prove fundamental in his gradual abandonment of all reference to natural subject matter. Schoenmaekers' philosophy of 'positive mysticism' set out in *Het nieuwe Wereldbeeld* (The New Image of the World, published 1915) and *Beginselen der Beeldende Wisikunde* (Principles of plastic mathematics, published 1916), was rooted in Theosophic doctrine. For Schoenmaekers, as in Theosophic doctrine, the polarities of the horizontal and the vertical, equated with the polarities, spirit-male and matter-female and their mystical intersection in the form of the cross are fundamental, and were also discussed by Mondrian in *Sketchbook I* (no.65). In a drawing in this sketchbook of the groin-piers at Domburg, the piers are drawn parallel with the horizon line of the sea, annotated with the letters b, c, d while the sea is marked a, (see fig.2). Beside the annotated drawing Mondrian notes:

> Man, line, female
> Vertical and horizontal,
> Line a, at rest
> Lines b, c, d, not at rest
> but pointing the direction (*Sketchbook* I p.4).

Mondrian later acknowledged the importance of Theosophy in *De Stijl* as 'another expression of the same spiritual movement which we represent in painting' (*De Stijl* vol.1.5. March, 1918 p.54).

The early compositions at Laren: 'Composition 1916, Plus and Minus': 'Study for Composition 1916' and the three canvases exhibited in the May 1917 *De Hollandsche Kunstkring* in Amsterdam: 'Compositions in Colour A and B' and 'Composition in Line' (nos.78, 79, 81 and figs.4, 5) are conceived as strict configurations of lines and planes, yet all derive from specific motifs. These were respectively abstracted from preliminary drawings of the church façades both at Domburg and at Notre Dame des Champs, Paris and of the pier and ocean motif.

'Composition 1916' retains a vestigial oval form, the strident tonalities (again the secondary hues of the 1914 Paris façade paintings) on a grey ground, paling at the edges of the canvas. However, unlike the 1914 Parisian façades in which the rectangular configurations contain references to elements of the motif, in 'Composition 1916', with the even distribution of lines and the release of the colour patches from contained rectangular forms, the pictorial elements are no longer bound to the motif. A photograph of the painting which followed, 'Composition in Lines: black and white', sent by Mondrian in a letter to H.P. Bremmer in July 1916 (fig.4) indicates that he pursued this concern with linear structure.

In the move from the plus-minus notational structure of the 'Composition in Lines' in its early state (figs.4, 5) to the black bars in the finished painting, Mondrian freed the pictorial elements from depiction of natural motifs. There is a marked change from the residual horizon line, and

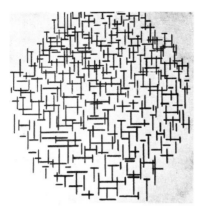

Fig.4

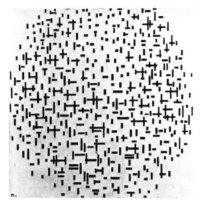

Fig.5

consequent horizontal emphasis, in the early state of the painting to the open areas and thick grey-black bars of the finished painting. The addition of colour planes to the bars followed in the 'Compositions in Colour A and B' (no.81).

Mondrian like Van der Leck abandoned all reference to subject matter in five canvases of 1917 which explore the random distribution of unbounded colour areas on a flat ground (nos.81, 82). The heavy over-painting in these and several canvases of 1917–18 suggests empirical adjustment of the colour areas during the process of painting.

Mondrian realised the different direction his work was taking by February 1918, from that of Van der Leck, 'in my work colour planes upon a flat ground do not produce unity. This manner works for Van der Leck, whose manner is different anyway', (Quoted in J.M. Joosten and R.P. Welsh 1973 op. cit.). This led to two important innovations: on the one hand Mondrian introduced a black-grey line bounding the colour areas (no.85) thereby binding them to the plane, and on the other, he introduced a grid-based structure dividing rectangular and square canvases into rectangular grids (in a 16 × 16 pattern), to which asymmetric configurations of colour and line were added. The grid is usually not overtly stated, as in the two checkerboard canvases (nos.83, 84) of 1919 in which colour alone creates the asymmetry. On his return to Paris in 1919, Mondrian re-introduced the black-grey bounding lines to the colour areas (no.85) and increased the variation in the component squares and rectangles.

78 **Plus and Minus; study for Composition 1916**
 *c.*1915–16
 Oil and pencil on canvas, $48\frac{3}{4} \times 34\frac{3}{8}(124 \times 74)$
 National Museum of Modern Art, Kyoto

79 **Composition 1916** 1916
 Oil on canvas, $47\frac{3}{4} \times 29\frac{1}{2}(120 \times 74.9)$
 Solomon R. Guggenheim Museum, New York

80 **Composition based on diamond shape** 1914–16
 Charcoal, $19\frac{3}{4} \times 17\frac{5}{8}(50.1 \times 44.7)$
 Harry Holtzman, Lyme, Connecticut

81 **Composition in Colour B** 1917
 Oil on canvas, $19\frac{3}{4} \times 17\frac{3}{8}(50 \times 44)$
 Rijksmuseum Kröller Müller, Otterlo

82 **Composition with Colour Planes** 1917
 Oil on canvas, $18\frac{7}{8} \times 24(48 \times 61)$
 Private Collection

83 **Composition: Checkerboard Light Colours** 1919
 Oil on canvas, $33\frac{7}{8} \times 41\frac{3}{4}(86 \times 106)$
 Gemeentemuseum, The Hague (167.1971)

84 **Composition: Checkerboard Dark Colours** 1919
 Oil on canvas, $33\frac{7}{8} \times 40\frac{1}{2}(86 \times 102)$
 Gemeentemuseum, The Hague (168.1971)

85 **Composition in Grey, Red, Yellow and Blue** 1920
 Oil on canvas, $39\frac{1}{4} \times 39\frac{1}{2}(99.7 \times 100.3)$
 Tate Gallery, London (T.915)

BART VAN DER LECK 1876–1958

There is a brief interdependence in the work of Mondrian and Bart van der Leck during 1916–17, following Van der Leck's arrival in Laren in April 1916. In March 1916 Van der Leck completed the large canvas 'The Storm' (Rijksmuseum Kröller Müller, Otterlo fig.6) executed in bold flat areas of primary colour, depicting a typical Hague school scene of a storm at sea watched by two fisher-women on the beach at Scheveningen. He then moved to Laren where he remained until May 1919. His first paintings at Laren, 'Composition No.1 1916' shows the immediate effect of his contact with Mondrian. Essentially a portrait of his daughter Noortje the broad colour planes of 'The Storm' are reduced to small coloured rectangles still firmly descriptive.

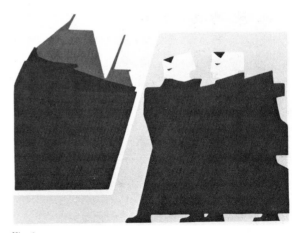

Fig.6

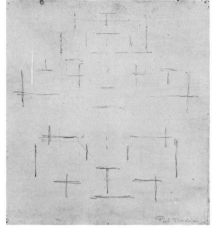

80

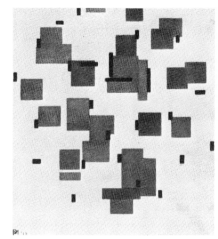

81

83

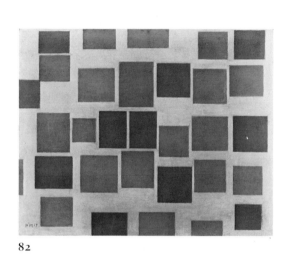

82

84

85

86d

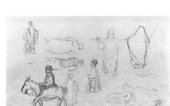

86e

87

88

97

98

101

100

92

94

96

86 **Five sketches of donkeys and riders, Zaccar sketchbook** 1914
Pencil and watercolour,
a) $4\frac{5}{8} \times 9\frac{7}{8}(11.9 \times 22.7)(440$ KL 10)
b) $4\frac{5}{8} \times 9\frac{7}{8}(11.9 \times 22.7)(440$ KL 11)
c) $7\frac{1}{4} \times 11\frac{5}{8}(19.6 \times 29.5)(136$ KL 53)
d) $7\frac{1}{4} \times 11\frac{5}{8}(19.6 \times 29.5)(133$ KL 76)
e) $4\frac{1}{2} \times 8(11.5 \times 20.2)(136$ KL 163)
Rijksmuseum Kröller Müller, Otterlo

87 **Sketch for a Woman on a Donkey** 1914
Pencil, $10\frac{1}{4} \times 16\frac{3}{8}(25.8 \times 41.5)$
Rijksmuseum Kröller Müller, Otterlo (440 KL 54)

88 **Study for Arabs on donkeys** 1915
Charcoal and watercolour, $11\frac{3}{4} \times 20\frac{3}{4}(30 \times 52.2)$
Rijksmuseum Kröller Müller, Otterlo (440 Gr.17)

89 **Study for Composition No.1 Portrait of Noortje** 1916
Postercolour, $18\frac{1}{8} \times 19\frac{1}{8}(46 \times 48.5)$
Rijksmuseum Kröller Müller, Otterlo (108b–11)

90 **Study for Composition No.1 Portrait of Noortje** 1916
Postercolour, $18\frac{1}{4} \times 15\frac{7}{8}(46.5 \times 40.5)$
Rijksmuseum Kröller Müller, Otterlo (108b–12)

During 1916–17 Van der Leck, working from earlier drawings, (made in Spain and Algeria in 1914) developed a process of abstraction in a series of drawings in which positive-negative, additive-subtractive, line-plane elements are explored, (nos.86–88, 91–96). The linear elements of the 'Composition 1917 No.4 (Mine Triptych)' are essentially thin rectangles of primary colour on a white and black ground. There is a clear debt to Mondrian's plus/minus conception in 'Composition No.4' and in the essentially two-dimensional pattern of the linear elements in a cruciform structure with a residual horizon to Mondrian's 'Composition No.10', which was bought by H.P. Bremmer in the summer of 1916 (no.64). Greater degrees of abstraction followed in Van der Leck's 1917 paintings such as 'Compositions No.5 and 6 (Donkey Riders)' (no.96) in which the original subject is virtually indecipherable; only the silhouette of the two donkeys at the extreme right remain from the original drawings (nos.86, 88). Contact between Van der Leck, Mondrian, Van Doesburg and Huszar during 1917–18 resulted in the publication of the review *De Stijl*, dedicated to aesthetic and theoretical discussion as well as to the dissemination of the new abstract painting formulated during 1918–19. During 1918 Van der Leck worked on a series of paintings in which the natural motif is abandoned for the disposition of primary rectangles on a pristine white ground. The introduction of a diagonal element and Van der Leck's use of rectangles with clipped corners creates intense spatial ambiguities, together with problems of equilibrium and balance.

91 **Study for Composition 1917 No.5 (Donkey Riders)**
Gouache, $25\frac{5}{8} \times 62\frac{5}{8}(65 \times 159)$
J.P. Smid, Kunsthandel Monet, Amsterdam

92 **Study for Composition 1917 No.6 (Donkey Riders)**
Gouache, $25\frac{5}{8} \times 59(65 \times 159)$
J.P. Smid, Kunsthandel Monet, Amsterdam

93 **Study for Composition 1917 No.5 (Donkey Riders)**
Gouache, $26 \times 51\frac{1}{2}(67.5 \times 131)$
J.P. Smid, Kunsthandel Monet, Amsterdam

94 **Study for Composition 1917 No.6 (Donkey Riders)**
Gouache on tracing paper, $17 \times 47\frac{1}{4}(43 \times 120)$
J.P. Smid, Kunsthandel Monet, Amsterdam

95 **Study for Composition 1917 No.5 (Donkey Riders)**
Gouache, $24 \times 59\frac{1}{2}(61 \times 151)$
J.P. Smid, Kunsthandel Monet, Amsterdam

96 **Composition 1917 No.6 (Donkey Riders)**
Oil on canvas, $23\frac{1}{4} \times 57\frac{7}{8}(59 \times 147)$
Mrs A.R.W. Nieuwenhuizen Segaar-Aarse, The Hague

97 **Composition 1918 No.2**
Oil on canvas, $15\frac{7}{8} \times 12\frac{3}{4}(40.5 \times 32.3)$
Private Collection

98 **Composition 1918 No.3**
Oil on canvas, $17\frac{3}{4} \times 22(45 \times 56)$
Mrs A.R.W. Nieuwenhuizen Segaar-Aarse, The Hague

99 **Composition 1918 No.5**
Oil on canvas, $27\frac{1}{2} \times 27\frac{1}{2}(70 \times 70)$
Hannema-de Stuers Fundatie, Heino

100 **Composition 1918**
Oil on canvas, $21\frac{1}{8} \times 16\frac{3}{4}(54.2 \times 42.5)$
Tate Gallery, London (T.896)

Between 1914 and 1919 Van der Leck was colour adviser to the firm of Müller and Co. in The Hague. In this capacity he designed portfolio covers and advertising material as well as colour schemes for interiors and furnishings for Mrs Kröller Müller. A carpet design (no.101) indicates that in the disposition of the elements, as in the compositions of 1918 (nos.97–100) Van der Leck was concerned with the balance of geometric forms and with the weights of the three primary colours. One section of this carpet design can be directly related to 'Composition 1918 No.4' (Rijksmuseum Kröller Müller, Otterlo).

101 **Study for a Carpet**
Pencil and watercolour, $8\frac{7}{8} \times 6\frac{3}{4}(22.5 \times 17)$
Rijksmuseum Kröller Müller, Otterlo (1414–60)

THEO VAN DOESBURG 1883–1931

In his 'Rhythm of a Russian Dance' *c.*1918 Van Doesburg adopts the coloured bars of Van der Leck's contemporary work (nos.106, 96). Moreover he reproduced Van der Leck's 'Composition No.6 (Donkey riders)' in the first issue of the review *De Stijl*, (no.113). Van der Leck's method of working from the same motif on two canvases, one with rectangular planar elements and the other with a concentration of linear relationships, appears to have been important in Van Doesburg's work during 1918 in the variations of 'Composition XIII' for example (nos.109, 110) although Mondrian's 'Compositions in Colour A and B' also have important repercussions here.

'Composition XIII' is based on a process of abstraction from a still life, through a series of paintings (nos.107, 108) in which the elements of line and colour are freed from description function.

In 1916 Van Doesburg began to construct his compositions on a grid structure of 16 × 16 rectangular units (nos.103, 104) apparently arriving at this formulation via Apollinaire's discussion of scientific Cubism and geometry. Moreover experience gained in working on a gridded format for stained-glass window designs (from 1916) was of fundamental importance both to Van Doesburg and Vilmos Huszar, (nos. 111, 115) in the development of grid-based abstract painting.

102 **Autumn** 1915
Pastel, $9\frac{1}{4} \times 12\frac{3}{8}(23.5 \times 31.5)$
J.P. Smid, Kunsthandel Monet, Amsterdam

103 **Still Life; Geometrical Composition** 1916
Oil on canvas, $26\frac{1}{2} \times 25\frac{1}{2}(67 \times 64)$
Rijksmuseum Kröller Müller, Otterlo (123a)

104 **Still Life** 1916
Oil on canvas, $17\frac{3}{4} \times 12\frac{1}{2}(45 \times 31.7)$
Thyssen-Bornemisza Collection, Lugano

105 **Seven Studies for Rhythm of a Russian Dance** c.1917–18
Pen, pencil and ink,
a) $3\frac{1}{4} \times 2\frac{5}{8}(8 \times 6.4)$
b) $3 \times 2\frac{1}{8}(7.6 \times 5.3)$
c) $3\frac{3}{8} \times 1\frac{3}{4}(8.5 \times 4.3)$
d) $3\frac{1}{4} \times 2\frac{5}{8}(8 \times 6.5)$
e) $5\frac{1}{2} \times 4\frac{1}{4}(13.7 \times 10.6)$
f) $8 \times 5\frac{1}{4}(20.1 \times 13.1)$
g) $6\frac{1}{4} \times 4\frac{1}{4}(15.8 \times 10.5)$
Museum of Modern Art, New York, Gift of Nelly van Doesburg (26.691.1–7)

106 **Rhythm of a Russian Dance** 1917–18
Oil on canvas, $53\frac{1}{2} \times 24\frac{1}{2}(136 \times 62)$
Museum of Modern Art, New York, Acquired through the Lillie P. Bliss Bequest 1946

107 **Still Life** 1918
Oil on paper, $13\frac{1}{4} \times 10\frac{7}{8}(33.5 \times 27.5)$
Stedelijk Museum, Amsterdam (A.29245)

108 **Composition: Still Life** 1918
Gouache, $10\frac{1}{2} \times 10(26.6 \times 25.4)$
Stedelijk Museum, Amsterdam (A.6672)

109 **Composition XIII** 1918
Oil on wood, $11\frac{5}{8} \times 11\frac{5}{8}(29.5 \times 29.5)$
Stedelijk Museum, Amsterdam (A.29685)

110 **Composition XIII (Variation)** 1918
Oil on panel, $11\frac{3}{4} \times 11\frac{1}{2}(29.9 \times 29.2)$
Cincinatti Art Museum,
Bequest of Mary E. Johnston
(1967.1110)

111 **Stained glass composition** 1918
Gouache, $35\frac{1}{2} \times 21\frac{3}{4}(90 \times 55)$
Art Collection Kabeebec, Amsterdam

112 **De Nieuwe Beweging in der Schilderkunst**
J. Waltman, Delft, 1917
Private Collection

113 **De Stijl Magazine** 1917–31
Edited: Theo van Doesburg
M. Risselada, Delft

VILMOS HUSZAR 1884–1960

114 **Composition** 1916
Lithograph, $7\frac{3}{4} \times 6(19.5 \times 15)$
J.P. Smid, Kunsthandel Monet, Amsterdam

115 **Composition in Grey** 1918
Stained glass, $27\frac{1}{8} \times 24\frac{1}{4}(69 \times 61.5)$
Stedelijk Museum, Amsterdam (MA.164)

Huszar's figure paintings of 1917/18 are clearly derived from Van der Leck's 'The Storm' (fig.6) of 1916, in the flat broad planes of colour, with strong diagonal accents. By 1918 rectangular geometric forms predominate in Huszar's work. Some paintings of this date are closely based on forms in movement, such as 'Hammer and Saw' (now lost, reproduced in De Stijl 1.4. January 1918) (no.113), 'Dancing Couple' (Gemeentemuseum, The Hague) and one of the monotype prints of 1918 (no.117) is abstracted from a dancing figure, closely related to Van Doesburg's 'Rhythm of a Russian Dance' (nos.105, 106).

116 **Reclining Figure** 1918
Oil on canvas, $28\frac{3}{8} \times 62\frac{1}{2}(72 \times 159)$
J.P. Smid, Kunsthandel Monet, Amsterdam

117 **Composition – Four variations** 1918
Oil on canvas,
a) $12 \times 9\frac{1}{4}(30.5 \times 23.5)$
b) $9 \times 12(23 \times 30.5)$
c) $9\frac{1}{4} \times 12(23.5 \times 30.5)$
J.P. Smid, Kunsthandel Monet, Amsterdam
d) $9\frac{1}{4} \times 12(23.2 \times 30.5)$
Rijksmuseum Kröller Müller, Otterlo

118 **Composition** c.1921
Oil on triplex, $16\frac{1}{2} \times 20\frac{7}{8}(42 \times 53)$
J.P. Smid, Kunsthandel Monet, Amsterdam

CHRIS BEEKMAN 1887–1964

During 1917 Beekman was in contact with artists in Russia, although his work at this date was influenced by Van der Leck's 1913/14 figure paintings (nos.87, 88). Between 1918–20/21 the figures were abstracted in overlapping geometric planes.

119 **Drawing for Composition** 1918–19
Pencil and watercolour, $8\frac{3}{8} \times 9\frac{1}{2}(21.2 \times 24.2)$
Rijksmuseum Kröller Müller, Otterlo (250 KL 144)

120 **Composition** 1918–19
Oil on canvas, $15\frac{7}{8} \times 18\frac{1}{4}(40.5 \times 46)$
Rijksmuseum Kröller Müller, Otterlo (17/20)

102

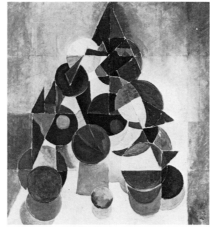

103

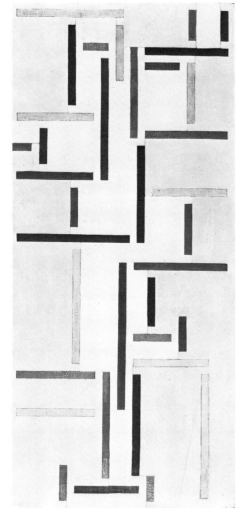

106

104

105

105

110

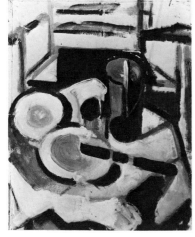

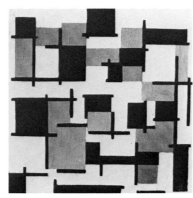

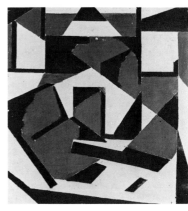

107

108

109

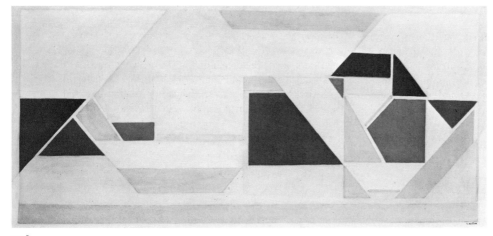

116

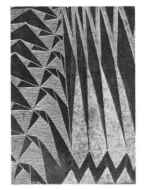

114

117

117

118

117

120

119

OTTO VAN REES 1884–1957

Van Rees worked in Domburg with Toorop in 1904 where his painting was characterised by block-like structured strokes. Between 1904 and 1914 he worked in Paris, living in Montparnasse after 1908. During this period he worked on a series of figure paintings in undulating planes of colour, and by 1914 had introduced triangulated and circular zones into his pictorial structure.

121 Composition: Landscape 1914
Oil on canvas, $24\frac{3}{4} \times 20\frac{7}{8}$ (63 × 53)
Gemeentemuseum, The Hague (10.1975)

Fig. 7

During the winter of 1914/15, while on military service, Van Rees replaced some of the paint areas with collaged elements. This introduced dynamism and a greater variety of texture in some works, for example the 'Dancer' of 1915 (now lost see fig. 7). This richness of surface is suppressed in Van Rees' work in Zurich (1915–18) where interdependence between his work and that of Hans Arp (nos. 138, 139) resulted in the exploration of basic geometric (principally segmented and triangulated forms). Van Rees explores these forms throughout a series of works. Thus the abstracted head, in the collage entitled 'Portrait of Adya' (present whereabouts unknown) is reduced to interlocking segmental and triangulated forms in the collaged 'Poster' for the Van Rees/Arp exhibition at the Galerie Tanner, Zurich (14–30 November 1915) and recurs on the cover of the portfolio made as a Christmas present for Hans Arp in December 1915. (nos. 122, 123). During 1916–17 Van Rees returned to overtly crystal Cubist painting in a series of still lifes (no. 124).

122 Untitled 1915
Collage on card, 30 × $22\frac{1}{4}$ (76 × 56.4)
Centraal Museum, Utrecht

123 Portfolio cover for Hans Arp 1915
Collage on card, $10\frac{5}{8} \times 9$ (27 × 23)
Kunstmuseum, Basle, Kupferstichkabinett,
Sammlung M. Arp Hagenbach (1968.546)

124 Still Life 1916–17
Oil on canvas, 16 × $13\frac{1}{8}$ (40.8 × 33.3)
Centraal Museum, Utrecht (18196)

ADRIANA VAN REES-DUTILH (Adya) 1876–1959

Between 1908 and 1914 there was a large group of Dutch artists working or exhibiting in Paris: Adya van Rees, Otto van Rees, Jacob Bendien, and Jan Deene, were influenced by the abstract decorative paintings of Otto Freundlich and František Kupka (nos. 17–20). Their work is characterised by the use of abstracted motifs (often heads) delineated in flat planes of colour in interlocking circular forms (nos. 125, 129, 130, 131). In some cases this provided a basis for the development of decorative abstract paintings.

125 The Free Spirit 1913
Pencil, $16\frac{1}{8} \times 12\frac{7}{8}$ (41.5 × 32.7)
Gemeentemuseum, The Hague (T8 1975)

126 Sandhur 1914
Silk embroidery, $20\frac{1}{8} \times 14\frac{3}{8}$ (51 × 36.5)
Kunstmuseum, Basle

JACOB BENDIEN 1890–1933

127 Painting I 1912
Oil on canvas, $25\frac{7}{8} \times 19\frac{3}{4}$ (65.6 × 50)
Centraal Museum, Utrecht

128 Painting 2 1912
Oil on canvas, $25\frac{5}{8} \times 18\frac{7}{8}$ (65 × 48)
Centraal Museum, Utrecht

JOHANNUS VAN DEENE 1886–1978

129 Landscape 1912
Oil on canvas, $28\frac{3}{4} \times 39\frac{3}{8}$ (73 × 100)
Private Collection

JAN SLUYTERS 1881–1957

Large fragmented planes, broken brush marks and thick paint application characterise the Cubist inspired, quasi abstract work, of Jan Sluyters in 1914 (no. 127).

130 Largo II 1913
Oil on canvas, $25\frac{3}{4} \times 20\frac{1}{4}$ (65.5 × 51.5)
Jacob Kuýper

JACOBA VAN HEEMSKERK 1876–1921

Like Mondrian and Van Rees, Jacoba van Heemskerk worked with Jan Toorop at Domburg, and by 1908 had established a working pattern, painting at Domburg in the summer and in The Hague during the winter months. In the 1910 St Lucas exhibition in Amsterdam she exhibited 'Luminist' paintings with Sluyters, Mondrian and Gestel. Influenced by Cubism in 1912 and by Mondrian's tree paintings (nos. 66–72) in particular, she painted a series of trees during 1912/14 (no. 131) in which loosely gridded structures and rounded contours predominate. Following her meeting with Herwath Walden of Der Sturm in 1912, her work was frequently shown in Berlin and increased her contact with German painting.

131 Composition No.6 (Trees) 1913
Oil on canvas, $47\frac{1}{2} \times 78\frac{1}{2}$ (120.5 × 199.5)
Boymans-van Beuningen Museum, Rotterdam

ADRIANUS JOHANNES DE WINTER (Janus) 1882–1966

During 1915–16 Adrianus de Winter, Theo van Doesburg and Johannes Tielens produced several gouache and watercolour improvisations, influenced directly both by Kandinsky's theoretical writings, and exhibition of his work in Holland. De Winter's Theosophic involvement clearly influenced Van Doesburg's conception of natural motifs depicted with richly coloured aural emanations, and constructed beneath orbicular forms (no.102). De Winter's work is characterised by the abstraction of natural motifs, principally flower and sea animal forms, depicted in often strident tonalities of free floating colour areas.

Van Doesburg published a psycho-analytic study of De Winter's work in 1916. (De Schilder de Winter en zijnwerk. Haarlem, 1916).

132 **Aura of an Egoist** 1916
Gouache, $22 \times 30(56 \times 76)$
Centraal Museum, Utrecht (13965)

133 **Noise of a Shell** 1915
Gouache, $27\frac{1}{8} \times 35(68 \times 89)$
Mrs A. Hoekstra-de Winter

ALBERT PLASSCHAERT 1866–1941

A self-taught painter, poet and writer, Plasschaert's drawings are related to a mystical philosophy which he discussed in a review *De Derde Weg* (The Third Way) published from his home in The Hague (1917–22). His abstract drawings (no.134) are constructed from short coloured crayon strokes reminiscent of drawings by Thorn Prikker.

134 **Opus 1528**
Crayon on paper, $55\frac{1}{8} \times 32\frac{1}{4}(140 \times 82)$
Dienst Verspreide Rijkskollecties, The Hague

ERICH WICHMAN 1890–1929

A painter, sculptor and writer, Wichman's early abstractions of 1912 were derived from landscape motifs depicted in broad planes of colour, enlivened with long and short strokes of thick paint. In 1913 he wrote a detailed defence of the development of 'abstract/pure' art from Cubism and Expressionism.

135 **Small Landscape** 1912
Oil on panel, $7\frac{1}{2} \times 9\frac{1}{2}(19 \times 24)$
Private Collection

LOUIS SAALBORN 1891–1957

Saalborn was an actor, painter and writer. Strongly influenced by Mondrian, with whom he took painting lessons 1907–8, in the horizontal/vertical structure and rounded contours of several paintings *c.*1912–16 (no.137). He was also influenced by Kandinsky both in the introduction of line and free patches of colour (no.136) and in a concern with synaesthesia. Both 'Scherzo' and 'Sarabande' are based on musical motifs, albeit in sketchy form.

136 **Scherzo** 1915
Pencil, crayon and watercolour,
$17\frac{3}{4} \times 11\frac{3}{4}(45 \times 30)$
Private Collection

137 **Sarabande** 1916
Oil on canvas, $31\frac{7}{8} \times 42\frac{5}{2}(81 \times 100)$
J.P. Smid; Kunsthandel Monet, Amsterdam

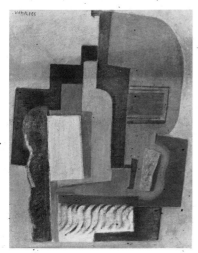

124

129

123

132

136

133

Dada and Abstract Art in Zurich 1915-20
Dawn Ades

As witnesses of the senseless destruction and chaos of the First World War, Dadaists everywhere shared a disgust for the prevailing social and political institutions of the West, had lost faith in the rationality of man, and viewed his vaunted machine technology with suspicion. Where Dadaists differed was in their reaction to this visible chaos. In Zurich, where Dada started early in 1916, the Dadaists believed that art could be more than a reflex action, a nihilistic matching of chaos with chaos, that indeed art had vital regenerative powers.

In Zurich in 1915, Arp wrote later in 'Dadaland', 'We searched for an elementary art that would, we thought, save mankind from the furious folly of these times. We aspired to a new order that might restore the balance between Heaven and Hell.' This 'elementary' art was to be, essentially, abstract.

Dada was originally innocent of any pretensions to being an artistic school, and the artists associated with it were encouraged to find their own voice. It would be impossible at this stage to define anything approaching a Dada style, indeed Dada was deliberately eclectic. However, the works of the Zurich Dadaists can be broadly categorised as sharing an interest in simple, elementary forms, lines and rhythmical relationships to the exclusion of the personal and the illusionistic, which was, I hope to show, inspired by a philosophical basis very different from that, say, of Mondrian.

The Dadaists were in basic agreement that it was necessary to find alternative sources for creative guidance, outside what they considered to be a corrupt Western post-Renaissance tradition, in areas untouched by empiricism and reason. So they looked amongst other things to the art of children and primitives. This was not in itself new, but the Dadaists were more radical in their experiments, wanting to begin again from zero.

Their attitudes to and expectations of abstraction were dynamic and far from unanimous. One of the fiercest confrontations was between the German writer and poet, Hugo Ball, a complex and ascetic thinker, who had founded the Cabaret Voltaire, Dada's nursery, and the Rumanian poet Tristan Tzara, who took over Dada when Ball withdrew in 1917. Ball had been an associate of Kandinsky in Munich but he became increasingly pessimistic about abstract art. The disappearance of the human form and fragmentation of objects in painting seemed to him evidence 'of how ugly and outworn the human countenance has become, and of how all the objects of the environment have become repulsive to us'; and doubtful about its value: 'will it bring more

than a revival of the ornamental and a new access to it?'. He objected to the use of the term 'abstract' in Tzara's lecture 'Expressionism and Abstract Art', which was, for him, indissolubly associated with the capacity for rational, calculating thought, and therefore alien to art.

Tzara had no such scruples about the term 'abstract art', and it was he who emphasised the use of the 'new medium', collage, in preference to oil painting. Although the new medium was adopted from cubism and futurism, the Dada artists pushed it much further: 'the new artist makes a vow: he paints no longer/illusionistic and symbolic reproduction/ but creates directly in stone, wood, iron, bronze, rocks moving organisms'. This emphasis on a new and 'constructive' art was attacked by the Berlin Dadaists who found that Zurich Dada smacked too much of 'art for art's sake'. In 1920, Huelsenbeck wrote 'I find in the Dadaism of Tzara and his friends, who made abstract art the cornerstone of their new wisdom, no new ideas deserving of very strenuous propaganda.' Most Berlin Dadaists wanted art to enter directly into the reality of political struggle and, if necessary, wither away altogether.

Hans Arp comes over as probably the most articulate and vehement defender of abstract art among the Dada artists.[1] Although his actual influence on the works of the other Dada artists was non-existent, he was the dominant personality. During the first weeks of Dada, Ball brooded over a conversation with Arp at length in his diary: 'Arp speaks out against the bombast of the gods of painting (the expressionists). He would like to see things more ordered and less capricious, less brimming with colour and poetry. He recommends plane geometry rather than painted versions of the Creation and the Apocalypse' (*Flight out of time*).

It could be said that Arp's commitment in principle to an 'absolute' or elementary art was for a time in advance of his actual works. Dating from the same period as 'Abstract Composition' (no.140) were the murals Arp and Otto van Rees executed on facing walls of the Pestalozzi Institute in Zurich. Arp's is abstract but still based on 'baroque' rather than simple forms, while van Rees reveals the influence of Delaunay in dominant colour circles and the unmistakable form of the Eiffel Tower.

In his catalogue introduction to the 1915 exhibition at the Galerie Tanner Arp wrote: 'These works are constructions of lines, planes, forms and colours. They seek to approach the inexpressible about man, the eternal.' However it was Sophie Taeuber who revealed to him the possibilities of a truly simple

geometrical art (see no.152). Her meticulous water-colours and coloured crayon drawings of 1916, prototypes of the collages and embroideries, must be influenced by her carefully planned designs on graph paper for embroidery and tapestry. These are often brilliantly coloured, while Arp's collages are subtly monochrome, with black, white, grey dominant, and the addition of shiny metallic paper. Arp wrote: 'We regarded the personal as burdensome and useless since it had grown in a rigid, lifeless world. We searched for new materials, which were not weighted down with tradition. Individually and in common we embroidered, wove, painted, pasted geometric, static pictures. Impersonal severe structures of surfaces and colours arose. All accident was excluded. No spots, tears, fibres, imprecisions should disturb the clarity of our work. For our paper pictures we even discarded the scissors with which we had at first cut them out, since they too readily betrayed the life of the hand. From this time on we used a paper cutting machine.' Arp soon, however, introduced a new and de-stabilising element. The collage reproduced in *Dada 2* is no longer constructed on a rigid vertical-horizontal plane, but the rectangles are tilted and overlap. He later renamed this work 'Rectangles arranged according to the laws of chance', and explained 'Since the disposition of planes, and the proportions and colours of these planes seemed to depend purely on chance, I declared that these works, like nature, were ordered "according to the law of chance", chance being for me merely a limited part of an unfathomable raison d'être, of an order inaccessible in its totality.' A passage from Worringer's *Abstraction and Empathy* illuminates Arp's conception of chance: 'With the Oriental, the profundity of his world feeling, the instinct for the unfathomableness of being that mocks all intellectual mastery, is greater and human self-consciousness correspondingly smaller.' Arp referred to his collages of this time as mandalas, objects of contemplation.

The most decisive change in Arp's work, which came in 1917–18, on the occasion of a visit to the idyllic countryside in Ascona, on the shores of Lake Maggiore, (nos.145–151), is still basically in harmony with his search for a non-personal, non-illusionistic, art.

The shifting organic shapes of this period were to form the basis of Arp's work for the rest of his life. His art was now, he felt, in harmony with the natural and unreasonable order.

He specifically associated the revolt against the rational and the search for an order that reflected a totality beyond man's intellectual grasp with Dada: 'Dada aimed to destroy the reasonable deceptions of man and recover the natural and unreasonable order. Dada wanted to replace the logical nonsense of the men of today by the illogical senseless'.[2]

Finally, like Ball, he rejected the term 'abstract': 'Man calls the concrete abstract. This is not surprising, for he commonly confuses back and front even when using his nose, his mouth, his ears, that is to say five of his nine openings. I understand that a cubist painting might be called abstract, for parts of the object serving as model for the picture have been abstracted. But in my opinion a picture or a piece of sculpture without any object for model is just as concrete and sensual as a leaf or a stone.'[3]

NOTES
1. For a detailed discussion of the dating of his Dada works see Alastair Grieve, 'Arp in Zurich', *Dada Spectrum*, op.cit.
2. Arp, *On my way*, poetry and essays 1912–47, New York 1948.
3. Ibid.

HANS ARP 1887–1966

Not all artists associated with Dada in Zurich are represented in this section. Those artists have been selected who were the most radical in their abstraction; it is not a coincidence that this includes Hans Arp, Sophie Taeuber, Marcel Janco, artists who were most active in Dada manifestations and closest to Hugo Ball and Tristan Tzara, respectively the founder and later animator of Dada in Zurich. Also included in this section are two artists, Hans Richter and Viking Eggeling, who met through Dada in 1918 and produced the first abstract film 'score'. Unfortunately these artists are not all, for a variety of reasons, as fully represented as they could be; none of Arp's chance works, for example, have been available. Nor are there any works by the Swiss painter Augusto Giacometti who, although his colour abstractions were first created before Dada, sympathised with its revolutionary qualities. Other artists like Christian Schad who organised a Dada season in Geneva in 1919, and Prampolini, are represented only through works that were reproduced in Dada magazines.

Arp destroyed almost all his work prior to and even during the early part of the Dada period in Zurich. He wrote of the Crucifixion works: 'In 1915 I produced my first "essential" picture. I believe that I was playing with some children's blocks at the time. My "first essential picture" grew out of this playing and building with elementary forms. It contains both the crucifixion and the head of Christ crucified.' A wool hanging version of the oil painting 'Crucifixion', worked by Adja van Rees, was exhibited at the Galerie Tanner in Zurich in November 1915 in a joint exhibition of Arp and O. and A. van Rees; (Tzara dated the inception of Dada from this exhibition.) All Arp's works were called *Gestaltung* (formations), and when the tapestry was reproduced in the first Zurich Dada periodical *Cabaret Voltaire*, May 1916, it was simply described as *teppich* (tapestry).

138 Crucifixion 1914
 Etching, $4\frac{1}{2} \times 3\frac{1}{2}(11\frac{1}{2} \times 9)$
 Lucien Lefebvre-Foinet

139 **Crucifixion** *c*.1915
Oil on canvas, $47\frac{5}{8} \times 47\frac{5}{8}(121 \times 121)$
Private Collection

At the *Cabaret Voltaire* exhibition in May 1916 Arp exhibited two 1914 drawings, and three collages. Although clearly influenced by Cubist collages, these works have eliminated any reference to subject matter, and are constructed in flat planes frequently using found material.

140 **Abstract Composition** *c*.1915
Collage, $9 \times 7\frac{3}{4}(23.8 \times 19.9)$
Kunstmuseum, Basle, Kupferstichkabinett
Sammlung M. Arp-Hagenbach (1968.481)

Arp emphasised the influence of Sophie Taeuber, whom he met at the Galerie Tanner exhibition in 1915 and was to marry in 1922. 'The limpid calm which is emitted from the vertical and horizontal compositions created by Sophie Taeuber influenced the baroque facture, the diagonal structure of my abstract "configurations". A profound and serene silence filled her constructions of colour surfaces. The exclusive use of rectangular horizontal and vertical planes were a decisive influence on my work.'

141 **Pathetic Symmetry** 1916–17
Embroidery, $30 \times 25\frac{5}{8}(76 \times 65)$
Kunstmuseum, Basle
This work was actually executed by
Sophie Taeuber Arp

142 **Collage Géometrique** 1916
Collage, $43\frac{1}{4} \times 35(110 \times 89)$
Fondation Arp e V.

143 **Pathetic Symmetry** 1916–17
Embroidery, $30 \times 25\frac{5}{8}(76 \times 65)$
Musée National d'Art Moderne, Centre Georges
Pompidou, Paris (AM.1248 0A)

144 **Collage** *c*.1917
Collage, $13\frac{1}{4} \times 7\frac{3}{4}(33.5 \times 19.5)$
Gerard Bonnier

Arp placed the definitive change to free organic forms in 1917: 'At Ascona I drew with pen and Indian ink broken branches, roots, grasses and stones that the lake had thrown up on the shore. Finally I simplified these forms and united their essence in moving ovals, symbols of the metamorphosis and the changing of bodies. The wood relief 'Earth Forms', reproduced by Picabia in *391* dated from this period and is the first of a long series . . . It was forms of this kind that inspired the woodcuts I made for Tzara's books *Vingt-cinq poèmes* and *Cinéma calendrier du coeur abstrait*.' It was in fact 'Plant Hammer' that Picabia reproduced in *391* no.8, February 1919, under the simple title 'wood relief'. The first examples of these free forms to appear were the illustrations to *Vingt-cinq poèmes*, in 1918.

145 **Dada Drawing** *c*. 1916
Indian ink and pencil, $7 \times 8\frac{1}{4}(17.8 \times 22.1)$
Fondation Arp e V.

146 **Woodcut for 'Cinéma calendrier du coeur abstrait' by Tristan Tzara** 1920
Woodcut, $10\frac{1}{4} \times 6\frac{1}{4}(20.6 \times 15.7)$
Kunstmuseum, Basle, Kupferstichkabinett
Sammlung M. Arp-Hagenbach (1968.498.4)

147 **Woodcut for 'Cinéma calendrier du coeur abstrait' by Tristan Tzara** 1920
Woodcut, $7\frac{3}{4} \times 6\frac{1}{2}(19.7 \times 16.5)$
Kunstmuseum, Basle, Kupferstichkabinett
Sammlung M. Arp-Hagenbach (1968.498.7)

148 **Woodcut for Der Zeltweg** 1919
Woodcut, $9\frac{3}{4} \times 8\frac{1}{8}(24.9 \times 20.6)$
Kunstmuseum, Basle, Kupferstichkabinett
Sammlung M. Arp-Hagenbach (1968.495.1)

149 **Woodcut for Der Zeltweg** 1919
Woodcut, $11\frac{1}{2} \times 9\frac{1}{4}(29.1 \times 23.5)$
Kunstmuseum, Basle, Kupferstichkabinett
Sammlung M. Arp-Hagenbach (1968.495.2)

150 **Plant Hammer**
Painted wood, $24 \times 19\frac{3}{4}(62 \times 50)$
Private Collection

151 **Oiseau Hippique**
Painted wood, $7\frac{1}{8} \times 6\frac{1}{4}(18 \times 16)$
Fondation Arp e V.

SOPHIE TAEUBER-ARP 1889–1943

From 1916 until 1929 Sophie Taeuber-Arp taught textiles at the School of Arts and Crafts in Zurich. Her geometrical watercolours and pencil drawings of 1916 were a decisive influence on Hans Arp, who designed costumes for her Dada dances. From about 1916–17, together with Arp, she renounced the use of oil paint in favour of less 'loaded' mediums, paper, tapestries, wood. The vertical-horizontal compositions evolved independently of the Dutch artists, and Arp recalled first seeing reproductions of works by Mondrian after the War.

152 **Vertical-Horizontal Composition** 1916
Crayon, $9 \times 7\frac{1}{4}(23 \times 18.5)$
Michel Seuphor

153 **Untitled Composition** *c*.1916
Gouache, $10\frac{7}{8} \times 14\frac{3}{4}(27.5 \times 37.5)$
Kunstmuseum, Berne

154 **Cushion Cover**
Embroidery, $21\frac{1}{4} \times 22(54 \times 56)$
Private Collection

155 **Untitled Composition** *c*.1918
Embroidery, $7\frac{3}{4} \times 4\frac{3}{4}(19.5 \times 12)$
Barbara Strebel

This a design for part of the backcloth for Gozzi's *König Hirsch* (king deer), a tragi-comic fairy tale in three acts for which Sophie also designed the marionettes. The 'tree' design fitted into a background otherwise entirely composed of regular rectangles.

156 **Collage** 1918
Collage, $6\frac{1}{4} \times 3\frac{7}{8}(15.4 \times 9.9)$
Kunstgewerbemuseum, Zurich, Graphische
Sammlung

143

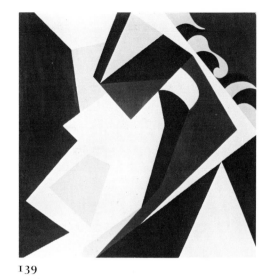

139

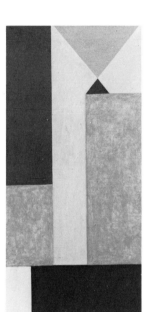 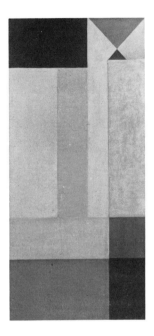 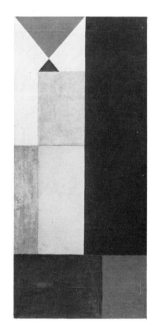

150

157

161

160

164

'In 1918 she painted a triptych for which she once again used oil colour and also different kinds of bronze gildings. This technique of gilding, which the naturalist tendencies of painting over the last century relegated to the background, Sophie took up again, stimulated by the paintings of the middle ages and the Byzantine period.' Arp, 'Jalons', 1950, *Jours Effeuillés*, 1966.

157 Triptychon 1918
Oil on canvas,
three sections each $44\frac{1}{8} \times 21\frac{3}{4}(112 \times 53)$
Kunsthaus, Zurich

The precise rectangles of the earlier works have become distorted like a square of material in the breeze. The colour and delicate forms are slightly reminiscent of Klee, and 'Square forms' shares some of his capacity to move backwards and forwards between figuration and abstraction. The figures in this work are not 'abstracted' but constructed as though from coloured blocks.

158 Little Triptych 1919
Watercolour, $8\frac{1}{4} \times 12\frac{1}{2}(21 \times 31.8)$
Kunstmuseum, Basle, Kupferstichkabinett
Sammlung M. Arp-Hagenbach (1968.433)

159 Square forms evoking a group of people 1920
Gouache, $16\frac{1}{2} \times 10\frac{1}{2}(42 \times 26.5)$
Private Collection

MARCEL JANCO b. 1895

A member of the Dada group from its foundation, Janco abandoned his architectural studies at the Zurich Polytechnic to devote himself to painting and sculpture. None of his sculptures of wire, feathers, etc., which were related to the fantastic masks he constructed for Dada performances have survived. By 1917 he was producing completely abstract woodcuts and plaster reliefs, which tend to have complex surfaces and a vertical, architectural format.

160 Dada Relief 1918
Bronze, $20\frac{7}{8} \times 13\frac{1}{4}(53 \times 33.5)$
Musée d'Art Moderne, Strasbourg

HANS RICHTER 1888–1976

Richter exhibited with Arp, the Van Rees, Janco, Tscharner, Helbig and Slodki at the Gallery Corray, the future Dada gallery, in January 1917; the press called them 'Zurich cubists'. Richter's evolution towards abstraction was comparatively slow; he made a series of Heads which progressively simplify and exaggerate essential shapes. 'Head' woodcuts are reproduced in *Dada* 3.

Richter met and began to collaborate with Eggeling, whose abstract works were far in advance of his, in 1918. Eggeling's 'Horizontal-Vertical Orchestra' and Richter's 'Praeludium' were the first complete scroll drawings, and were the basis of the first abstract films.

161 Dada Head 1918
Indian ink, $7\frac{1}{2} \times 5\frac{1}{2}(19 \times 14)$
Guido Rossi, Milan

162 Praeludium, artist's 1968 copy of original
*c.*1919–20
Pencil on paper scroll, $28 \times 190(71.2 \times 482.8)$
Yale University Art Gallery, Gift of Hans Richter

VIKING EGGELING 1880–1925

Eggeling's works are notoriously difficult to date. The first rough drafts for 'Horizontal-Vertical Orchestra' and 'Diagonal Symphony' appear to date from about 1915, when he was living in Ascona. In 1918 he moved to Zurich where he renewed contact with Arp and met Hans Richter, with whom he was to work in close contact on film 'scores' and experiments until 1921. His studies from 1915 show him building up a vocabulary of separate abstract forms; two lithographs were published in *Dada IV–V*: *Basse générale de la peinture: orchestration de la ligne*, and *Basse générale de la peinture: extension*. The pencil drawings 'Diagonal Symphony' were transcribed onto continuous rolls of paper, and were the basis of the film on which he began work in 1923. It received its first public performance in 1925. O'Konor said 'Eggeling's protest against the corrupt element in art, which to him meant the corrupt element in life, found expression in his efforts to create an abstract art, a *language* to establish, restore, a meaningful contact between public and artist, and that it was this that set him apart from the Dadaists.' I would suggest that it was precisely this which led him to associate so closely with them.

163 Composition *c.*1916
Oil on canvas, $19\frac{3}{4} \times 14(50 \times 35.5)$
Kunstmuseum, Basle

164 Diagonal Symphony
Pencil, $21\frac{5}{8} \times 83\frac{3}{4}(55 \times 213)$
Moderna Museet, Stockholm

Painting in Munich
Peter Vergo

If Germany had a geographical 'centre' of abstraction, that centre was Munich. The impulse to experiment with abstraction derived partly from the fact that turn-of-the-century Munich was also the city of *Jugendstil*, the German variant of art nouveau. Georg Hirth's periodical *Die Jugend*, which gave its name to the movement, first saw the light of day in Munich, and visitors to the city were struck by the ubiquitous presence of the new style.[1] German art nouveau was, however, far more abstract in tendency than the parallel movements in other countries. Some of the most significant Jugendstil designers like August Endell published important essays in which they examined the expressive potential of a language of abstract form,[2] while artists like Hans Schmithals (q.v.) turned these ideas into practice on a monumental scale.

At about the time Jugendstil was establishing itself as the dominant artistic movement in Munich, a foreigner who was also significantly to influence the development of abstract painting made his home there.[3] That foreigner was the Russian painter Wassily Kandinsky. Kandinsky soon gathered around him a circle of like-minded artists, and in 1909 this informal association took on formal guise as a properly registered exhibiting society, the *Neue Künstler-Vereinigung München* (New Artists' Association of Munich). Late in 1911, tensions within the association caused the resignation of Kandinsky and the more radical members, who then quickly arranged their own, independent exhibition as a counter-blast to the third exhibition of the *Neue Künstler-Vereinigung*. They called their hastily improvised show the 'first exhibition of the editors of *Der Blaue Reiter*'.

The *Blaue Reiter* (Blue Rider) has sometimes been identified with the abstract 'movement' in German art, which is doubly untrue, first because *Der Blaue Reiter* was never a movement or exhibiting society, but simply a book (published in Munich in May 1912) and two exhibitions, all bearing the same name; secondly because Kandinsky, in an essay published in *Der Blaue Reiter* under the title 'The Question of Form', made clear that he had no wish to preach abstraction or encourage other artists to paint abstract paintings, even describing his own abstract experiments as identical in their artistic aim with what he called the 'great realism' of Douanier Rousseau. The two *Blaue Reiter* exhibitions were likewise intended to show not the stylistic similarity, but rather the identity of *inner* striving which characterised the different facets of contemporary art.

Doubtless the temptation for other painters to experiment with abstraction was increased by Kandinsky's example and physical presence in Munich. He influenced the artists closest to him in so far as he caused them to entertain the possibility of abstraction, and to turn to philosophical and critical sources other than the writings of the Jugendstil designers in search of a justification for a kind of abstract painting which would be something more than mere ornament. Kandinsky himself, however, was throughout the whole of the period before the Great War unsure in his own mind as to the possibility of a totally non-representational art. He remained, moreover, remarkably isolated as far as his own work was concerned, and his paintings seem to have exerted little direct influence on his contemporaries. Some artists, like Macke and Klee, were initially suspicious of him,[4] and though they came to admire his work, their reservations to some extent persisted. Klee, in particular, doggedly pursued his own path in search above all of mastery of colour. Even Marc, who stood closest to Kandinsky, turned rather to Italian Futurism and Delaunay's Orphism for pictorial inspiration. The true impact of Kandinsky's experiments, in particular his writings and graphic works, is seen only later, after 1916, in the activities of the Zurich Dadaists – especially Arp, whose early woodcuts bear a marked resemblance to some of the prints from Kandinsky's *Klänge* (no.180).

NOTES

1. See for example Gabriele Münter's recollections in conversation with Edouard Roditi, in E. Roditi, *Dialogues on Art* (London: Secker & Warburg) 1960.
2. See for example August Endell, 'Formenschönheit und dekorative Kunst', *Dekorative Kunst* I, No.2 (November 1897) pp.75–77; *ibid.*, No.9 (June 1898) pp.119–125.
3. On Kandinsky's early years in Munich see Peg Weiss, *Kandinsky in Munich. The Formative Jugendstil Years* (Princeton U.P.) 1979.
4. See for example Macke, letter to Marc dated Christmas 1910, in *August Macke–Franz Marc. Briefwechsel* (Cologne: Verlag M. DuMont Schauberg) 1964, p.31f.

WASSILY KANDINSKY 1866–1944

Studied ethnography and jurisprudence at Moscow University before turning to painting. Pupil of Anton Ažbè and Franz von Stuck in Munich. President of the exhibiting societies 'Phalanx' (founded 1901) and the 'New Artists' Association of Munich' (founded 1909). Co-editor, with Franz Marc, of the almanac *Der Blaue Reiter* (The Blue Rider), published in Munich in May 1912.* Active not only as a painter, but also as theorist (*Über das Geistige in der Kunst*, Munich 1912, and numerous articles and essays) and poet (*Klänge*, Munich 1913 [1912?]). Widely credited with the 'invention' of abstract painting. Closely associated with Herwarth Walden's *Der Sturm* (from 1912), Kandinsky was recognised by 1914 as one of the major figures of Expressionist painting. Returning to Russia at the outbreak of the Great War, after the 1917 revolution he was active for a time in the field of art education, both as professor in Moscow and as a founder member of the 'Institute of Artistic Culture'. Joined the staff of the Bauhaus in summer 1922. His influence as a teacher is reflected in his major treatise of the post-war years, *Punkt und Line zu Fläche* (Point and Line to Plane) of 1926. Emigrated to France in 1933.

* See the documentary edition by Klaus Lankheit, *The Blaue Reiter Almanac*, London/New York, 1974.

Lit: Paul Fechter, *Der Expressionismus*, Munich, 1914; Will Grohmann, *Wassily Kandinsky, Life and Work*, London/New York, 1958; Peg Weiss, *Kandinsky in Munich, The Formative Jugendstil Years*, Princeton, 1979; *Kandinsky, The Munich Years 1900–14*, Edinburgh International Festival, 1979.

'Composition 4', though it initially makes an 'abstract' impression, is still a predominantly representational painting. It shows a landscape with battling horsemen in the upper left-hand corner, a castle, Cossacks bearing lances (the vertical black lines which divide the picture) and a reclining couple (lower right). Kandinsky's own account of the picture reveals that he was thinking both of allusions to specific objects and events, and in terms of the 'abstract' effect of colours and forms. The related drawings and studies show that the composition was long-since clearly envisaged by the artist; the drawings are not really 'preparatory' at all, and the Tate's picture 'Cossacks' (see no.165), though often referred to as a 'study', is clearly not a study for the final painting in any normal sense of the term. This 'fully-fledged' character is also to be found in the so-called 'preparatory' drawings and studies for many of Kandinsky's other major paintings of this period.

Lit: Kandinsky, 'Komposition 4', in *Kandinsky 1901–1913*, Berlin: 'Der Sturm', 1913, pp.xxxiii–iv.

165 Cossacks (Study for Composition 4) 1910–11
Oil on canvas, $37\frac{1}{4} \times 51\frac{1}{4}(94.5 \times 131.5)$
Tate Gallery (4948)

166 Sketch for Composition 4 1911
Line etching, hand coloured $5\frac{1}{2} \times \frac{1}{4}(13.9 \times 20.9)$
Published in the almanac *Der Blaue Reiter*, Munich: R. Piper & Co., 1912, preceding p.65
Städtische Galerie im Lenbachhaus, Munich

167 Drawing for Composition 4 1910
Crayon, $4\frac{3}{8} \times 7\frac{7}{8}(11 \times 20)$
Private Collection, Paris

Kandinsky only published four essays on individual paintings in his own lifetime. His description of 'Painting with White Border' provides a fascinating account of his working methods. The artist tells us that the painting's dominant feature, the 'white edge' which dominates the right-hand side, only occurred to him at a late stage in the work's development, an observation confirmed by the preparatory drawings and studies which show, however, that most of the other important motifs are already present. Kandinsky's description reveals that he himself was, by this date, conceiving of his own pictures in highly abstract terms. None the less, certain motifs can still be identified, e.g. the St George on horseback with lance; while Kandinsky himself draws attention to the presence of the troika, a favourite motif in his works of this period.

Lit: Kandinsky, 'Das Bild mit weißem Rand', in *Kandinsky 1901–1913*, Berlin: 'Der Sturm', 1913, pp.xxxix–xxxxi; Angelica Zander Rudenstine, *The Guggenheim Museum Collection. Paintings, 1880–1945*, New York, 1976, vol.1, p.256f.

168 Oil Study for Painting with White Border
Oil on canvas, $39\frac{1}{4} \times 31(99.5 \times 78.5)$
Phillips Collection, Washington
(Katherine S. Dreier Bequest)

169 Study for Painting with White Border
Watercolour, $10\frac{3}{4} \times 14\frac{7}{8}(27.5 \times 37.8)$
Städtische Galerie im Lenbachhaus, Munich
(GMS.131)

170 1st variant of 'Sketch for Painting with White Border'
Watercolour and chalk, $12 \times 9\frac{1}{2}(30.3 \times 24.1)$
Städtische Galerie im Lenbachhaus, Munich
(GMS.354)

171 2nd variant of 'Sketch for Painting with White Border'
Watercolour and pencil, $12\frac{1}{4} \times 9\frac{3}{8}(31.7 \times 23.9)$
Städtische Galerie im Lenbachhaus, Munich
(GMS.160)

172 Study for Painting with White Border
Pencil, $10\frac{3}{4} \times 14\frac{7}{8}(27.5 \times 37.8)$
Städtische Galerie im Lenbachhaus, Munich
(GMS.396)

173 Study for Painting with White Border
Pencil, $10\frac{3}{4} \times 14\frac{7}{8}(27.5 \times 37.8)$
Städtische Galerie im Lenbachhaus, Munich
(GMS.395)

174 Study for Painting with White Border
Black chalk, $8\frac{1}{4} \times 9\frac{3}{4}(20.9 \times 24.9)$
Städtische Galerie im Lenbachhaus, Munich
(GMS.452)

175 Study for Painting with White Border
Black chalk, $8\frac{1}{4} \times 9\frac{3}{4}(21.1 \times 24.7)$
Städtische Galerie im Lenbachhaus, Munich
(GMS.451)

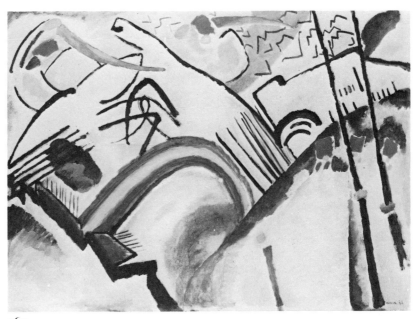

165

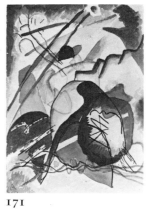

169

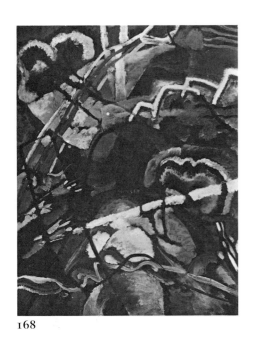

168

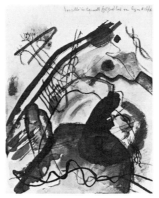

170

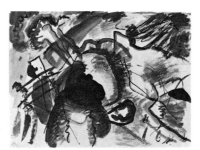

171

175

174

173

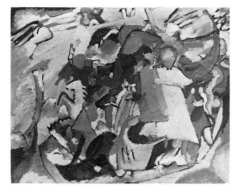

176

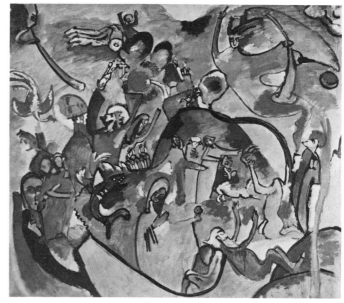

177

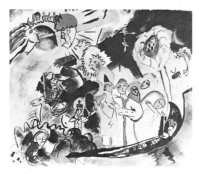

178

179

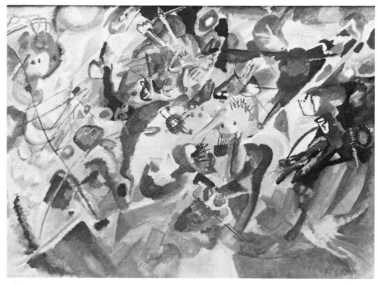

183

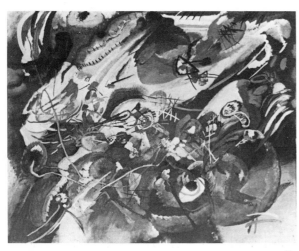

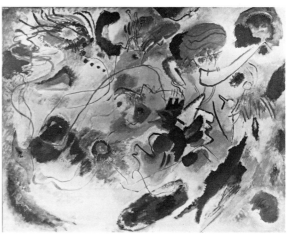

181

182

184

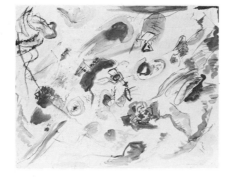

190

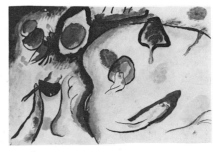

192

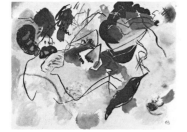

185

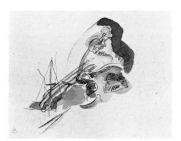

186

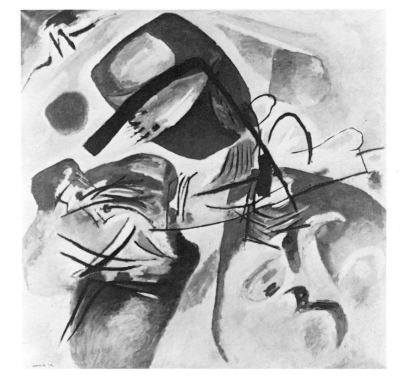

193

187

188

189

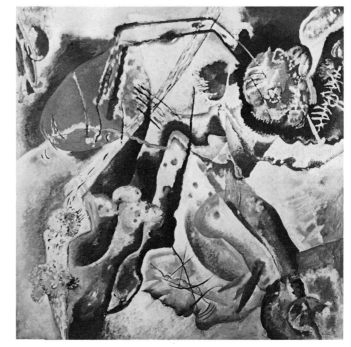

194

Many of Kandinsky's pre-1914 paintings include elements of Christian iconography, or indeed are based entirely on religious themes, especially the resurrection and the last judgement. These themes are, on occasion, treated in a highly representational, 'primitive' manner. Kandinsky had been impressed by Bavarian religious glass-paintings he had seen in and around Murnau after 1908, and he himself made a number of experiments with the technique of painting behind glass (not shown in this exhibition because of their fragility). These experiments, and the paintings and watercolours in which he repeats the same themes (e.g. nos.177, 178) often serve as the starting point for a radical abstracting process in the course of which the motifs are often 'dissolved' (Kandinsky's own term) almost beyond the point of recognition. It is perhaps clear that the brush drawing for *Klänge* (no.179) is based on the same repertoire of motifs as the Last Judgement pictures; but the theme of the drawing, or of the *Klänge* woodcut (no.180) would scarcely have been clear to us without some knowledge of the works that preceded it.

Lit: *Kandinsky, Painting on Glass. Anniversary Exhibition*, New York: The Solomon R. Guggenheim Museum, 1966. With an essay by Hans Konrad Roethel.

176 **All Saints' Day I** *c.* 1911
Oil on pasteboard, $19\frac{3}{4} \times 25\frac{3}{8}(50.2 \times 64.5)$
Städtische Galerie im Lenbachhaus, Munich (GMS.71)

177 **All Saints' Day 2** 1911
Oil on canvas, $33\frac{7}{8} \times 39(86 \times 99)$
Städtische Galerie im Lenbachhaus, Munich (GMS.62)

178 **All Saints' Day** 1910/11
Watercolour, $15 \times 18\frac{1}{8}(38 \times 46)$
Private Collection, Hofheim/TS

179 **Last Judgement** 1912
Brush and pencil, $8\frac{1}{4} \times 11\frac{1}{4}(21.9 \times 28.5)$
Städtische Galerie im Lenbachhaus, Munich (GMS.378)

180 **Klänge** 1913 (1912?)
An anthology of Kandinsky's poems and woodcuts, published by R. Piper & Co., Munich. Open to show the woodcut 'Last Judgement'; cf no.179.
British Library, London

In 'Composition 6' and 'Composition 7' of 1913, representational allusions seem to have vanished altogether. Yet it is difficult not to feel that these are apocalyptic pictures, and our suspicions are confirmed by Kandinsky's own acknowledgement that 'Composition 6' derived from a glass painting, now lost, on the theme of the deluge. It may be apparent from no.185 that 'Composition 7', too, is an apocalyptic work, the compositional lay-out of the 'Last Judgement' and 'All Saints' Day' paintings being carried across into the preparatory studies for this far more complex painting of 1913. The large number of drawings and sketches bear witness to the immense effort this picture cost Kandinsky; but even here, the most schematic of the composition drawings show that the basic structure at least was clear in the artist's mind from the beginning.

Lit: Kandinsky, 'Komposition 6', in *Kandinsky 1901–1913*, Berlin: 'Der Sturm', 1913, pp.xxxv–viii.

181 **Study for Composition 7** 1913
Oil on canvas, $30\frac{3}{4} \times 39\frac{3}{8}(78 \times 100)$
Private Collection

182 **Picture No.183 (Study for Composition 7)** 1913
Oil on canvas, $30\frac{3}{4} \times 39\frac{1}{4}(78 \times 99.5)$
Städtische Galerie im Lenbachhaus, Munich (GMS.63)

183 **Study for Composition 7 (Sketch No.3)** 1913
Oil on canvas, $35\frac{1}{4} \times 49\frac{1}{4}(89.5 \times 125)$
Städtische Galerie im Lenbachhaus, Munich (GMS.68)

184 **Study for Composition 7(6)** 1913
Watercolour and pencil, $7\frac{1}{4} \times 10\frac{3}{4}(18.4 \times 27.1)$
Städtische Galerie im Lenbachhaus, Munich (GMS.136)

185 **Study for Composition 7 (5)** 1913
Watercolour and pencil, $9\frac{3}{8} \times 12\frac{1}{2}(23.9 \times 31.6)$
Städtische Galerie im Lenbachhaus, Munich (GMS.135)

186 **Study for part of Composition 7** 1913
Watercolour, $9\frac{3}{8} \times 12\frac{3}{8}(23.9 \times 31.5)$
Städtische Galerie im Lenbachhaus, Munich (GMS.134)

187 **Study for Composition 7** 1913
Pen and ink, $8\frac{1}{4} \times 13(21 \times 33.1)$
Städtische Galerie im Lenbachhaus, Munich (GMS.407)

188 **Study for Composition 7** 1913
Pencil, $4\frac{5}{8} \times 6\frac{3}{4}(11.8 \times 17.3)$
Städtische Galerie im Lenbachhaus, Munich (GMS.614)

189 **Study for Composition 7** 1913
Pencil, $9\frac{3}{8} \times 12(23.8 \times 30.4)$
Städtische Galerie im Lenbachhaus, Munich (GMS.367)

In certain isolated oils and watercolours of the period 1910–14, Kandinsky pushes recognisable iconography to the very limits of abstraction. 'Watercolour for Improvisation 25' (no.192) still retains identifiable motifs associated with the theme of the Garden of Delights; but works such as 'Black Arch' or 'With Red Spot' present what one can only with extreme hesitancy identify as landscape elements.

Of particular interest is the sheet formerly in the possession of Madame Nina Kandinsky, which has become known as the 'First Abstract Watercolour' (no.190). A number of scholars, including both Lindsay and Roethel, believe that this work, though signed and dated 1910, belongs in fact among the studies for 'Composition 7' of 1913; Lindsay has also suggested that the work was signed and dated by Kandinsky some years after its execution, being one of a small group of items returned to the artist by Gabriele Münter after the First World War. Against this view, Madame Kandinsky herself has maintained that the sheet was already signed and dated when Kandinsky retrieved it shortly after he, and the Bauhaus, moved from Weimar to Dessau in 1926.

199

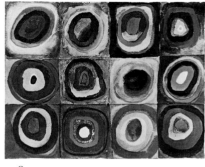

198

195

200

197

196

201

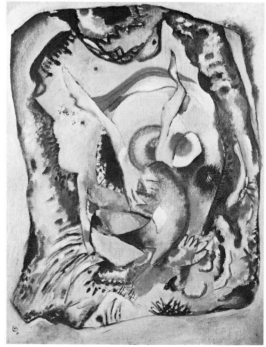

202

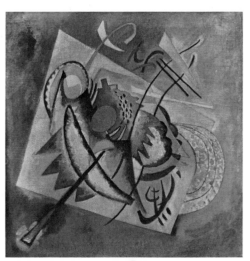

204

Lit: Kenneth C. Lindsay, 'Will Grohmann, Kandinsky', *Art Bulletin* XLI, no.4, December 1959, pp.348–50; Hans Konrad Roethel, *Kandinsky: the Road to Abstraction*, London, Marlborough Fine Art, 1961 n.p.; Kenneth C. Lindsay and Peter Vergo (eds.), *Wassily Kandinsky, Complete Writings on Art* (in preparation), Introduction and note 8.

190 'First Abstract Watercolour'
Watercolour, $19\frac{5}{8} \times 25\frac{5}{8}$ (50×65)
Musée National d'Art Moderne, Centre Georges
Pompidou, Paris (AM.1976-864)

191 In Circle 1911
Watercolour, $19\frac{1}{4} \times 18\frac{7}{8}$ (49×48)
Private Collection, Paris

192 Watercolour for Improvisation 25 1912
Watercolour and ink, $12\frac{1}{4} \times 18\frac{3}{4}$ (31×47.5)
Solomon R. Guggenheim Museum, New York
(FN.1162)

193 With Black Arch 1912
Oil on canvas, $73\frac{1}{4} \times 77\frac{1}{8}$ (186×193.3)
Musée National d'Art Moderne, Centre Georges
Pompidou, Paris (AM.1976-852)

194 With Red Spot 1914
Oil on canvas, $51\frac{1}{8} \times 51\frac{1}{8}$ (130×130)
Musée National d'Art Moderne, Centre Georges
Pompidou, Paris (AM.1976-853)

Kandinsky executed only a small number of designs for ornament, and an even smaller number of colour exercises. These designs show how different his work in this genre is from his genuine attempts, however halting, to create an abstract vocabulary of expressive form.

195 Designs for Ornament
Pencil, $4\frac{3}{8} \times 9\frac{5}{8}$ (11.1×24.5)
Städtische Galerie im Lenbachhaus, Munich
(GMS.1120)

196 Designs for Ornament
Pencil, $8\frac{1}{4} \times 6\frac{1}{8}$ (20.8×15.5)
Städtische Galerie im Lenbachhaus, Munich
(GMS.536)

197 Designs for Ornament
Pencil, $8\frac{1}{4} \times 10\frac{5}{8}$ (20.8×27)
Städtische Galerie im Lenbachhaus, Munich
(GMS.986)

198 Colour Study: squares with concentric rings
*c.*1913
Watercolour and body colour with black chalk,
$9\frac{1}{2} \times 12\frac{1}{2}$ (23.9×31.6)
Städtische Galerie im Lenbachhaus, Munich
(GMS.446)

199 Colour Study with Grid *c.*1913
Watercolour and pencil, $12 \times 9\frac{1}{2}$ (30.3×24)
Städtische Galerie im Lenbachhaus, Munich
(GMS.368)

Kandinsky's reaction to the shock of war and forced repatriation, and his surprise at the abstract-geometric work of Malevich and the Suprematists, is reflected in his temporary return to some of the subjects he had treated in much earlier pictures, in a form far less abstract than his paintings of 1913–14. The drawing (no.200) depicting a picnic scene is an example of this recessive tendency in his work during the years of war and revolution. As early as 1916, however, he was able to create works which explore further the abstract vocabulary of his pre-war experiments, e.g. 'On Light Ground' (no.202); while 'In Gray' is a worthy successor to his apocalyptic 'Compositions' of 1913. Identifiable motifs were not, on the other hand, destined to vanish entirely from his painting. 'Red Oval' (no.204) shows us, albeit in geometric form, the motif of the rowing boat which is also to be found in many of his pre-war pictures.

200 Untitled Drawing (Picnic) 1916
Watercolour, $13\frac{5}{8} \times 13\frac{1}{2}$ (34.5×34.2)
Solomon R. Guggenheim Museum, New York
(FN.1053)

201 Composition 1916
Watercolour, $8\frac{7}{8} \times 13\frac{3}{8}$ (22.4×33.7)
Kunstmuseum, Berne, Hermann and Margrit Rupf-
Stiftung

202 On Light Ground 1916
Oil on canvas, $39\frac{3}{8} \times 30\frac{3}{4}$ (100×78)
Musée National d'Art Moderne, Centre Georges
Pompidou, Paris

203 In Gray 1919
Oil on canvas, $50\frac{3}{4} \times 69\frac{1}{2}$ (129×176)
Private Collection, Paris

204 Red Oval 1920
Oil on canvas, 28×28 (71×71)
Solomon R. Guggenheim Museum, New York

AUGUST MACKE 1887–1914

Studied in Düsseldorf, both at the Academy and as a pupil of Ehmcke at the School of Applied Arts. His wife's uncle was the Berlin manufacturer Bernhard Koehler, who enabled the young artist to make several visits to Paris, and later supported the publication of the almanac *Der Blaue Reiter* (no.166). Macke's friendship with the painter Franz Marc (q.v.) brought him into contact with the *Blaue Reiter* circle. Though initially rather suspicious of Kandinsky, Macke subsequently came to admire his work. He also contributed an essay, 'The Masks', to the almanac, and showed works at both the *Blaue Reiter* exhibitions in Munich (December 1911 and spring 1912). Together with Franz Marc, he visited Delaunay in Paris in autumn 1912, and in spring 1914 accompanied the artists Paul Klee (q.v.) and Louis Moilliet on a trip to North Africa. Called up for military service at the outbreak of war, Macke was killed on the Western Front in September 1914.

Macke's training in the applied arts is reflected in the abstract and near-abstract designs he made for embroideries and decorative materials (e.g. no.209). Other 'abstract' watercolours and drawings, though not specifically designated as such, are clearly related to his designs

for objects of applied art. Macke did, however, make a small number of paintings and a somewhat larger number of drawings and watercolours which may be considered genuinely abstract, in the sense that they have neither any obvious decorative intent, nor any clear relationship to natural forms. Some works, for example no.217, contain what may be distant references to landscape motifs; in its colours (and also, to a lesser extent, its forms) this pastel also reveals the influence of Delaunay's Orphism. In a number of works of 1912–14, Macke experimented with the formal vocabulary of Cubism. The exact chronology of his painting of this period is, however, a matter of some debate. The drawings and watercolours, in particular, are only rarely dated by the artist himself, and most of the titles of his 'abstract' works are also later ascriptions.

Lit: Gustav Vriesen, *August Macke*, Stuttgart, 1957; Elisabeth Erdmann-Macke, *Erinnerung an August Macke*, Stuttgart, 1962; *August Macke – Franz Marc. Briefwechsel*, Cologne, 1964; *August Macke 1887–1914. Aquarelle und Zeichnungen*, Münster, Westfälisches Landesmuseum, 1976.

205 Coloured Forms I 1913
Oil on panel, 21 × 15⅜ (53.5 × 39)
Estate of Dr Wolfgang Macke, Bonn

206 Coloured Forms III 1913
Oil on panel, 11½ × 9½ (29 × 24)
Estate of Dr Wolfgang Macke, Bonn

207 Colour – Form Composition 1914
Oil on canvas, 21 × 17¼ (53.5 × 44)
Private Collection

208 Abstract Pattern III 1912
Watercolour, 10⅝ × 12½ (27 × 32)
Estate of Dr Wolfgang Macke, Bonn

209 Fish Pattern: design for embroidery 1912
Watercolour, 10⅝ × 12⅝ (27 × 32)
Estate of Dr Wolfgang Macke, Bonn

210 Abstract Forms 1912
Watercolour, 13⅛ × 17 (33.4 × 43)
Estate of Dr Wolfgang Macke, Bonn

211 Abstract Forms 1913
Pencil, 8 × 6¼ (20.5 × 16)
Estate of Dr Wolfgang Macke, Bonn

212 Abstract Forms II 1913
Pencil and crayon, 8 × 6¼ (20.5 × 15.8)
Städtische Galerie im Lenbachhaus, Munich
(G12 403)

213 Abstract Symbols IV 1912/13
Brush, 4 × 6⅜ (10.2 × 16.2)
Estate of Dr Wolfgang Macke, Bonn

214 Abstract Symbols VII 1912/13
Brush, 4 × 6⅜ (10.2 × 16.2)
Estate of Dr Wolfgang Macke, Bonn

215 Abstract Symbols IX 1912/13
Brush, 4 × 6⅜ (10.2 × 16.2)
Estate of Dr Wolfgang Macke, Bonn

216 Abstract Composition II 1913
Crayon and watercolour, 8¼ × 6⅜ (21 × 16.3)
Estate of Dr Wolfgang Macke, Bonn

217 Colour Composition 1913
Pastel, 11⅜ × 17⅜ (29 × 44)
Estate of Dr Wolfgang Macke, Bonn

218 Coloured Forms I 1913
Watercolour, 9¼ × 12 (23.7 × 29)
Private Collection

219 Coloured Forms II 1914
Crayon, 6¼ × 3¾ (16 × 9.4)
Estate of Dr Wolfgang Macke, Bonn

220 Coloured Forms V 1914
Coloured chalk, 8⅛ × 5⅛ (20.5 × 13)
Estate of Dr Wolfgang Macke, Bonn

221 Abstract Composition 1914
Watercolour and collage, 10½ × 12¼ (26.6 × 31.1)
Estate of Dr Wolfgang Macke, Bonn

222 Forms Composed in Space 1914
Charcoal, 4⅜ × 6⅝ (11 × 17)
Estate of Dr Wolfgang Macke, Bonn

FRANZ MARC 1880–1916

Marc turned from philosophy and theology to the study of art, enrolling as a pupil of Hackl and Diez at the Munich Academy. In 1910 he settled in Sindelsdorf (Upper Bavaria). The following year he joined the New Artists' Association of Munich, and resigned together with Kandinsky in order to prepare the counter-exhibition of the 'editors of the *Blaue Reiter*' (December 1911). The *Blaue Reiter* almanac itself contains Marc's important statements 'Spiritual Treasures' and 'The German "Fauves"'; he also contributed as an essayist to the periodicals *Pan* and *Der Sturm*. In the company of August Macke (q.v.) he visited Delaunay in Paris in autumn 1912. In 1913 he showed an important collection of paintings at Herwarth Walden's 'Erster Deutscher Herbstsalon' in Berlin. Called up at the outbreak of war, his *Letters from the Battlefield* and 'Sketchbook from the Battlefield' provide a significant record of his wartime reflections and experiences. Marc was killed at Verdun on 4 March 1916.

Like Macke, Marc devoted only a small part of his time to abstract experiments; unlike Macke, he created a number of works which show the gradual dissolution of identifiable motifs (nos.228, 231). Though the artists of the *Blaue Reiter* circle were, in general, disapproving of Italian Futurism, Marc appears to have borrowed some elements of the Futurists' pictorial language. Some of his abstract works, in particular, are cut across by strong diagonals reminiscent of Futurist painting. The 'Sketchbook from the Battlefield' is also interesting, containing a wide range of motifs both abstract and representational. The two 'abstract' drawings (nos.232, 233), one entitled 'strife', seem closely related to a work such as the oil painting 'Struggling Forms' (not in exhibition); while a far more representational drawing such as no.234 bears, surprisingly, the inscription 'Stickerei' (i.e. for an embroidery).

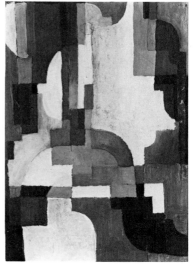

205

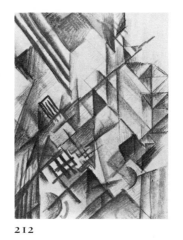

212

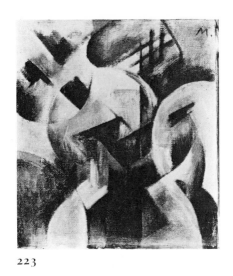

223

221

216

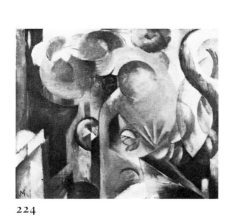

224

232

226

227

225

233

230

228

229

231

Lit: Klaus Lankheit (ed.), *Franz Marc im Urteil seiner Zeit*, Cologne, 1960, and *Franz Marc, Katalog der Werke*, Cologne, 1970. See also the same author's annotated edition of the 'Sketchbook from the Battlefield' (*Skizzenbuch aus dem Felde*, Berlin, 1967) and of the *Blaue Reiter Almanac*, London/New York, 1974.

223 Small Composition I 1913
Oil on canvas, $18\frac{1}{4} \times 16\frac{3}{8} (46.5 \times 41.5)$
Private Collection

224 Small Composition III 1913–14
Oil on canvas, $17\frac{7}{8} \times 22\frac{1}{4} (45.5 \times 56.5)$
Städtisches Karl Ernst Osthaus Museum, Hagen

225 Small Composition IV 1914
Oil on canvas, $15\frac{3}{8} \times 19\frac{1}{4} (39 \times 49)$
Galerie Stangl, Munich

226 Abstract Composition 1913
Watercolour, $5\frac{1}{2} \times 3\frac{1}{2} (14 \times 9.2)$. Postcard to Lily Klee, date of postmark 7 December 1913. On the verso, a handwritten message from Maria Marc.
Private Collection

227 Sonatine for Violin and Piano 1913
Watercolour, $4 \times 6 (10 \times 15)$. Postcard to Lily Klee, date of postmark illegible save for the year, 1913. With handwritten text.
Private Collection

228 Stables 1913
Pencil and ink, $6\frac{5}{8} \times 8\frac{5}{8} (16.8 \times 22)$. Study for the oil painting of the same title now in the Solomon R. Guggenheim Museum, New York. See Angelica Zander Rudenstine, *The Guggenheim Museum Collection, Paintings 1880–1945*, New York, 1976, vol.2, p.500f.
Galerie Stangl, Munich

229 Abstract Forms 1913–14
Pencil, $8\frac{5}{8} \times 6\frac{1}{2} (22 \times 16.5)$
Galerie Stangl, Munich

230 Abstract Drawing 1914
Pencil, $6\frac{5}{8} \times 8\frac{5}{8} (16.9 \times 22.1)$
Staatliche Kunsthalle Karlsruhe,
Kupferstichkabinett

231 House in Garden 1914
Pencil, $8\frac{5}{8} \times 6\frac{1}{2} (22 \times 16.5)$
Galerie Stangl, Munich

232 Page from 'Sketchbook from the Battlefield' fol.18
Pencil, $4 \times 6\frac{1}{4} (10.2 \times 15.7)$
Staatliche Graphische Sammlung, Munich

233 Page from 'Sketchbook from the Battlefield' fol.24
Pencil, $4 \times 6\frac{1}{4} (10.2 \times 15.7)$
Inscribed lower left 'Streit' (strife)
Staatliche Graphische Sammlung, Munich

234 Page from 'Sketchbook from the Battlefield' fol.29
Pencil, $4 \times 6\frac{1}{4} (10.2 \times 15.7)$
Inscribed lower right 'Stickerei' (embroidery).
Staatliche Graphische Sammlung, Munich

GABRIELE MÜNTER 1877–1962

1901–2 studied with the *Jugendstil* artist Angelo Jank in Munich. In 1902, Münter met Kandinsky through the painting classes of the artists' association 'Phalanx'. Together with Kandinsky, she was a founder member of the New Artists' Association of Munich (established 1909), and with him, she resigned from the association in order to organise the counter-exhibition of the 'editors of the *Blaue Reiter*', which opened in Munich in December 1911.

Though she remained Kandinsky's companion until the outbreak of war in 1914, Münter retained a distinct, highly individual personality and her own philosophy of art. It was, however, as she herself admitted a philosophy which left little room for abstraction. Her very few works of this kind, though painted perhaps in deference to Kandinsky's ideas, betray little resemblance to his pictures.

Lit: Johannes Eichner, *Kandinsky und Gabriele Münter, Von Ursprüngen moderner Kunst*, Munich, [1957]; conversation with Edouard Roditi, in E. Roditi, *Dialogues on Art*, London, 1960; Kandinsky and Franz Marc, *The Blaue Reiter Almanac*, documentary edition by Klaus Lankheit, London/New York, 1974.

235 Study with White Spots 1912
Oil on pasteboard, $15\frac{1}{4} \times 10 (38.5 \times 25.5)$
Städtische Galerie im Lenbachhaus, Munich
(GMS.667)

GEORG MUCHE b.1895

1913–1915 studied in Munich and Berlin. Closely associated with Herwarth Walden, who showed Muche's work at the Sturm gallery from 1916. Active as teacher at the Bauhaus, in Berlin and as professor at the Breslau Academy. His painting 'Large Picture XX' marks an important stage in the development of a post-Cubist abstract vocabulary.

Lit: Horst Richter, *Georg Muche*. Monographien zur Rheinisch-westfälischen Kunst der Gegenwart, vol.18, Recklinghausen: Verlag Aurel Bongers, 1960.

236 Large Picture XX 1915
Oil on canvas, $55\frac{1}{8} \times 37\frac{1}{2} (139.5 \times 96)$
Ludwig Steinfeld, Schlüchtern (Hesse)

237 Joining Together 1914
Pencil, $8\frac{1}{8} \times 4\frac{7}{8} (20.5 \times 12.4)$
Georg Muche

238 Linear Rhythm 1915
Ink and pencil, $15\frac{3}{8} \times 13\frac{3}{8} (39 \times 34)$
Georg Muche

239 With Stressed Diagonal 1916
Ink, $5\frac{1}{2} \times 5\frac{3}{8} (14 \times 13.6)$
Georg Muche

240 Constituent Parts 1916
Ink, $4\frac{7}{8} \times 6\frac{1}{2} (12.5 \times 16.5)$
Georg Muche

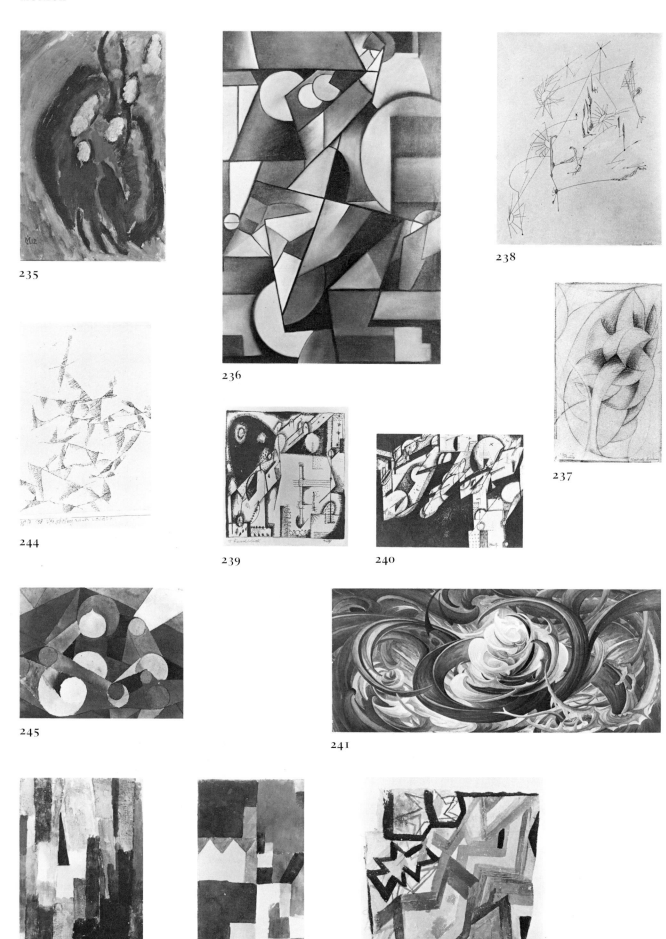

235

236

238

237

244

239

240

245

241

246 247 249

Hans Schmithals 1878–1964

Studied in Munich at the art school run by the *Jugendstil* artists Obrist and Debschitz in the early 1900s. Visited Paris between 1909 and 1911, after which he occupied himself mainly with decorative works and architecture and design. Although Schmithals's works of this period are both representational in origin, being based on motifs such as fire, glaciers and so on, and (usually) decorative in intent, they show clearly the vast potential *Jugendstil* offered for the development of abstraction.

241 **Composition** 1902
Mixed media, $18\frac{3}{4} \times 43 (48 \times 110.5)$
Stadtmuseum, Munich

242 **Triple Rhythm** 1910–12
Mixed media, $16\frac{1}{8} \times 12 (41 \times 30.5)$
Private Collection, Milan

Alexei Von Jawlensky 1864–1941

A student of the Russian Realist painter Ilya Repin at the Petersburg Academy, Jawlensky abandoned a promising military career and, in 1896, travelled to Munich in the company of Marianne von Werefkin, enrolling, like Kandinsky, in the private school run by the Slav painter Anton Ažbè. In 1909 co-founder, with Kandinsky, of the *Neue Künstler-Vereinigung München* (New Artists' Association of Munich), of which Jawlensky became vice-president. Neither he nor Werefkin showed in either of the *Blaue Reiter* exhibitions in Munich (December 1911 and spring 1912), and their work is not represented in the *Blaue Reiter Almanac*. Their names have, however, become associated with the *Blaue Reiter*, partly because Walden showed their work alongside that of the 'Blue Riders' proper – Kandinsky, Marc, etc. – in Berlin in 1913. In 1924 Jawlensky became a member of the group 'The Blue Four', the other members being Kandinsky, Klee and Feininger.

Jawlensky's early work is clearly influenced first by Divisionist colour theories and then by Fauve painting. His 'Fauvist' paintings, with their bright colours and strong contours, in turn briefly influenced Kandinsky's work produced in Munich and in Murnau during the course of 1909. Jawlensky did not, however, follow Kandinsky along the path to consistent abstraction, but rather evolved a very small number of abstract works by a gradual process of simplifying elements of portrait and landscape studies; no.243 belongs to the latter group.

Lit: Clemens Weiler, *Alexej Jawlensky*, Cologne, 1959; *Jawlensky*, Frankfurt, Kunstverein, 1967.

243 **Night** 1916
Oil on paper, $14\frac{3}{4} \times 10\frac{5}{8} (35.5 \times 27)$
Kunstmuseum, Basle, Gift of Hans Gessner, Münchenstein 1941

Paul Klee 1879–1940

Like Kandinsky a pupil of Franz von Stuck at the Munich Academy, after five years spent in Switzerland Klee returned to the Bavarian capital in 1906. In 1911 he joined the *Neue Künstler-Vereinigung München* (New Artists' Association of Munich). In April 1912 he visited Delaunay in Paris; his translation of the French artist's essay 'On Light' appeared in Walden's periodical *Der Sturm* in January 1913, to coincide with the Delaunay retrospective exhibition mounted by the Sturm gallery. In 1914 Klee visited North Africa in the company of August Macke and Louis Moilliet. This experience marks a decisive turning point in his development as a colourist.

Klee was perhaps the most versatile and certainly the most eclectic of the painters associated with the *Blaue Reiter* circle. Even the small number of works in the present exhibition gives some idea of the scope of his leanings: towards primitive art, Cubism, Delaunay's Orphism, Italian Futurism. Like his compatriot Johannes Itten, Klee was quite happy to work simultaneously with abstract and representational means, and refused to see abstraction as an end in itself. None the less, his abstract works of 1915–1916 are remarkable not least for their use of geometric form and often, as in no.245, for their sense of rhythm. (Klee was an accomplished musician, a gift he also had in common with Itten.) A wider selection of abstract works from this period is at present to be seen as part of the exhibition of Klee's early years on show at the Städtische Galerie im Lenbachhaus, Munich.

Lit: Will Grohmann, *Paul Klee*, Stuttgart: W. Kohlhammer, 1954; *The Diaries of Paul Klee*. Edited with an introduction by F. Klee, London: Peter Owen, 1965; Christian Geelhaar, *Paul Klee and the Bauhaus*, Bath: Adams and Dart, 1973; J.S. Pierce, *Paul Klee and Primitive Art*, New York: Garland Publishing, 1976; *Paul Klee, Schriften. Rezensionen und Aufsätze*, hrsg. von Chr. Geelhaar, Cologne: DuMont Buchverlag, 1976; *Klee und Kandinsky. Erinnerung an eine Malerfreundschaft*, Stuttgart, Staatsgalerie, 1979.

244 **Fleeing to Right, Abstract** 1913
Indian ink, $5\frac{5}{8} \times 4\frac{1}{4} (14.2 \times 10.7)$
Kunstmuseum, Berne, Paul Klee Foundation

245 **Dynamism of a Landscape** 1914
Watercolour, $6 \times 7\frac{5}{8} (14.8 \times 19.3)$
Roland Collection

246 **Brown Triangle on a Right-angle** 1915
Watercolour, $8\frac{3}{8} \times 5\frac{1}{4} (21.2 \times 13.2)$
Kunstsammlung Nordrhein-Westfalen, Dusseldorf

247 **Representation of a Town** 1915
Watercolour, $8\frac{1}{8} \times 4\frac{3}{8} (20.4 \times 11.1)$
Private Collection

248 **Monuments on a Slope** 1917
Watercolour, $5 \times 7\frac{1}{2} (12.7 \times 19)$
Private Collection

249 **Coloured and Graphic Angles** 1917
Watercolour, $8\frac{5}{8} \times 8\frac{1}{4} (20.5 \times 19.5)$
Private Collection

Hoelzel and Itten
Peter Vergo

Apart from the artists of the *Blaue Reiter* circle, there were a number of painters who made a significant contribution to the development of abstraction, but whose achievement has been unjustly neglected. In the case of Hoelzel and Itten, their lifelong dedication to teaching has seemed, perhaps, to push their own creative efforts into the background. Each, however, created a significant body of abstract work, and evolved theories about the physiological and psychological effects of colours and forms which helped provide a systematic basis for a rationale of abstract painting.

Even before 1900, Hoelzel made a series of abstract designs which, though clearly decorative in intent, are far more expressive than the for the most part geometric decorations produced by many of his *Jugendstil* contemporaries.[1] In 1901 he published in the Viennese periodical *Ver Sacrum* an essay on the 'pictorial distribution of forms and masses'.[2] Many of his statements regarding the 'abstract' elements of composition and form to be found even in representational painting recall Maurice Denis's celebrated reminder to artists that a painting, before being a nude or a warhorse, was primarily a flat canvas with colours arranged in a certain order and divided up according to certain rules.[3] There is, in any case, an evident relationship between Hoelzel's paintings of the early 1900s and those of the French Symbolists, especially the Nabis, with their search for a monumental, religious art. This relationship was cemented in 1907 when Hoelzel met the 'arch–Nabi', Paul Sérusier, in Stuttgart.

In 1904 Hoelzel published his most important early statement, 'On Means of Artistic Expression'.[4] The following year he succeeded Leopold Graf Kalckreuth as teacher of composition at the Stuttgart Academy. His appointment marks the beginning of even more strenuous efforts to define and systematise the compositional principles of painting. However, many of his most significant observations on form and composition were made in the course of teaching, and only gathered together and published much later by pupils and followers.[5]

Hoelzel's early preoccupations had been line and form. Subsequently, he came to devote far more attention to colour. He acknowledged the importance of Chevreul's experiments with regard to the 'simultaneous contrasts' of colours. His own, primarily intuitive theories were, however, far closer to those of Goethe and Runge. Though based on the usual three pairs of fundamental colour opposites (red and green, blue and orange, yellow and violet),

Hoelzel later 'extended' his colour circle to embrace eight, and then twelve colours, calling the two systems 'diatonic' and 'chromatic' respectively.[6] The terms, he explained, were borrowed from music, since musicians often exploited the vocabulary of painting in a similar way.[7] The importance he came to attach to colour may be judged by his own confession: 'My entire life belongs to colour, to its artistic juxtaposition and handling in painting.'[8]

Hoelzel attracted an extraordinary number of gifted pupils: during the early years Theodor von Hörmann, Emil Nolde; later Ida Kerkovius (after 1905 in Stuttgart), Oskar Schlemmer, Willi Baumeister, Johannes Itten. Itten, who studied with Hoelzel between 1913 and 1916, inherited both his teacher's pedagogical gift and his intense interest in colour. Immediately after completing his studies in Stuttgart, he opened his own school in Vienna, and was the first teacher to arrive at the Bauhaus in Weimar with a fully developed theory of colour.[9] In 1921, by way of an aid to the study of colour, he published the multi-plate colour diagram (lithograph) no.270. Based on the 'colour sphere' devised by Philipp Otto Runge, it symbolises Itten's interest in the paintings and colour theories of the German Romantics. This colour 'star' and the accompanying grid showing the gradations of colours form the basis of many of Itten's abstract paintings. However, like Hoelzel, he never regarded abstraction as an end in itself, and his diaries and sketchbooks show colour diagrams and abstract studies side by side with drawings made from nature and figure studies. The most important parts of his pedagogical method have been published in English under the title *The Elements of Colour*[10] and *Design and Form*.[11] Shortly before his death, Itten paid tribute to Hoelzel's influence as a teacher in an article, 'Adolf Hoelzel and his Circle'.[12]

NOTES

1. Two of these designs are published in Arthur Roessler, *Neu-Dachau. Ludwig Dill, Adolf Hölzel, Arthur Langhammer*, Bielefeld/Leipzig: Velhagen und Klasing, 1905, p.125.

2. 'Uber Formen- und Massenverteilung im Bilde', *Ver Sacrum* IV, 1901, p.243f.

3. 'Se rappeler qu'un tableau – avant d'être un cheval de bataille, une femme nue, ou une quelconque anecdote – est essentiellement une surface plane recouverte de couleurs en un certain ordre assemblées.' See Maurice Denis, *Du symbolisme au classicisme. Théories*, Paris: Hermann, 1964, p.33.

4. 'Uber künstlerische Ausdrucksmittel und deren Verhältnis zu Natur und Bild', *Die Kunst für Alle*, XX Jg., 15 Nov. 1904, pp.18–88; 1 Dec. 1904, pp.121–42.

5. See in particular Maria Lemmé, *Adolf Hölzel, Gedanken und Lehren*, Stuttgart/Berlin, 1933; also Walter Hess, *Das Problem der Farbe in den Selbstzeugnissen moderner Maler*, Munich: Prestel Verlag, 1953, p.91f.

6. See the diagram published in Hess, *loc. cit.*, p.95.

7. *ibid.*, p.96

8. Lemmé, *loc. cit.*, p.24

9. Warmest thanks are due to Frau Anneliese Itten, Zürich, for the hours she sacrificed for the sake of this exhibition, and in order to discuss and explain her husband's work.

10. London/New York 1970. Originally published in German in 1961 under the title *Die Kunst der Farbe*.

11. Revised edition London/New York 1975. Originally published in German in 1963 under the title *Gestaltungs- und Formenlehre*.

12. Johannes Itten, 'Adolf Hölzel und sein Kreis', *Der Pelikan, Zeitschrift der Pelikan – Werke Günther Wagner Hannover*, Heft 65, April 1963, pp.34ff.

ADOLF HOELZEL 1853–1934

Studied at the Vienna Academy and in Munich under the painter W. von Diez, whose influence is reflected in the realism of Hoelzel's early paintings. In 1887 he visited Paris and became acquainted with the work of Monet and Manet; the following year he established himself at Dachau, near Munich, where he devoted himself to landscape painting and (after 1891) to teaching. Appointed to the Stuttgart Academy in 1905 (a post he retained until 1919), Hoelzel gathered around himself a remarkable group of students, several of whom, like Itten (q.v.) were to become teachers at the Bauhaus. In 1914, together with his students, he decorated the foyer of the *Werkbund* exhibition in Cologne with a painted mural (frieze).

'Composition in Red' (no.250) prefigures Hoelzel's paintings of 1914–18 not only in its high level of abstraction, but also in its theme, that of the adoration, which was to occupy a central position within the artist's work. For Hoelzel, the adoration came to symbolise the expressive power of the subject in painting – something which, like Kandinsky, he was unwilling to abandon entirely. Thus the same motifs of the Virgin and Child and group of kneeling figures can still be traced in paintings of *c*.1916–17 (e.g. nos.254, 256) which initially make a highly abstract impression, due principally to the emphasis given to geometric colour areas with heavily stressed outlines. These features, and the decorative effect produced by some of these paintings, also pre-figure Hoelzel's later work in stained glass.

Lit: *Adolf Hölzel, Sein Weg zur Abstraktion*, Stadt Dachau, Schloss zu Dachau, 1972; *Adolf Hölzel, Ölbilder, Pastelle, Zeichnungen*, Pforzheim, Kunst- und Kunstgewerbeverein, 1977; *Adolf Hölzel. Gemälde, Pastelle, Zeichnungen. Ausstellung und Katalog von Hanna Peter*, Stuttgart, Staatsgalerie, 1979; Wolfgang Venzmer, *Adolf Hölzel. Catalogue raisonné* (in preparation).

250 Composition in Red 1905
Oil on canvas, $26\frac{3}{4} \times 33\frac{1}{2} (68 \times 85)$
Pelikan-Kunstsammlung, Hannover

251 Madonna *c*.1914
Oil on pasteboard, $15 \times 11\frac{5}{8} (38 \times 29.5)$
Private Collection

252 Fugue on Theme of Resurrection 1916
Oil on canvas, $33 \times 26\frac{3}{8} (84 \times 67)$
Pelikan-Kunstsammlung, Hannover

253 Fantasy (Abstraction II) 1916
Oil on canvas, $20\frac{1}{2} \times 24 (52 \times 61)$
Staatsgalerie, Stuttgart

254 Adoration *c*.1917
Oil on pasteboard, $7\frac{3}{8} \times 9\frac{5}{8} (18.6 \times 24.5)$
Frau Doris Dieckmann-Hoelzel

255 Adoration, Red Group *c*.1917
Oil on pasteboard, $7\frac{1}{4} \times 9\frac{1}{2} (18.5 \times 24)$
Frau Doris Dieckmann-Hoelzel

256 Geometric Composition *c*.1917
Oil on pasteboard, $7\frac{1}{8} \times 9\frac{1}{2} (18 \times 24)$
Frau Doris Dieckmann-Hoelzel

257 Adoration *c*.1917/18
Oil on card, $12\frac{1}{4} \times 16\frac{1}{2} (31 \times 42)$
Private Collection

258 Colour Composition 1918
Oil on pasteboard, $7\frac{1}{2} \times 9\frac{7}{8} (19 \times 25)$
Private Collection

259 Composition 1912–16
Pen and ink, $5\frac{3}{4} \times 4\frac{3}{8} (14.5 \times 11)$
Pelikan-Kunstsammlung, Hannover

260 Composition 1914
Pen and ink, $3 \times 3\frac{1}{2} (7.5 \times 9)$
Pelikan-Kunstsammlung, Hannover

261 Abstract Division of Space 1914–16
Crayon, $11\frac{1}{8} \times 8\frac{7}{8} (28.4 \times 22.5)$
Pelikan-Kunstsammlung, Hannover

262 Abstract Composition 1916–17
Pencil, $8\frac{1}{2} \times 5\frac{1}{4} (21.5 \times 15.3)$
Pelikan-Kunstsammlung, Hannover

JOHANNES ITTEN 1888–1967

Studied mathematics and science before turning to painting in 1912. A pupil of Adolf Hoelzel (q.v.), Itten devoted the greater part of his life to teaching. He established his own school in Vienna in 1916, and in 1919 was invited by Gropius to take charge of the preliminary courses at the Weimar Bauhaus. It was largely on Itten's initiative that Gropius subsequently invited Muche, Schlemmer, Klee and Kandinsky to join the staff of the Bauhaus. Itten himself, however, was not happy with Bauhaus's growing emphasis on production and design, and left Weimar in 1923, later continuing his activities as a teacher in Berlin, Krefeld and Zürich.

Itten's turn to abstraction has sometimes been ascribed to his mystical leanings, but it was as much a product of his studies of form, begun under Hoelzel, and his interest in

Romantic colour theory. Whereas a watercolour like no.263 is clearly a study in colour and form, a painting such as 'Horizontal-Vertical' (no.265 and the related crayon drawing, no.267) is neither an exercise in colour nor a work to which any decorative or ornamental purpose can be attributed. It is an abstract composition in its own right, and cannot confidently be linked with any representational starting-point. 'Meeting' (no.264), on the other hand, perhaps derives from earlier pencil studies of a winding stone staircase – a suitable place for romantic assignations?

The inscribed drawing, no.268, is a particularly interesting document, since it testifies to Itten's intense interest in music. He was a gifted musician (Paul Klee's father, who was the young Itten's music-teacher, maintained the boy could just as well have turned to music for a career as to painting). Among other subjects, Itten was intrigued by the idea of translating musical structures into visual terms, apparently a topic of heated debate between Itten and the composer J.M. Hauer in Vienna after the First World War. This topic finds visual expression in no.269, where the entwined 'threads' that give the drawing its title are, it seems, those of simultaneously progressing melodic lines. At the same time, there is an evident structural relationship with a work such as 'Meeting' – indeed, the motif of the spiral – like the colour rings and grids – recurs at intervals throughout Itten's creative oeuvre.

Lit: W. Rotzler, *Johannes Itten, Werke und Schriften*. With an oeuvre-catalogue by Anneliese Itten. Zürich: Orell Füssli Verlag, 1972; *Johannes Itten, Bilder und Studien*, Ulm: Kunstverein, 1976.

263 **Study of the Effects of Colour – Depth** 1915
Pencil and watercolour, $10\frac{3}{8} \times 14\frac{1}{2}(26.5 \times 37)$
Anneliese Itten, Zurich

264 **Meeting** 1916
Oil on canvas, $41 \times 31(105 \times 80)$
Kunsthaus, Zurich

265 **Horizontal–Vertical** 1916
Oil on canvas, $29 \times 22(73.7 \times 56)$
Anne-Marie and Victor Loeb Foundation

266 **Study for 'Meeting'** 1915–16
Pencil and watercolour, $15\frac{3}{8} \times 11\frac{3}{8}(39 \times 29)$
Anneliese Itten, Zurich

267 **Horizontal–Vertical** 1917
Crayon, $8\frac{7}{8} \times 9(22.5 \times 23)$
Anneliese Itten, Zurich

268 **Drawing** 1918
Pencil, $11 \times 8\frac{1}{2}(28 \times 21.5)$
Inscribed by the artist: 'Proportion is the plane on which music and painting meet.'
Anneliese Itten, Zurich

269 **Threads** 1918
Crayon, $9 \times 12\frac{1}{4}(23 \times 31)$
Anneliese Itten, Zurich

270 **Colour Sphere in 7 Gradations and 12 Colours**
Published in Bruno Adler (ed.), *Utopia: Dokumente der Wirklichkeit*, Weimar, 1921
Lithograph, $18\frac{3}{4} \times 12\frac{1}{2}(47.5 \times 32)$
Anneliese Itten, Zurich

JOSEPH KÖLSCHBACH 1892–1947

Studied at the Düsseldorf Academy; broke off his studies after seeing the famous Cologne *Sonderbund* exhibition of summer 1912 in order to devote himself to independent work. By this time, he was friendly with both Max Ernst and August Macke, and associated with the group of 'Rhenish Expressionists' who exhibited in Bonn in 1913. In the autumn of the same year, Kölschbach was also represented at Walden's *Erster Deutscher Herbstsalon* in Berlin.

Though friendly with Macke, Kölschbach did not associate with the Munich *Blaue Reiter* circle. He shared, however, many of Kandinsky's interests, including experiments with the technique of painting on glass (*Hinterglasmalerei*), completing a cycle of glass paintings of the twelve apostles, destined for exhibition in Berlin in 1913. There is also a remarkable similarity between Kölschbach's 1912 series of watercolours of 'landscape and figural motifs, abstracted', of which no.271 is one, and Kandinsky's work of the same period, which Macke had perhaps described to him, and examples of which he had certainly seen at the Cologne *Sonderbund* exhibition.

Lit: *Die Rheinischen Expressionisten. August Macke und seine Malerfreunde*, Bonn, Städtisches Kunstmuseum/Recklinghausen: Verlag Aurel Bongers, 1979, pp.211ff.

271 **Untitled** 1912
Watercolour, $13\frac{1}{2} \times 10\frac{3}{4}(34.5 \times 27.5)$
Private Collection

MAX ERNST 1897–1976

From 1913 Max Ernst exhibited with the Rhenish Expressionists; he was familiar with Futurism and Cubism and his paintings fluctuated between these poles and a naive realism until c.1919. His experiments with abstraction were short-lived during the period covered by this exhibition and reached a peak with a handful of works in 1916–17, of which 'Landscape with Tower' is one (no.272).

In 1919, Ernst founded Dada in Cologne with Baargeld, and was joined by Arp in 1920; from 1924 he was a member of the Surrealist Movement in Paris. His Dada works are frequently based on abstract forms treated to look figurative. 'No.272' is an interesting prototype, using synthetic Cubist construction to suggest the presence of architectural forms.

272 **Landscape with Tower** 1916
Oil on canvas, $23\frac{1}{2} \times 17(59.7 \times 43.2)$
Private Collection

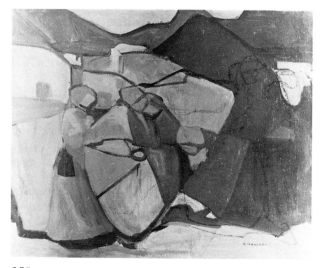

250

252

259

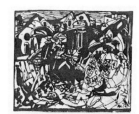

260

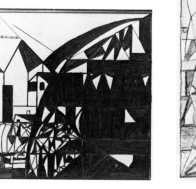

262

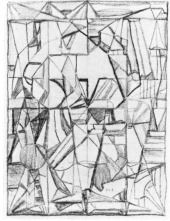

261

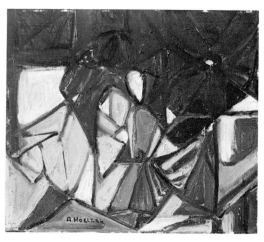

253

269

267

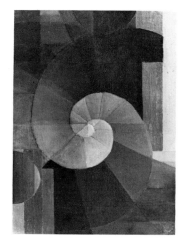

264

Rayonism, Suprematism and Constructivism
Susan Compton

Looking back at the ten years from 1912 to 1922 in Russia one can see in microcosm the whole history of abstract painting. Beginning with the informal, largely abstract, Expressionism represented by paintings which Wassily Kandinsky sent back from Munich to Russian exhibitions, we proceed rapidly to the post-impressionist extreme of Larionov's Rayonism and the dynamic geometry of Malevich's Suprematism. Almost at once we find a second generation, ready to reduce art to a laboratory experiment, to investigate in a scientific way, the properties of picture surface, construction, line and colour.

From 1911 onwards avant-garde exhibitions shocked the critics. Rebels from the *Knave of Diamonds* founded *Donkey's Tail* and *Target* and were in turn ousted by *Tramway V* and *Zero-Ten*. After the political revolutions of 1917 there were fewer fancy names for exhibitions but critics continued to argue about the merits of 'Productivism' or 'Constructivism' versus 'Suprematism'. Indeed, by 1922, at least one young Russian critic decided that easel painting was dead. As one radical innovation followed another with amazing rapidity, it seemed as though artists had reduced painting to a series of formalist devices. Attention shifted from 'meaning' to 'making'.

Today, once more, the first generation of Russian non-representational artists, Kandinsky, Malevich and to some extent Larionov and Goncharova, have come to be distinguished from those who followed them. Recognition is again accorded to the 'content' with which these original inventors of non-objective painting imbued their work. Thus, although in conversation with Alfred Barr in the 1930s, Rodchenko maintained that he was friends with the older artists, contemporaries deny such a rapport, agreeing that his 'materialist' position was deplored by the older artists whose work was intended to express quite other values, in the case of Malevich, often spiritual values.

The choice of artists represented here has been made deliberately to chart the progress of three major approaches to non-objective art within Russia, Rayonism, Suprematism and Constructivism, for Kandinsky has properly been regarded as a Munich artist. Thus Larionov's canvases, beginning with his 'Self Portrait' (no.273) are supplemented by lithographs which show the evolution of Rayonism, which he formulated during 1912 and made public early in 1913 with such paintings as 'Portrait of a Fool' (no.277). To his work is added that of his friend, Goncharova, who also experimented with Rayonism as can be seen in her fine 'Landscape No. 47' (no.296).

Although Malevich had been a close friend of Goncharova in 1911–12 and contributed to Larionov's *Target* exhibition as late as April 1913, during that year he completely rejected their Rayonism. From 'Morning in the Village after Snowfall' (no.304) shown in April, he worked through to 'Woman with Water Pails' (no.308) and 'Head of a Peasant Girl' (no.310), both shown in November. At the same time he was working on Cubist pictures, for he had noted in a letter in May 'I feel no-one in Russia has produced a pure cubist work'. He sent 'Samovar' and 'Completed Portrait of Ivan Klyun' to Paris in March 1914 to remedy the deficiency. In Petrograd in March 1915 his Cubist experiments could be seen to have resulted in a new style, for 'Englishman in Moscow' (no.311) and 'Woman at the Poster Column' (no.312) were both on view there in an exhibition entitled *Tramway V*. The jump from these paintings to his Suprematist style, unveiled publicly at *Zero-Ten, the last futurist exhibition* in December that year, is explained in the breathless letters he wrote to Matyushin. Formally, the alterations he made to 'Black rectangle, Blue triangle' (no.323) before exhibiting it in 1919, allow a clue to the possibility of there having been transitional paintings.

At first Malevich did not simply label his pictures 'Suprematist composition' though he would have been following the lead of both Kandinsky and Larionov who often chose non-descriptive titles for their work. Unfortunately the identification of most of the pictures shown at *Zero-Ten*, (such as nos.320, 321), has proved impossible; however 'Painterly realism of a peasant woman in two dimensions' is a small red, almost-square form, surrounded by a white ground, belonging to the Russian Museum in Leningrad (unfortunately not included in this exhibition). History catches up with the artist so quickly, that when Rodchenko included an almost-square, red canvas in the 5 × 5 = 25 Constructivist exhibition in Moscow in 1921 it was noted that Malevich had 'done it already'. Critics did not notice the difference, that Rodchenko had called his canvas 'Pure red colour' and drawn an analogy with mural painting. In 1915, Malevich had worked from a different premiss. He had explained in the *Zero-Ten* catalogue: 'In naming several pictures, I do not wish to show that one must look for their form in them, but I want to indicate that real forms were looked upon as heaps of formless pictorial masses from which was created a painted picture which has nothing in common with nature.'

One of the best and most influential artists of the period, Tatlin, has had to be excluded from the

exhibition, not only because he was primarily a sculptor but because of the impossibility of obtaining significant works. Rodchenko's own début was sponsored by Tatlin at the *Shop* exhibition which he organised in Moscow in March 1916. Rodchenko showed compass and ruler drawings (no. 331) Malevich was a fellow exhibitor with earlier 'a-logical' canvases, including 'Englishman in Moscow' (no. 311) rather than his current Suprematist pictures. In 1980, Rodchenko's ink drawings will no doubt be linked with Kupka's 'Amorpha' composition and the related drawings, but equally, if not more important for the appreciation of Rodchenko's originality, is the fact that he had learned 'descriptive' geometry in his art training in Kazan and was a passionate admirer of the work of Aubrey Beardsley.

Rodchenko rapidly developed forms of non-objective painting in rivalry to Malevich's Suprematist advances. Although Rodchenko's 'Black on Black' paintings make an interesting antithesis to Malevich's 'White on White' (no. 327), Rodchenko's black inventions seem in retrospect more closely linked to the contemporary fascination for a science-fiction cosmos. In 1920 Evgeny Zamyatin wrote *We* (Penguin Modern Classics 1972) which was not published but was well known among intellectuals; Konstantin Yuon painted the figurative, vividly imagined 'New Planet' (recently on view at *Paris-Moscou*), while El Lissitzky devised fantastic illustrations for Ehrenburg's *Six Tales with Easy Endings* (Berlin, 1922) in which he combined realistic figures flying through space with abstract elements derived from Suprematism.

Perhaps these inventions were a form of escapism from the horrors of civil war and the aftermath of revolution, but against this background the earnest polemics of the protagonists of 'laboratory art', lead by Rodchenko, gain some perspective. In her post-Cubist abstractions (nos. 343, 344) Alexandra Exter investigated forms which grew naturally out of the astonishing set-designs she had made for Tairov's 'Kamerny' theatre from 1916 onwards. Likewise, shortly after the 5 × 5 = 25 exhibition, where she was a co-exhibitor with Exter and Rodchenko, Lyubov Popova was invited to design sets for Meyerhold's revolutionary stage ideas. There is a close link between the form of Popova's linear paintings (nos. 339, 340) and the Constructivist theatre designs she made for Meyerhold in the three years before her untimely death in 1924.

The works by other artists cannot be categorised under the 'umbrella' labels Rayonism, Suprematism or Constructivism. Thus the poet, Elena Guro (who died in 1913) and her husband Mikhail Matyushin were key members of the St Petersburg 'Union of Youth'. The poet Benedikt Livshits left a vivid account of visits to their apartment where Vladimir Burlyuk (who painted his portrait, no. 349) was a frequent visitor. Also active in the 'Union of Youth' was Olga Rozanova who made the remarkable series of collages (nos. 351) which were published early in 1916 by A. Kruchenykh as *Universal War* in an edition of 100 copies.

So rich is the variety of non-objective art produced in Russia before 1921 that exclusions inevitably had to be made, but much of the work on view is secure in attribution and easily dated by reference to contemporary exhibition catalogues, reviews and book illustration. Such material has been used throughout to correct the somewhat fanciful chronology begun as early as 1913, when Russian avant-garde painters and poets, labelled 'Futurists' by critics, determined to antedate their inventions to those of the Italians.

BIBLIOGRAPHY

Camilla Gray: *The Great Experiment in Russian Art 1863–1922*, Thames and Hudson, London, 1962

V. Marcadé: *Le Renouveau de l'art picturale Russe 1863–1914*, L'Age d'Homme, Lausanne, 1971.

Russian Art of the Avant-garde Theory and Criticism 1900–1934 ed. John E. Bowlt, Documents of 20th Century Art, Viking Press, New York, 1976.

K istorrii russkogo avangarda/The Russian Avant-garde, N. Khardzhiev, K. Malevich, M. Matyushin, Hylaea Prints, Stockholm, 1976.

Benedikt Livshits: *The One and a half-eyed Archer*, translated by John E. Bowlt, Oriental Research Partners, Newtonville, Mass. 1977.

Susan Compton: *The World Backwards, Russian Futurist Books 1912–1916*, The British Library, London, 1978.

'Paris-Moscou 1900–1930', Centre Georges Pompidou, Paris, 1979.

Rayonism

MIKHAIL LARIONOV 1881–1964

After graduating from the Moscow School of Painting, Sculpture and Architecture in September 1910, Larionov was obliged to undertake his military conscription which had previously been deferred. Although in the army he was able to continue to paint, he was denied the contact with other artists which was such a feature of his life both before and afterwards. He marked his return to civilian life by holding a one-day exhibition at the Society of Free Aesthetics in Moscow in December 1911.

In spite of Larionov's later attempts to make out that he had been the first artist in Europe to develop a non-representational style, it is not until 1912 that clear evidence of the beginnings of his Rayonism or Rayism are documented. The style of his 'Head of a Soldier' reproduced in the catalogue of the second *Blaue Reiter* exhibition held in Munich in March 1912 anticipates that of his 'Woman at the Window' no. 274 in which a few 'rays' can be seen. Lithographed drawings such as 'Woman at the café table' (no. 276b) show that among other styles he explored a kind of Cubism derived from Léger before rejecting volume in favour of line which is the main constituent of Rayonism.

While contributing a remarkable sequence of inventive illustrations to Russian Futurist books (278–9) Larionov resumed his role of leader of avant-garde painters in Moscow and organised two important exhibitions, *Don-*

key's Tail, March 1912, and *Target*, April 1913. Although he had shown only one or two Rayonist paintings in exhibitions from December 1912, he included five paintings in Rayonist style at the *Target*, among them 'Portrait of a Fool' (no.277). However, Larionov did not relinquish his earlier Neo-primitivism: the 'Four Seasons' in this style were included in the same show. By the end of 1913 he formulated 'Everythingness', while continuing with Rayonism in a form he designated 'Pneumorayonism'.

Larionov was called-up on the outbreak of war in 1914, having hurried back from Paris where his exhibition at the Galerie Paul Guillaume (17–30 June) had been reviewed by Apollinaire. He was discharged from active service through illness in 1915 and, with Goncharova, left Russia for Switzerland where he joined Diaghilev. Thereafter much of his energy was devoted to ballet design with the result that he exhibited less often. Some of his theatrical studies are included to show his changed approach to abstraction (nos.282–4).

By always adopting a polemical stance, Larionov had acted before the war as a spearhead for artists and writers who were trying to develop a modern, Russian style to rival Cubism and Futurism in western Europe. He did not entirely reject the object even in his Rayonist paintings, which he described in 1913 as 'concerned with spatial forms that can arise from the intersection of the reflected rays of different objects, forms chosen by the artist's will', but he insisted on the self-sufficiency of painting 'it has its own forms, colour and timbre'. The artists who were to call themselves Constructivists in 1921 (Rodchenko, Popova and Exter) must have found in Larionov's writings and in such paintings as 'Sea beach' (no.287) and 'Red Rayonism' (no.293) a technical attitude to painting, devoid of philosophical or spiritual aspirations, and therefore an alternative to Malevich's Suprematism.

Lit: Eli Eganbyuri: *Nataliya Goncharova. Mikhail Larionov*, Moscow, 1913 (The introduction is translated, but with interpolations including additional dates not in the original text in *Michel Larionov, une avant-garde explosive* ed. Michel Hoog and Solina de Vigneral, Lausanne, 1978.) Waldemar George: *Michel Larionov*, Paris, 1966. Tatiana Loguine: *Gontcharova et Larionov, cinquante ans à Saint Germain-des-Prés*, Klincksieck, Paris, 1971.

Two main themes have been chosen to illustrate Larionov's work. The first begins with his 'Self Portrait' (no.273) and continues the exploration of forms based on a figure, in works of vertical format. The second theme is more completely non-objective and consists of horizontal pictures. A few known titles including the important early 'Rayonist landscape' (Russian Museum, Leningrad) allow a reading from a basis of landscape or cityscape.

Larionov's 'Self Portrait' is his second version of the subject and was also published among other postcards by Kruchenykh in 1912 (nos.275a, b). It represents Larionov's most advanced Neo-primitive style before he began Rayonism.

273 Self Portrait
 Oil on canvas, 41 × 35 (104 × 89)
 Private Collection, Paris

274 Portrait of a Woman/Woman at the Window
 Oil on canvas, 40⅛ × 33 1/16 (102 × 84)
 Musée National d'art Moderne, Centre Georges Pompidou, Paris (AM.3110P).

275 a. Portrait of A. Kruchenykh 1912
 Transfer lithograph on postcard,
 5⅝ × 3¾ (14.2 × 9.5)
 b. Street 1912
 Transfer lithograph on postcard,
 3¾ × 5⅝ (9.5 × 14.2)
 Victoria and Albert Museum (E.900-1961)

276 a. Young Lady in a Café: a drawing in rayonist style
 Brush with ink on paper, 10 × 5⅜ (25.5 × 13.6)
 b. Woman at the Café Table
 Transfer lithograph on paper,
 7 9/16 × 5¾ (19.1 × 14.5)
 Additional example of lithograph from *Worldbackwards (Mirskontsa)* A. Kruchenykh, V. Khlebnikov, Moscow, November 1912
 Victoria and Albert Museum (E.893 and E.900.1961)

Fig.1

Fig.2

Underlying 'Blue Rayonism' is Larionov's important 'Portrait of a Fool' shown in April 1913 at the *Target* exhibition. He later altered the picture slightly to make the head less readable than it appears in a photograph reproduced in the biography of Larionov (and Goncharova) published in July of that year. Even by then, the dating of this portrait and, by implication, of Larionov's move towards a non-objective style, was confused by an error printed on the cover of the catalogue of the *Union of Youth* exhibition in St Petersburg where 'Portrait of a Fool' was first exhibited, implying that it had taken place in 1911–12 rather than 1912–13 (proved by reviews). However, in Larionov's biography, written by Ilya Zdanevich under the pseudonym Eli Eganbyuri, 'Portrait of a Fool' is dated 1912 while a related drawing is dated 1911 (fig.1). The drawing is much closer in style to the approach adopted by Vladimir Burlyuk in his 'Portrait of Benedikt Livshits' (no.349) which was discussed at the time in terms of Cubism. The delicate tracery of lines on 'Blue Rayonism' today show an advance on the blocks of rays visible in the photograph in Eganbyuri's book (fig.2) which retain the facetting of the related drawing. In its present form (probably achieved in 1913–14) the picture shows Larionov's Rayonism at its best and makes a fascinating contrast with Malevich's 1913 paintings.

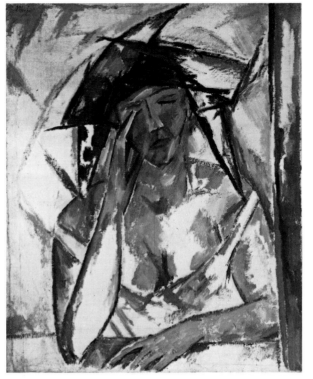

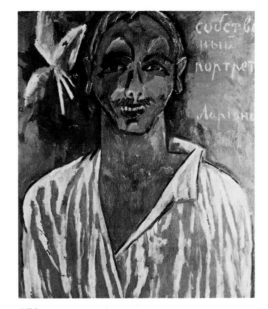

273

275a

275b

274

278b

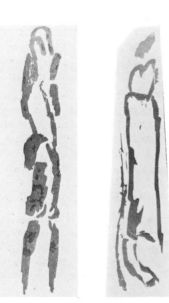

279a–d

277 Blue Rayonism/Portrait of a Fool 1912
Oil on canvas, $27\frac{1}{2} \times 25\frac{5}{8}$ (70 × 65)
Private Collection

**278 a. Untitled
 b. Lady with a hat
 c. Portrait**
Transfer lithographs
Additional examples of illustrations pasted onto gold
paper in A. Kruchenykh: *Pomade* (*Pomada*), Moscow,
Kuzmin and Dolinsky, February, 1913.
 d. Untitled
Print
This print is with a collection of extra prints, which
are surplus illustrations for books, but this one
appears to have remained unpublished.
Victoria and Albert Museum, London (E.900-1961)

279 a-c. Nudes
Additional prints for A. Kruchenykh: *Half-alive* (*Polu-
zhivoi*) Moscow, Kuzmin and Dolinsky, February,
1913
 d. Untitled
Additional print, apparently unpublished
Victoria and Albert Museum, London (E.900-1961)

280 Rayonist Composition No.8 *c.*1913–14
Tempera, $20 \times 14\frac{3}{4}$ (50.8 × 37.5)
Museum of Modern Art, New York, Gift of the artist
(40.36)

281 Rayonist Composition: Head(s) 1913–17
Oil on paper, $27\frac{1}{4} \times 20\frac{1}{2}$ (69.2 × 52.1)
Museum of Modern Art, New York, Gift of the artist
(37.36)

In December 1915 the première of the ballet *Le Soleil de
Nuit* in Geneva marked Larionov's debut as scene designer
for Diaghilev. Associated with his work for the stage are a
group of theatrical studies in an abstract style in which
Larionov adopted both a linear and a volumetric approach.
Thus no.284 represents a direct continuation of Rayonism,
while, at the other extreme, 'Spiral' (no.283) once existed
as a three-dimensional relief.

282 Beacon Light 1915
Gouache,
Philadelphia Museum of Art (41.79.65)

283 Spiral
Tempera, $30\frac{5}{8} \times 21\frac{1}{4}$ (77.7 × 54)
Museum of Modern Art, New York, Gift of the artist
(38.36)

284 Untitled
Pochoir, $12\frac{3}{4} \times 19\frac{3}{4}$ (32.5 × 50.3)
From '*Gontcharova, Larionow, L'Art décorative
théâtrale moderne*', Edition La Cible, Paris 1919
Mary Chamot

The second sequence of Larionov's work begins with a
lithograph (no.285) published in November 1912, which
has double-meanings, like many Russian Futurist book-
titles. Upright, it connects with sabres and graffiti, the
subject-matter of Larionov's many 'Soldiers' paintings.

Sideways, as shown here, the lines anticipate Rayonism,
but the imagery can be interpreted as paleolithic, connect-
ing it to a preoccupation of Russian Futurists, who were
interested in the most ancient times as well as the most
modern. The lithograph has recently been attributed to a
minor artist (Rogovin) but Larionov's signature is visible
along the left-hand edge, here hidden in the binding of the
book.

285 Untitled
Transfer lithograph, $5\frac{7}{8} \times 7\frac{1}{2}$ (15 × 18.6)
Included in A. Kruchenykh and V. Khlebnikov:
Worldbackwards (*Mirskontsa*) Moscow, Kuzmin and
Dolinsky, December 1912.
British Library, London

Because Larionov exhibited a number of works entitled
simply 'Rayonist Construction', it is very difficult to be
precise about the exact date of any work which was not
reproduced in a contemporary catalogue. A photograph of
'Rayonism, Sea-beach' no.287 appears in the catalogue of
the exhibition *No.4* organised by Larionov in March 1914
in Moscow, where it is entitled 'Lady/Beach pneumo-
rayonism'. A tentative order is suggested for the remainder
of this sequence of works, dates are given only where there
is evidence for them, though it seems likely that all
antedate the exhibition which Larionov held in Rome in
Anton Bragaglia's studio, after January 1917 and before
May when he left Italy.

286 Brown and Yellow Rayonism
Oil on canvas, $19\frac{1}{4} \times 24\frac{1}{4}$ (49 × 61.5)
Private Collection, Paris

287 Rayonism, Sea Beach 1913
Oil on canvas, $21\frac{1}{4} \times 27\frac{1}{2}$ (54 × 70)
Galerie Gmurzynska, Cologne

288 Rayonist drawing
Pencil, $9\frac{1}{2} \times 6\frac{1}{2}$ (24.1 × 16.5)
Tate Gallery, London (T.1325)

289 Rayonist Composition: Domination of Red
 1913–14
Oil on canvas, $20\frac{3}{4} \times 28\frac{1}{2}$ (52.7 × 72.4)
Museum of Modern Art, New York, Gift of the artist
1936 (36.36)

290 Rayonist Composition *c.*1916
Gouache, $17\frac{3}{4} \times 22$ (45 × 56)
Galerie Gmurzynska, Cologne

291 Nocturne
Oil on canvas, $19\frac{3}{4} \times 24$ (50 × 61)
Tate Gallery, London (6192)

292 Rayonist Composition No.9 1914–17
Tempera, $10\frac{3}{8} \times 18$ (26.3 × 45.7)
Museum of Modern Art, New York, Gift of the artist
(41.36)

293 Red Rayonism *c.*1914–17
Gouache, $10\frac{5}{8} \times 13$ (27 × 33)
Private Collection, Paris

277

280

281

286

285

283

287

288

289

291

292

293

NATALIYA GONCHAROVA 1881–1962

Nataliya Goncharova is best known for her Neo-primitive paintings and the colourful sets and costumes she made for Diaghilev's production of *Le Coq d'Or* for the 1914 season of *Les Ballets Russes* in Paris. On that occasion Goncharova and her inseparable companion, Larionov, held a small exhibition with catalogue introduction by Apollinaire. He ruefully commented that while avant-garde artists in France received little recognition, in Russia Goncharova had not only been invited to design the ballet but she had also held two successful, enormous retrospective exhibitions.

Catalogues of these exhibitions (Moscow, September 1913 and St Petersburg, March 1914) show that Rayonism was only one of the styles in which she was working. She had been active with Larionov in organising exhibitions and as spokesman at meetings organised in conjunction with them. She always attached importance to the eastern roots of Russian art and insisted that modern Russian art should not associate too closely with western European developments. After she left Russia with Larionov in June 1915 much of her artistic activity was absorbed by working for the theatre.

Lit: Eli Eganbyuri: *Nataliya Goncharova. Mikhail Larionov*, Moscow, 1913.* Mary Chamot: *Goncharova – Stage Designs and Paintings*, Oresko Books, London, 1979. Tatiana Loguine: *Gontcharova et Larionov Cinquante ans à Saint Germain-des-Prés*, Klincksieck, Paris, 1971
*See note under Larionov above.

Fig.4

Fig.5

Fig.3

Fig.6

The subject of 'Trees' has been chosen to illustrate, where possible, Goncharova's experiments in Rayonism and abstraction which, like Larionov's, began in 1912. The lithograph from A. Kruchenykh's book, *Hermits* shows her reaction to contemporary Parisian art, though the re-arrangement of the natural forms of the trees is almost a 'text-book' illustration of the idea of 'shift' (*sdvig*) which Russian futurist poets regarded as an essential ingredient of Cubism. A more original approach can be seen in 'Wood' (fig.3) which was reproduced in a Petersburg miscellany *A Trap for Judges 2* in the same month, February 1913. The same composition is more fully developed in the oil painting 'Landscape No.47' (no.296) which was reproduced with the title 'Wood – Rayonist treatment' in March 1914 in the catalogue of her St Petersburg retrospective.

In the oil painting, the trees of the earlier, printed version are overlapped and broken-up by brush-strokes which double as tree trunks and huge rays. A more extreme version of a 'Rayonist Construction', a title which featured in small groups of works in both 1913 and 1914 catalogues, is a composition, no.297 which preserves the colouring of tree forms. The subject is more distinct in 'Composition – the Forest' (no.299) which may be a project for a theatre décor. It derives from a drawing reproduced in the biography *Nataliya Goncharova. Mikhail Larionov* (fig.4) and a lithograph included in a book of poems by Bolshakov, *Le Futur*, (fig.5) which includes some of Goncharova's most abstract designs (no.300).

Even though she later deplored the extreme stance that Malevich took in his Suprematism, she continued to

explore a form of abstraction derived from natural forms. The most influential example in Russia must be the design she had made for the cover of the *Second Centrifuge Miscellany* (fig.6) which was published in May 1916. This dynamic abstraction, based on the idea of 'centrifugal force' seems to have had a profound effect on the investigations of Alexandra Exter in 1916–17 (no.342) and on the future Constructivists.

294 Trees
Transfer lithograph, $7\frac{11}{16} \times 5\frac{3}{4}$ (19 × 14.5)
Included in A. Kruchenykh: *Hermits: a poem*
(*Pustynniki: poema*) Moscow, Kuzmin and Dolinsky,
January, 1913
British Library, London

295 Rayonist Composition
Pastel, $12\frac{1}{2} \times 8\frac{1}{2}$ (31.7 × 21.5)
Tate Gallery, London (T.1119)

296 Landscape No.47 1913–14
Oil on canvas, $21\frac{1}{2} \times 18\frac{3}{8}$ (54.6 × 46.7)
Museum of Modern Art, New York,
Gift of the artist 1936

297 Rayonist composition
Oil on paper, glued on cardboard,
$19\frac{1}{4} \times 25\frac{1}{4}$ (49 × 64)
Thyssen-Bornemisza Collection, Lugano

298 Untitled 1913–14
Oil on canvas, $16\frac{1}{8} \times 13$ (41 × 33)
Galerie Gmurzynska, Cologne

299 Composition, The forest 1913–14
Oil on canvas, $21\frac{1}{2} \times 31\frac{1}{2}$ (54.6 × 80)
Scottish National Gallery of Modern Art, Edinburgh

300 Untitled 1913
Transfer lithograph, $7\frac{1}{2} \times 6\frac{1}{8}$ (19.9 × 15.5)
Illustration in K. Bolshakov: *Le Futur*, Moscow,
September, 1913
The Library, Victoria and Albert Museum, London.

301 Untitled
Lithograph, $19\frac{3}{4} \times 12\frac{3}{4}$ (50.3 × 32.5)
From *Gontcharova, Larionow, L'Art décorative théâtrale moderne*, La Cible, Paris 1919
Mary Chamot

302 Portrait of Diaghilev 1919
Pochoir, $19\frac{3}{4} \times 12\frac{3}{4}$ (50.3 × 32.5)
From *Gontcharova, Larionow, L'Art décorative théâtrale moderne*, La Cible, Paris 1919
Mary Chamot

303 a. Composition
Watercolour, $11 \times 7\frac{7}{8}$ (28.8 × 20)
b. Composition
Watercolour, $11\frac{1}{8} \times 7\frac{7}{8}$ (28.2 × 20)
Museum of Modern Art, New York, Gift of the artist
(103.36 and 91.36)

Suprematism

KAZIMIR MALEVICH 1878–1935

In 1911 and 1912 Malevich had worked on a series of peasant-subjects with Nataliya Goncharova. He had explored a style based on traditional Russian art, both *lubki* (broadsheets) and *kamennye baby* (ancient stone sculptures). By April 1913 when he first exhibited 'Morning in the Village after Snowfall' (no.304) he had evolved a way of combining these traditional Russian sources with western innovations. Perhaps because it is a snow-scene, of all Malevich's peasant subjects 'Morning in the Village after Snowfall' most nearly prefigures his Suprematist canvases of 1915 with coloured triangles and rectangles on a white ground. It helps to justify his later assertion that Suprematism arose in 1913.

However, it is clear from the illustrations which Malevich made in the summer (nos.305–7) that he explored a variety of styles in 1913. It proved a critical year, for he began thoroughly to study French Cubism after breaking with Larionov, disagreeing with his Rayonism. 'All these sticks of Larionov's and others are an easy thing' he wrote in disgust to Matyushin in May 'I feel no-one in Russia has produced a pure Cubist work.' He succeeded in making faithful Cubist pictures such as 'Samovar' with its almost monochrome colour scheme, but his departure from French art is shown here in 'Head of a Peasant Girl' (no.310) and its related lithograph (no.309).

During 1913 Malevich took an active part in Russian futurist activities culminating in the opera *Victory over the Sun* for which he designed the décor and costumes. His inventive use of colour and lighting astonished his friends for he succeeded in creating magical effects with spotlights, causing arms, legs and heads to appear and disappear in bewildering patches of geometric colour: here indeed lay the beginnings of Suprematism. But during 1914 he combined this experience with his study of Cubism and 'Englishman in Moscow' (no.311) is a most dramatic result. One painting followed another in a remarkable series of carefully calculated compositions in which words and planes increasingly eclipsed the figurative element (no.312).

In strong contrast to these easel paintings are the war propaganda posters and postcards which Malevich made in 1914–15. In them he returned to folk art, literally

Fig.7

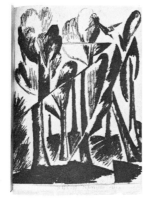

294

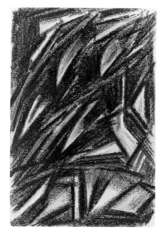

295

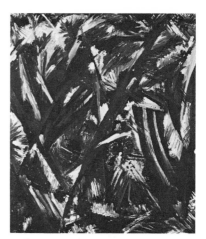

296

297

298

299

300

303a

303b

recreating the style of *lubki* in caricatured figures of an exuberant abandon. The juxtaposition of colours and the scale of the people is arbitrary and stylised, they reveal quite another aspect of Malevich's complex personality. A parallel contradiction can be found in his experimental, semi-abstract drawings of 1914–15 (fig.7) where geometric shapes are related to real objects. These were banished from the Suprematist, geometric paintings he revealed at *Zero-Ten, the last futurist exhibition* which opened on 17 December, 1915.

In the history of abstraction in painting this Petrograd exhibition remains a landmark. In one room Tatlin showed his counter-reliefs, sculptures of basic materials crossing the empty corner-space from one wall to another. In another room Malevich's canvases (nos.318, 320–1) were dominated by his 'Black Square' hung high up on the wall, across the corner. In Russia this position was loaded with added significance, for in an inn an icon was always hung in this way and travellers would bow to it as they crossed the threshold. The 'Black Square' was intended as a landmark, a *tabula rasa*, the signal for a new beginning for painting. Malevich's success can be measured by the fact that it has posed an enigma ever since, and that none of the painted versions of his square have been made available for this exhibition, not even the 'Peasant woman in two dimensions', the small, red square.

Lit: Troels Andersen: *Malevich, catalogue raisonné of the Berlin Exhibition 1927*, Amsterdam, 1970 (including bibliography). Letters in: *Ezhegodnik rukopisnogo otdela pushkinskogo doma na 1974 god*, Leningrad, 1976. *Malevitch Suprematism 34 drawings* reprint: Gordon Fraser, London, 1974. *Kasimir S. Malevič, Scritti* ed. A.B. Nakov, Feltrinelli, Milan, 1977. *Malevitch*, Centre Georges Pompidou, Musée National d'art moderne, Paris, 1978 (including bibliography). *Kasimir Malewitsch zum 100 Geburtstag* (texts in German and English), Galerie Gmurzynska, Cologne, 1978. Larissa A. Shadowa: *Suche und Experiment*, Dresden, 1978. Simon Pugh: 'Suprematism: an unpublished manuscript by Malevich' pp.100–105, *Studio International*, vol.183 no.942 March 1972. Susan P. Compton: 'Malevich and the Fourth dimension pp.189–195, *Studio International*, vol.187 no.965, April, 1974. Susan P. Compton: 'Malevich's Suprematism – The Higher Intuition' pp.576–585, The *Burlington Magazine*, no.88, vol.CXVIII, August, 1976.

The first sequence of work by Malevich culminates in the 'eclipse' paintings which he showed in March 1915 at the *Tramway V* exhibition in Petrograd, nos.311 and 312.

304 Morning in the Village after Snowfall 1913
Oil on canvas, $31\frac{1}{2} \times 31\frac{1}{4}(80 \times 79.5)$
Solomon R. Guggenheim Museum, New York
(FN.1327)

305 Simultaneous Death in an Aeroplane and at the Railway 1913
Lithograph, water-colour, $4\frac{1}{2} \times 6\frac{7}{8}(11.5 \times 17.5)$
Kunstmuseum, Basle, Kupferstichkabinett, Sammlung M. Arp-Hagenbach (1968.414)

306 Prayer 1913
Lithograph, water-colour $6\frac{7}{8} \times 4\frac{1}{2}(17.5 \times 11.5)$
Kunstmuseum, Basle, Kupferstichkabinett, Sammlung M. Arp-Hagenbach (1968.413)

307 Peasant Woman goes for Water 1913
Transfer lithograph, $7\frac{1}{2} \times 5\frac{5}{16}(18.5 \times 13.5)$
In A. Kruchenykh: *Let's Grumble (Vozropshchem)*, (St. Petersburg, EUY) June 1913
British Library, London

308 Woman with Water Pails 1913
Oil on canvas, $31\frac{5}{8} \times 31\frac{5}{8}(80.3 \times 80.3)$
Museum of Modern Art, New York, 1935

309 Peasant Woman 1913
Lithograph, $3\frac{1}{2} \times 5(8.4 \times 12.1)$
Glued to cover of Zina V. and A. Kruchenykh: *Piglets (Porosyata)* (St Petersburg EUY) August, 1913
British Library, London

310 Head of a Peasant Girl 1913
Oil on canvas, $31\frac{1}{2} \times 37\frac{1}{2}(80 \times 95)$
Stedelijk Museum, Amsterdam (A.7673)

311 An Englishman in Moscow 1914
Oil on canvas, $34\frac{5}{8} \times 22\frac{1}{2}(88 \times 57)$
Stedelijk Museum, Amsterdam (A.7656)

312 Woman at the Poster Column 1914
Oil on canvas/collage, $28 \times 25\frac{1}{4}(71 \times 64)$
Stedelijk Museum, Amsterdam (A.7657)

The second sequence has been chosen to show drawings related to a form of composition which Malevich later rejected, no.315. The first, no.313, is inscribed 'Lady' (*Dama*) but, although one of the titles in the catalogue of the *Zero-Ten* exhibition is 'Lady. Colour masses of the fourth and second dimension' it is not possible to identify the painting. The gouache, no.315, is probably a copy from the eighth lithograph in *Suprematism 34 drawings*. After 1923 Malevich included a tiny drawing of the scheme in a manuscript and wrote next to it: 'The next development appears in the different forms of the elongated squares and in no.8 we see the appearance of the curved shape, which later destroys itself and does not play any part and does not enter into any compositional relationship.' (Quoted from *Studio International* March 1972, pp.100–101 where this manuscript was published by Simon Pugh.)

313 Lady
Pencil, $5\frac{3}{4} \times 3\frac{3}{8}(14.7 \times 8.6)$
Musée National d'Art Moderne, Centre Georges Pompidou, Paris (AM.1975.225)

314 Untitled 1914(?)
Pencil, $6\frac{1}{2} \times 4\frac{1}{2}(60.5 \times 11.5)$
Städtische Museum, Mönchengladbach, Etzold Collection

315 Untitled
Gouache, $11\frac{5}{8} \times 8\frac{7}{8}(29.5 \times 22.5)$
Mr and Mrs Ahmet Ertegun

Like 315 in the previous sequence, Malevich later rejected the forms from which he derived the Suprematist painting no.318. He repeated a preparatory drawing (upper right on the sheet of three drawings, no.316) as number 9 in the manuscript referred to above and wrote beside it: 'In

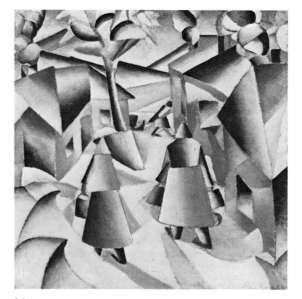

304

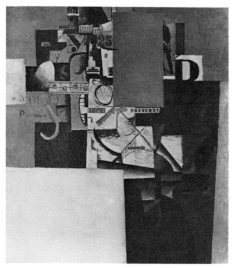

311

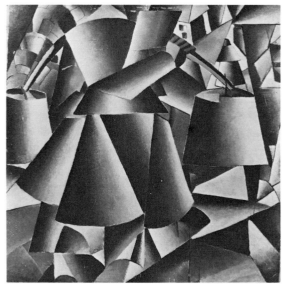

308

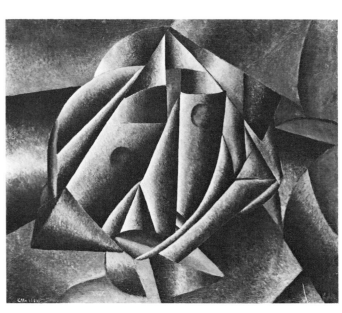

310

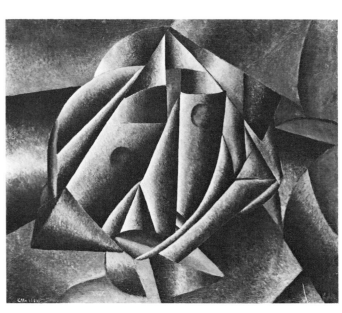

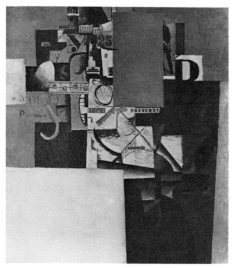

312

number 9 we see a particular composition of the suprematist state of the square dividing into several forms, which later does not evolve.' Nevertheless, hung with the black square at the top as it is shown in the installation photograph of the *Zero-Ten* exhibition, the oil painting no.318 makes a considerable impact. Related to it is the drawing, no.317, which is one of the very few which can be connected to diagrams in C. Howard Hinton's *The Fourth Dimension*, (New York and London, 1904), which was well-known in Malevich's circle.

A clue as to why Malevich rejected these forms lies in the small framed drawing on the sheet of three Suprematist drawings, no.316. It contains the square, circle and cross which he posited as basic to Suprematism but he has arranged them in separate compartments to form a triptych, a sequential hieroglyphic language, or even a design for mural decoration. They reappear in a vertical, rectangular lithograph in *Suprematism 34 drawings* but with the cross arranged at 45° so that it becomes a 'dynamic' form. Malevich saw this dynamism as an essential ingredient for the development of Suprematism beyond the 'static' forms of square and circle and all his 'dynamic' forms are arranged at an angle, not on a vertical or horizontal axis.

316 **Untitled sheet of drawings** *c.*1915.
Pencil, $7\frac{7}{8} \times 9\frac{7}{8} (20 \times 25)$
Galerie Gmurzynska, Cologne

317 **Untitled**
Pencil, $6\frac{1}{4} \times 4\frac{3}{8} (16 \times 11.2)$
Musée d'Art et d'Histoire, Geneva

318 **Suprematist Painting** 1915
Oil on canvas, $31\frac{1}{2} \times 24\frac{1}{2} (80 \times 62)$
Stedelijk Museum, Amsterdam (A.7683)

Malevich rejected the 'third dimension' in all the titles listed in the catalogue of the *Zero-Ten* exhibition and only one of the paintings visible in the installation photograph included an element represented in three dimensions. A drawing, no.319, showing parallelipipeds in axonometric perspective suggests the way Malevich arrived at the dynamic arrangement of 'Eight Red Rectangles' no.320 which hung in the show.

319 **Volumetric suprematist elements** 1915
Pencil, $4 \times 3 (10.2 \times 7.7)$
Museum Ludwig, Cologne

320 **Suprematist Painting, Eight Red Rectangles** 1915
Oil on canvas, $22\frac{5}{8} \times 19 (57.5 \times 48.5)$
Stedelijk Museum, Amsterdam (A.7672)

In composition, 'Aeroplane flying' is related to 'Eight Red Rectangles' and, like it, hung in the *Zero-Ten* exhibition. Confusingly there is no title in the catalogue which includes the word 'aeroplane'.

321 **Aeroplane Flying** 1915
Oil on canvas, $22\frac{5}{8} \times 19 (57.3 \times 48.3)$
Museum of Modern Art, New York (248.35)

A drawing, no.322, shows the triangle and rectangle of the oil painting no.323, but in three-dimensions with the

triangle apparently piercing a thin rectangle. Above it a cube is drawn dynamically extended in space. These ideas are central to contemporary descriptions of the 'fourth dimension', indeed the triangle and rectangle are found in a diagram in C. Bragdon's *Primer of Higher Space (The Fourth Dimension) and Man the Square*, New York, 1913, which was known in Petersburg.

322 **Suprematist Composition**
Pencil, $6\frac{1}{2} \times 4\frac{3}{8} (16.4 \times 11.1)$
Museum Ludwig Cologne

Although there are apparently no known oil paintings by Malevich which could be described as 'transitional' to Suprematism, 'Black rectangle, Blue triangle' no.323, has been altered to the form it has today, which is how it appeared in 1919 when it was photographed in an exhibition installation. Under the white paint next to the blue triangle is the Russian letter 'V' (a roman 'B') and there are two overpainted diagonals leading from each of the two corners of the black rectangle. This makes it tempting to connect the original version of the painting with the exhibition *Tramway V* which would suggest a date early in 1915.

323 **Suprematist Painting, Black Rectangle, Blue Triangle** 1915
Oil on canvas, $22\frac{1}{2} \times 26\frac{1}{4} (57 \times 66.5)$
Stedelijk Museum, Amsterdam (A.7671)

After the exhibition *Zero-Ten* Malevich developed 'dynamic Suprematism' (nos.324–5) before he began to explore the 'fading away' of forms in his series of 'White on White' paintings (no.327) which provoked Rodchenko to his 'Black on Black' compositions in response. Although represented by so few paintings here Malevich exhibited thirty-eight Suprematist works at *Zero-Ten* and fifty-nine two years later at the *Knave of Diamonds* exhibition of March 1917, numbers which convey something of the extent of his inventiveness.

324 **Untitled**
Pencil $7\frac{1}{4} \times 9\frac{1}{2} (18.5 \times 24)$
Galerie Gmurzynska, Cologne

325 **Dynamic Suprematism** 1916
Oil on canvas, $31\frac{5}{8} \times 31\frac{1}{2} (80.3 \times 80)$
Tate Gallery, London (T.2319)

326 **a. Sensation of Fading Away** 1920
b. Dynamic Suprematism 1920
Lithographs on facing pages
In K. Malevich: *Suprematism. 34 Drawings (Suprematizm 34 risunka).* Unovis, Vitebsk, 1920
Private Collection

327 **Suprematist Painting** 1917–18
Oil on canvas, $38\frac{1}{4} \times 27\frac{1}{2} (72.5 \times 51)$
Stedelijk Museum, Amsterdam (A.7666)

328 **On New Systems in Art**
?Transfer lithography
Cover for K. Malevich: *O novykh sistemakh v iskusstve* executed by El Lissitsky. Unovis, Vitebsk, 1919
British Library, London

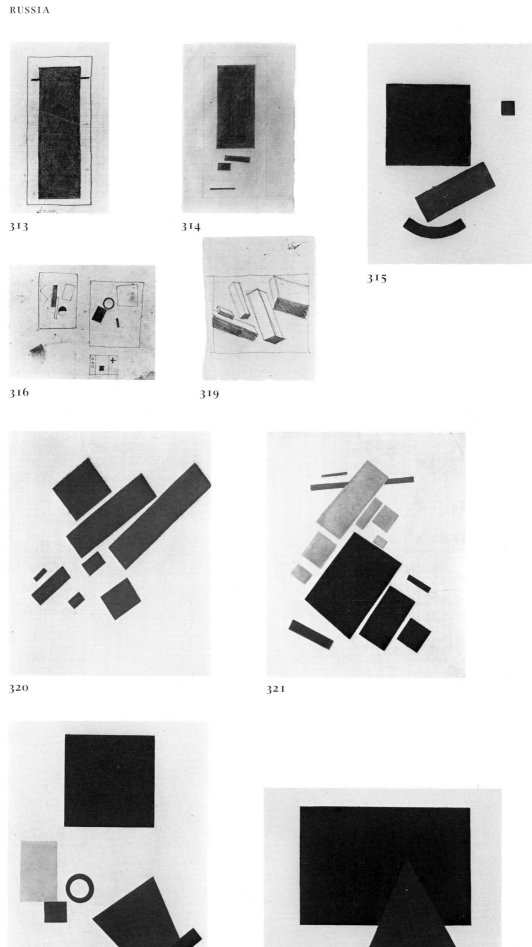

313

314

315

316

319

320

321

318

323

329 Credo
Pencil, $6\frac{1}{2} \times 4\frac{1}{2} (16 \times 11.5)$
Obverse of cover of K. Malevich '*God is not cast down: Art, Church, Factory*', (*Bog ne skinut: Iskusstvo, Tserkov, Fabrika*) Unovis, Vitebsk, 1922
British Library, London

IVAN KLYUN 1878–1942

From 1912–16 Ivan Klyun was a close associate of Malevich who made two portraits of Klyun in 1912 and 1913. Klyun contributed to the exhibitions *Tramway V* (Petrograd, 1915) and *Zero-Ten* (Petrograd, 1915). In the second he exhibited 'pure sculpture' which Malevich later described as an antecedent for the three-dimensional 'Architektons' on which he worked in the 1920s. By that time Klyun had turned away from Suprematism, describing the 'Black Square' as a 'sarcophagus being exposed to public view in the new cemetary of art – the Museum of Pictorial Culture' (Ivan Klyun: 'The Art of Colour' in the catalogue of *Non-Objective Art and Suprematism*, Tenth State Exhibition, Moscow, 1919).

Klyun's group of 'Geometric Forms' (no.330) illustrates the period when he was closest to Malevich and is included as an 'alphabet' of Suprematist forms.

330 Geometric Forms 1917
Oil on paper, 7 works each $10\frac{1}{4} \times 8\frac{3}{4} (27 \times 22.5)$
George Costakis

Constructivism

ALEXANDER RODCHENKO 1891–1956

The tightly organised ruler and compass drawings (no.331) which Rodchenko exhibited at *The Shop* in March 1916 are in strong contradiction to the floating coloured planes of Suprematist paintings which Tatlin had refused to allow Malevich to include in this exhibition. Thus, from this first occasion when he showed work in Moscow, Rodchenko declared an opposing basis for his non-objective work. In 1918 he deliberately rivalled Malevich's 'White on White' canvases (no.327) with his own 'Black on Black' inventions. Rodchenko's forms seem to loom out of the blackness and, in his dynamic compositions he expresses the violence of the cosmos, a black hole rather than the eclipse or the 'fading away' of Malevich's white shapes.

After the political revolutions of 1917, Rodchenko helped to organise the Museum of Artistic Culture in Moscow; in 1919 he became co-director with Olga Rozanova of the Industrial Art Faculty and in 1920 he joined *Inkhuk* (Institute of Artistic Culture). He reorganised the administration of this institute in 1921, advocating Productivism, the mass production of industrial and applied art. In his own work he had begun experiments with constructions which he exhibited in May 1921 before making his final statement as a painter with his wife Stepanova, Lyubov Popova, Alexandra Exter and Alexander Vesnin at the $5 \times 5 = 25$ exhibition in September. There Rodchenko hung pure colour canvases in the three primary colours which he designated the 'last paintings'. However, the design he made for a copy of the catalogue (no.336) shows colour construction applied to line, echoing the extraordinary originality of his linear non-objective paintings (no.333).

Lit: G. Karginov: *Alexander Rodchenko*, Thames and Hudson, London, 1978. *Alexander Rodchenko* ed. David Elliott, Museum of Modern Art Oxford, 1979.

331 Untitled 1916
Indian ink on paper, $15\frac{1}{4} \times 11\frac{3}{4} (39 \times 29)$
Galerie Gmurzynska, Cologne

332 Composition with two circles 1918
Oil on canvas, $9\frac{7}{8} \times 8\frac{1}{2} (25 \times 21.5)$
George Costakis

333 Non-objective Painting 1919
Oil on canvas, $33\frac{1}{4} \times 28 (84.5 \times 71.1)$
Museum of Modern Art, New York, Gift of the artist through Jay Leyda, 1936

334 Untitled *c.* 1919
Oil on wooden board, $15\frac{1}{4} \times 13\frac{1}{2} (38.6 \times 34.2)$
Private Collection

335 Untitled 1920
Oil on panel, $33\frac{1}{4} \times 27\frac{1}{2} (84.5 \times 70)$
Private Collection

335 a. Untitled 1918–20
Oil on card, $18\frac{3}{16} \times 14\frac{3}{16} (46.5 \times 36.5)$
Rosa Esman Gallery and
Adler/Castillo Inc., New York

336 Catalogue cover for '$5 \times 5 = 25$' exhibition, September 1921
Crayon and pencil on paper, $7\frac{7}{16} \times 5\frac{1}{2} (19 \times 14)$
Private Collection

LYUBOV POPOVA 1889–1924

Like Alexandra Exter, Lyubov Popova had first-hand experience of western Europe. She visited Italy in 1910 and studied in Paris with Le Fauconnier and Metzinger during the winter 1912–13. She worked with Tatlin and the future Constructivist, Alexander Vesnin in 1913–15, visiting Paris again in 1914. The remarkable cubist construction, recently on view in the *Paris-Moscou* exhibition (ex-catalogue) showed that she had a far more fully developed understanding of Parisian Cubism than her paintings alone might have suggested.

In 1916 she came under the influence of Malevich after the *Zero-Ten* exhibition but for the most part she continued to compose her non-objective paintings from overlapping forms, ultimately derived from Cubism. Her study of the relationship of colour and construction resulted in 'Pictorial Architectonics' and the gouache, no.337 illustrates her principle of 'rotative dynamics'.

In the arguments which took place between rival factions after the 1917 revolutions, Popova took the part of those who proclaimed 'laboratory art' in the Moscow *Inkhuk* (Institute of Artistic Culture). She joined Rodchenko, Exter, Stepanova and Vesnin to try to provide a 'bridge between art and industry' and their exhibition, entitled $5 \times 5 = 25$, held in Moscow in September 1921 marks the culmination of four years of their 'laboratory' experiments.

$5 \times 5 = 25$ is usually seen as the beginning of Constructivism which Popova developed in her original designs for Meyerhold's theatre productions before her untimely death in 1924.

327

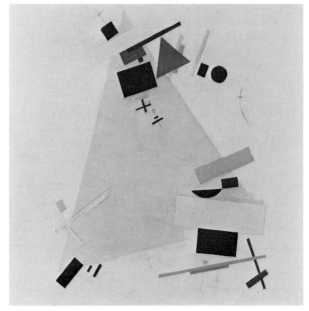

325

322

324

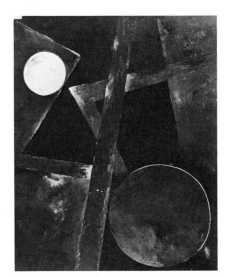

335

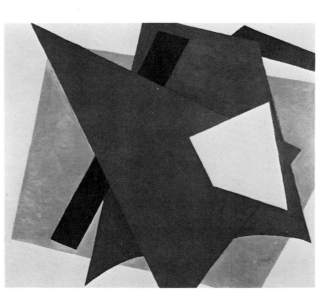

338

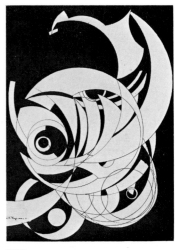

331

337 Non-objective *c.*1917–18
Gouache on paper, $17\frac{5}{16} \times 11\frac{13}{16}(44.5 \times 30)$
Georg Friedrich Weisbrod

338 Architectonic painting
Oil on canvas, $31\frac{1}{2} \times 35\frac{5}{8}(80 \times 90.5)$
Museum of Modern Art, New York,
Philip Johnson Fund 1958

339 Architectonic painting
Oil on canvas, $27\frac{1}{2} \times 17\frac{3}{4}(70 \times 45)$
George Costakis

340 Untitled
Gouache, $16 \times 11\frac{3}{4}(40.5 \times 30)$
Mrs Rachel Adler, New York

341 Cubistic Interior 1913–14
Oil on canvas, $41\frac{9}{16} \times 34\frac{1}{16}(115.5 \times 86.5)$
George Costakis

342 Untitled *c.*1917
Gouache, $25\frac{9}{16} \times 19\frac{11}{16}(65 \times 50)$
Peter Brendel, Uebersee-Chiemsee

343 Colour construction 1921
Oil on canvas $34\frac{5}{8} \times 28\frac{3}{8}(88 \times 72)$
Private Collection, Dusseldorf

344 Dynamics of colour 1921–2
Oil on canvas $41\frac{3}{4} \times 28(106 \times 71)$
Georg Friedrich Weisbrod

The Union of Youth

A number of early pioneers in the development of non-objective art in Russia belonged to the 'Union of Youth,' founded in the autumn of 1909 by avant-garde artists in St Petersburg. Between 1910 and 1914 they organised five exhibitions which attracted Moscow artists, including Larionov and Goncharova, Malevich, David Burlyuk and Alexandra Exter, though they belonged to rival factions within Moscow. The 'Union of Youth' also published three numbers of a journal and sponsored theatrical performances of which *Victory over the Sun* and *Vladimir Mayakovsky, A Tragedy* were the most widely publicised. Because of its relatively stable financial situation the 'Union of Youth' provided an important platform from which artists were able to develop radical ideas and it created a progressive climate in Petersburg which no doubt contributed to the founding in 1913 of the Dobychina gallery, where Goncharova's retrospective was held in 1914 and the first Suprematist paintings were exhibited at *Zero-Ten* in 1915.

The title 'Union of Youth' has therefore been chosen to link the remainder of the artists in this section.

Alexandra Exter 1882–1949

Alexandra Exter's financial independence allowed her to spend part of each year in Europe before the outbreak of war in 1914. She worked in Paris, sharing a studio with Ardengo Soffici in spring 1914, frequented the *Académie Vasiliev* (where Léger gave two important lectures), knew the sculptor Archipenko and recommended that he be given an exhibition in Petersburg. Thus she was in a unique position to inform Russian avant-garde artists about current events in the Paris art world. On her visits to Moscow and Petersburg she brought back with her material evidence in the form of photographs and copies of the journal *Les Soirées de Paris*.

After the outbreak of war in 1914 she changed from the personal, Cubist-based style of 'Cubistic Interior' (no.341) to a much more fully abstracted style, at first dependent on recognisable motifs, but developing into studies of movement and weight (no.342) which anticipate the post-revolutionary 'laboratory' work of Popova and Rodchenko. In these her 'art' work ran parallel to her theatre designs for productions for A. Tairov's 'Kamerny theatre' for which she worked from 1914 until she left Russia in 1923.

Lit: J. Tugendhold: *Alexandra Exter as artist and scene designer*, Berlin, 1922. A.B. Nakov: *Alexandra Exter*, Galerie Jean Chauvelin, Paris, 1972. Susan P. Compton 'Alexandra Exter and the Dynamic Stage', pp.100–102, *Art in America*, September–October 1974, no.5.

Exter's 'Cubistic Interior' (no.341) was reproduced in the *First Journal of Russian Futurists No.1–2 (Pervyi zhurnal russkikh futuristov 1–2)* published before 22 March, 1914. In 1914 she began making illustrations for books and the colour plates in V. Kamensky's *Sun of Wolves (Volchye solntse)* are remarkable. However, by 1917 a portfolio consisting exclusively of her own work was announced by the publishing house 'Centrifuga' (*Tsentrifuga*). No.342 is one of seven gouaches with a page with the imprint 'Centrifuga' of identical dimensions, intended for this portfolio, *Explosion, Movement, Weight (Razryv, Vizhenie, Ves)* which was not printed. These experiments in formal analysis, ran parallel with her theatrical designs, and form a parallel to the similar range of work which Larionov was doing in Switzerland and Rome in 1915–17 (nos.282–284).

Elena Guro 1877–1913

Elena Guro is better known as a writer than as an artist though some of her drawings were included in Russian Futurist miscellanies; they usually show a sequence of progressively more abstracted natural forms.

Lit: Kjeld Bjørnager Jensen *Russian Futurism, Urbanism and Elena Guro*, Arkona, Aarhus, Denmark, 1977.

345 Organic Line
Ink on paper $9\frac{1}{2} \times 6\frac{3}{4}(24 \times 17)$
George Costakis

Mikhail Matyushin 1861–1934

While known as the author of a text on the 'Fourth dimension' and a review of Gleizes and Metzinger's *Du Cubisme* in the *Union of Youth Journal No.3* and even as the composer of the music for the futurist opera *Victory over the Sun*, Matyushin is perhaps less well-known as an artist. With his wife, Elena Guro, he was active in sponsoring avant-garde writers and artists and he set up his own

printing imprint, 'Zhuravl'. He became more and more interested in the visual arts and after the revolutions of 1917 he became a professor at the Free Art Studios in Petersburg. Although he was a friend of Malevich he developed a totally different form of non-objective painting based on nature and 'the widening of vision'.

Lit: Alla Povelikhina 'Matyushin's Spatial System' in *The Isms of Art in Russia 1907–30*, Galerie Gmurzynska, Cologne, 1977.

346 **Spherical Structure (Usikirkko)** 1916
Water colour, $8\frac{1}{4} \times 11\frac{3}{4}(21 \times 29.7)$
Galerie Gmurzynska, Cologne

347 **Lake, enlargement of field of vision** 1916
Watercolour, $8\frac{1}{4} \times 12\frac{1}{8}(21 \times 30.8)$
Galerie Gmurzynska, Cologne

348 **a. Noise-note** (*zvukoshut*) 1921
Charcoal, $8\frac{3}{4} \times 14\frac{1}{4}(23 \times 37)$
b. Noise-note (*zvukoshut*) 1921
Charcoal, $14\frac{1}{4} \times 8\frac{7}{8}(36 \times 22.4)$
Galerie Gmurzynska, Cologne

VLADIMIR BURLYUK 1886–1917

Vladimir Burlyuk studied art in Petersburg and was a frequent visitor at the home of Guro and Matyushin according to the memoirs of Benedikt Livshits whose portrait he painted in 1911 (no.349). Livshits describes his visit to the Burlyuk brothers' home in south Russia, telling how Vladimir and David 'Picassoed' their latest work by rubbing the canvases in the dirt to give them texture. Vladimir evolved a personal route towards abstraction though little of his work is extant today and knowledge rests on photographs and illustrations.

349 **Portrait of Benedikt Livshits** 1911
Oil on canvas, $17\frac{3}{4} \times 11(45 \times 28)$
Ella Jaffé Freidus, New York

The 'Dancer' (no.350) has been attributed by the Städtische Galerie to Vladimir Burlyuk, but only on the basis of its style. A reattribution to Vladimir's brother, David, is suggested here because in 1962 David Burlyuk exhibited an almost identical 'Dancer' in New York which he called: '*Tänzerin 1960, idea from 1910*'. Like other emigré artists, David painted new versions of his own early subjects, however there is no reason to suppose he would have stolen this idea from his younger brother. Although active in the 'Hylaea' group in Moscow where he lived, David exhibited in four of the five 'Union of Youth' exhibitions in Petersburg between 1910 and 1914.

350 **Dancer** *c.*1910
Oil on canvas, $39\frac{3}{8} \times 24(100 \times 61)$
Städtische Galerie im Lenbachhaus, Munich
(G.12 532)

OLGA ROZANOVA 1886–1918

Olga Rozanova was an active member of the 'Union of Youth'. Her essay 'Concerning the Principles of New Art' was published in the union's third journal in March 1913 and illustrated by early attempts to make her art more abstract. In the introductory page to his book *Universal War* the poet Alexei Kruchenykh paid tribute to Rozanova, with whom he had collaborated on so many books, citing her art as an anticipation of Suprematism. Scholarly opinion is divided on whether the sequence of ravishing collages in this book (no.351) were in fact made by the poet or the artist (who had lived with him for several years). Looking at all the other books which Kruchenykh made before and afterwards without Rozanova's participation and looking at the paintings by Rozanova in non-objective style, mainly preserved in the Soviet Union, it seems impossible to believe that Kruchenykh did more than wield the glue-brush. Since Rozanova died suddenly in 1918 proof may be hard to find.

351 **Universal War**
Cover, title page and twelve collages on blue paper, $9 \times 13(23 \times 33)$.
Made for A. Kruchenykh's *Universal War* (*Vselenskaya voina*) Petrograd, February, 1916. Edition of 100 copies.
Mr and Mrs Edgar H. Brunner

ARISTARKH LENTULOV 1882–1943

One painting by Aristarkh Lentulov has been included as a post-script to this section as an example of a quite different approach to abstract painting in Russia. Lentulov had studied in St Petersburg from 1905–10 but he was never a member of the 'Union of Youth'. He is best known as a founder of the Moscow *Knave of Diamonds* exhibitions, of which the first took place in December 1910–January 1911. Lentulov was in Paris in 1911, working in LeFauconnier's studio, and, over the next few years, he developed a personal style. His paintings were more abstract than those of other *Knave of Diamonds* artists, who were accused of 'Cézannisme' by progressive Moscow artists, particularly Goncharova and Larionov.

The 'Landscape of Kislovod' represents Lentulov's most extreme abstract style, but it is an abstraction from nature rather than a 'non-objective' painting. The distinction is crucial to the appreciation of the achievement of all the other artists included in the Russian section.

351 **a. Landscape of Kislovod** *c.*1916
Oil on canvas
Národní Galerie, Prague

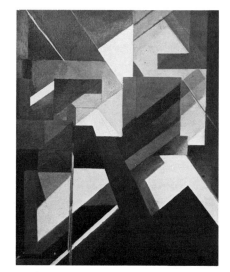

343

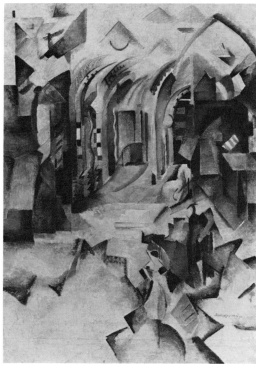

341

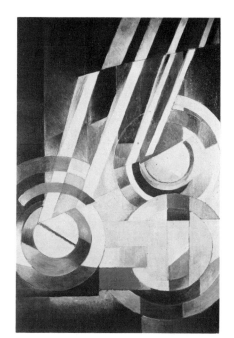

344

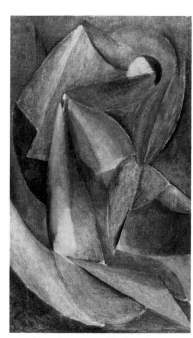

346

347

350

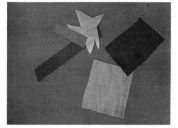

351

The Italians: from Futurism towards Abstraction
Christopher Green

Of the Italians it was the Futurists who came closest to abstraction between 1910 and 1920. Yet, their painting began and ended with a passionate commitment to life at its most immediate as well as up-to-date. For them, abstraction was a means of conveying with special intensity the essence of certain kinds of experience; it was never detached from the everyday. As early as April 1910 the *Technical Manifesto of Futurist Painting* announced the Futurist painters' faith in live, 'dynamic sensation'. Umberto Boccioni, Giacomo Balla and Gino Severini, the three Futurists to sign the *Technical Manifesto* who were to come closest to abstraction, all had emerged from Neo-Impressionism's long Indian summer in the first decade of the century; none of them was to lose the faith it gave them in the evidence of their senses, at least before 1914.

Futurist painting in 1910 and 1911 was indeed concerned with the mobility of reality as it strikes the retina, but Boccioni especially involved himself in the communication of mental and emotional states, and it was this updated Symbolist commitment that took him his first steps in the direction of abstraction. Internal states required more than merely representational means of expression, as Boccioni saw it, and he invented the internationally contagious notion of 'force-lines' to supply his need. 'Force-lines', teamed up with zones and touches of colour were, he claimed in February 1912, to 'guide and augment the emotion of the spectator,' like music.

Boccioni's comments on 'force-lines' were designed for the visitors to the first Futurist exhibition in Paris. Severini had been in Paris since 1906 and the poet F.T. Marinetti, leader of the Futurists, belonged as much there as in Italy, but it was only briefly in 1911 and then with the exhibition in 1912 that the Milanese Futurist painters, most memorably Boccioni and Carlo Carrà, could take on French Cubism face to face. With the inevitable attacks came more covert collusion, and Parisian talk of 'pure painting' undoubtedly pulled Boccioni further towards abstraction, with, alongside him, eagerly aware of his 'force-lines' in theory and practice, Severini.

By the time Boccioni made his move towards 'pure painting' as clear in his work as in his words, Severini had made his move too. During the summer of 1912 Severini produced a scintillating series of pictures on dancer themes, combining Cubist dislocations with Futurist cinematic repetitions to capture the noisy athleticism of Parisian dance-halls. After a short Italian interlude, he took these still literal interpretations of movement to far purer

conclusions, searching for rhythmic combinations of contrasting lines and colours to convey the energy of his subject more by equivalence. Successive elliptical curves and clashing coloured surfaces create cacaphonic sensations whose origin in direct experience is left unconcealed; Severini's dancers catch the eye far more insistently than, for instance, the Eiffel Tower axes of Delaunay's 'Window' paintings. Yet, that Severini thought of these paintings in 'pure' terms is plain from the catalogue-statement he published when they were shown for the first time in London in 1913. He saw them as 'plastic rhythms', the outcome of 'an overpowering need for abstraction', and, though Apollinaire was partly responsible for that 'need', the images it generated anticipate at least one Parisian sally into 'pure painting', Léger's 'Contrasting Forms' of a few months later.

Severini's 'Dancer' paintings of 1912-13 are intensely physical – they communicate the force of physical sensations rather than emotional states; in the same way, Boccioni's move towards greater 'purity' went with a shift towards a more physical brand of dynamism, less obviously concerned with emotion than his early exploration of 'force-lines' had been. He made his move more with sculpture than with painting, most memorably with the drawings and sculptures on the theme of a striding figure which led up to the star-turn of his Futurist sculpture exhibition of June 1913 in Paris, his 'Unique Forms of Continuity in Space'. From these were spawned the ambitious painting 'Dynamism of a Football Player' and, probably at the end of the year, 'Dynamism of a Human-Body' (one of two related paintings) (no. 355).

Boccioni's aim in this sequence of two- and three-dimensional images was to express movement, just as Severini's was; but his human vehicle for movement possessed an irresistible mechanised power altogether alien to the frivolity of Severini's dancers – even when playing football, it was the Nietzschian super-man brought up-to-date; at the same time, Boccioni approached his mobile subjects in his own way. Purloining the terminology of Henri Bergson (a philosopher of profound importance to the French 'pure painters' too), he wrote of his desire to capture in his art the 'absolute movement' of his subject, its inner dynamism, along with its 'relative movement', its constantly changing relationship to its surroundings. 'State of mind' was a crucial part of inner dynamism (absolute movement), but, in no sense sentimental, this was subsumed in images of great physical power where what Boccioni now called

'force-forms' rather than 'force-lines' fused together the figure and the swirling atmosphere through which it thrust. Behind these renderings of unstoppable action lay, among other stimuli, the photographic attempts to record the essence of actual movement made by the physiologist Etienne Marey and the Futurist's ally Anton Giulio Bragaglia, but Boccioni himself insisted that his means were *not* representational. His search was for pure forms which would, without mere imitation, express the continuity of movement – 'the unique forms of continuity in space'. The subject remained central to his art, but he aimed to express the dynamism of his experience of it by means no longer in debt to observation. And this too was his aim when, in 1914, he turned to another subject whose dynamism had long appealed to him, the horse at a gallop, producing a further series of drawings and paintings accompanied by a single relief construction (nos. 357–360).

The 'Horse' series of 1914 is concerned not only with movement but also with the conflict between the environment and the horse that cleaves through it; such conflicts were perhaps more obviously and consistently the concern of Balla when he, like Boccioni and Severini, took up the expression of motion. Balla might have been both Boccioni's and Severini's teacher (their guide into Neo-Impressionism), and he might have signed the painters' *Technical Manifesto* in 1910, but, older than them and based in Rome, he remained on the peripheries of the Futurist movement, even if his art came to express its central concerns with such concentrated conviction.

His earliest fully Futurist work did not appear until 1912, but from that moment forward he focused on the problem of movement and its depiction. At first, immensely impressed by Marey's and Bragaglia's photographs, his was an even more literal cinematic approach than Severini's had been in his earlier 'Dancers', and it was only with a return to the long-standing Neo-Impressionist concern, colour and light, that he began to think of depicting movement in abstract terms. First in Düsseldorf late in 1912, then back in Rome, he made a series of watercolours and oils which he called 'Iridescent Interpenetrations' (nos. 364–366). It had always been Neo-Impressionist practice to translate sensations of light into purely pictorial terms – dots and dabs of unmixed colour – but here Balla worked in an unprecedentedly abstract way with interlocking geometric shapes, trying one luminous colour-combination after another without the slightest hint of a specific subject. These were essentially experimental paintings, apparently not made for exhibition (though a decorative purpose might have been envisaged at first), but they certainly helped to convince Balla that even where he retained a recognisable subject-matter he could convey the essence of its dynamism by the purest of pictorial means.

His earliest mobile subjects had hardly been modern – a violinist, a dachshund, his daughter – but in 1913, alongside studies of the swerving flight of swallows, he turned to a throughly modern subject; the Fiat Type-1. His aim in the drawings and paintings he produced to celebrate this speedy little box on wheels was, as he put it in 1915, 'to discover (the) laws and essential linear forces' of its thrust through space. Partly by abstracting from cinematically successive images of body-work and wheels, partly by imposing a dynamic angular system of planes, he arrived at increasingly pure expressions of the car at speed and the environment that it penetrates (nos. 367–370). By now, of course, he knew of Boccioni's 'force forms', and it could be said, not altogether unjustly, that Balla was sucked into his dynamic abstract style in the slip-stream of his one-time pupil's striding super-man. But he arrived at his abstractions of velocity in comparative isolation by intensive experiment, and he reached a degree of purity far beyond Boccioni.

1913 was the year of Futurism's apogee, but the end of that year and the first months of 1914 saw a couple of final contributions to the Futurist exploration of abstract expression. Late in 1913 Severini wrote a manifesto (not published at the time) which began: 'We wish to enclose the universe in a work of art. Objects no longer exist;' it was he who was to make these contributions. Marinetti's notion of analogy, whereby the poet was to bring together distant ideas by an imaginative leap comparable with wireless, this was the key to one of Severini's new departures – his analogy paintings. Probably while convalescing at Anzio, he painted 'Sea = Dancer', the sight of the waves beating rhythmically on the beach reminding him of the dancers whose vitality he had loved for so long. His formal and chromatic means had, however, become far purer than in the earlier 'Dancer' series, creating far freer associative possibilities, and it was thus that his fusion of sea and dancer could generate yet another analogy given extravagant pictorial expression in 'Dancer + Sea = Vase of Flowers' (no. 363). Dependent conceptually on Marinetti's thinking they might have been, but these were a unique addition to Futurist painting; less unique was perhaps Severini's purest abstract series, painted on the theme of the 'spherical expansion of light' in 1914 (no. 362). They are his brilliant riposte to Delaunay's 'Circular Forms' paintings and to Balla's 'Iridescent Interpenetrations'.

Futurism did not die with the outbreak of the War its leaders had always wanted, and Balla in particular, joined by a new ally in Fortunato Depero, took his exploration of the abstract equivalents for speed even further, opening them out, literally, into three dimensions with wire constructions of prophetic novelty. But the movement lost its leaders among the painters and with them its momentum. Boccioni was lost to death in 1916, Severini to a species of synthetic Cubism and Carrà to the mysterious meta-

physics of Giorgio de Chirico. There was just one other significant and original Italian addition to the history of abstract painting during the Great War, and this came from an unexpected, independent source, the Florentine painter, Alberto Magnelli. Through 1913, in contact with the circle around the Futurist periodical *Lacerba*, Magnelli was responsive to the movement, but he was more responsive to the Parisian 'avant-garde' when he arrived in the French capital early in 1914. On this visit he met Apollinaire, Picasso, Léger and Archipenko among others, and

Parisian notions of 'pure painting' lie deep behind the series of numbered compositions that he produced back in Florence in 1915 (no.371). A process of abstracting combined with the imposition of a 'pure' formal vocabulary took him far from representation in these canvases, and, for all their unusualness, their Delaunay-like colour gives them an unmistakable Francophile quality. They were, with their far less Delaunay-like successors, the 'Lyrical Explosions'(no.372), the very last Italian echoes of Orphism.

Umberto Boccioni 1882–1916

The studies nos.352–354 were probably made either at the time of or just after the completion of Boccioni's major sculpture, 'The Unique Forms of Continuity in Space'. Nos.353 and 354 are directly related to a large painting, 'Dynamism of a Footballer' (Collection Sidney Janis, New York), which was worked on for much of 1913. All are attempts to convey the unity and continuity of a single sequence of actions without breaking them down into successive stages, although there are hints at cinematic repetition in the treatment of the legs in nos.353 and 354. The straight lines that penetrate the figures from outside in nos.352 and 353 express the direction of their movement and the space through which they pass. No.354 demonstrates the high degree of abstraction that Boccioni achieved in pursuit of his goal. The painting, 'Dynamism of a Human Body II' (no.355), is one of the pictorial products of studies of this kind. It is one of a pair, the other (not in the exhibition) being closer to the studies shown and more abstract. However, it is memorable as a manifestation of Boccioni's irrepressible daring, attempting the far more difficult feat of conveying the motion of a figure rushing towards the spectator.

352 Dynamism of a Human Body 1913
Ink, $5 \times 4\frac{1}{4}(12.7 \times 10.3)$
Civiche Raccolte d'Arte, Gabinetto dei Disegni, Milan

353 Dynamism of a Human Body 1913
Ink, $8\frac{1}{4} \times 12\frac{1}{4}(21.2 \times 31.1)$
Civiche Raccolte d'Arte, Gabinetto dei Disegni, Milan

354 Figure Study 1913
Charcoal and ink,
$11\frac{1}{2} \times 9(29.3 \times 22.9)$
Civiche Raccolte d'Arte, Gabinetto dei Disegni, Milan

355 Dynamism of a Human Body II 1913
Oil on canvas, $31\frac{1}{2} \times 25\frac{3}{4}(80 \times 65)$
Civica Galleria d'Arte Moderna, Milan

During 1912 Boccioni had attempted to give dynamic expression to static subjects – seated figures and, notoriously, a bottle – in order to convey the movement he believed to be inherent in all things as we experience them. This is a later treatment of the same theme. Its brilliant

colour and rotating composition demands comparison with Léger's contemporary 'Contrasting Forms' (nos. 38–39), and with his equally dynamic interpretation of still life subjects (no.40).

356 Still Life with Melon 1913
Oil on canvas, $31\frac{5}{8} \times 31\frac{5}{8}(80.3 \times 80.3)$
Kunstmuseum Hannover mit Sammlung Sprengel, Hannover

The studies nos.357–359 and related painting no.360 on the theme of the horse at a gallop were probably the work of 1914. The horse was a recurrent theme in Boccioni's Futurist painting: in 1910–11 as the tireless force behind the city's construction ('The City Rises', The Museum of Modern Art, New York), in 1912 as an efficient and swift vehicle of transport ('Elasticity', Collection Dr Riccardo Jucker, Milan), and here as the irresistible expression of the thrill of speed. Bred to function to the optimum in the service of man, often treated as a machine in fact as in science and art, before the Great War the horse was not so anachronistic an image for a Futurist to exploit as it seems now. Using the dynamic forms evolved in the figure compositions of 1913 Boccioni conveys once again the unity and continuity of the horse's action, the angular forms that stand for houses in the studies recalling Balla's use of such forms in his slightly earlier expressions of automobile velocity (nos.367,368). 'Plastic Forms of a Horse (no.360) is one of Boccioni's most uncompromisingly abstract and most explosive images of dynamism, equestrian or human.

357 Linear Study for Horse + Rider + Houses 1914
Ink, $4\frac{1}{4} \times 6\frac{1}{4} 10.4 \times 15.7)$
Civiche Raccolte d'Arte, Gabinetto dei Disegni, Milan

358 Study No.1 for Plastic Dynamism of Horse + Houses 1914
Ink, $8 \times 12(20.3 \times 30.4)$
Civiche Raccolte d'Arte, Gabinetto dei Disegni, Milan

359 Study No.4 for Horse + Houses 1914
Ink, and watercolour, $5\frac{1}{4} \times 8\frac{3}{8}(13.4 \times 21.3)$
Civiche Raccolte d'Arte, Gabinetto dei Disegni, Milan

360 Plastic Forms of a Horse 1914
Oil on canvas, $15\frac{3}{4} \times 15\frac{3}{4}(40 \times 40)$
Dr Luigi Sprovieri

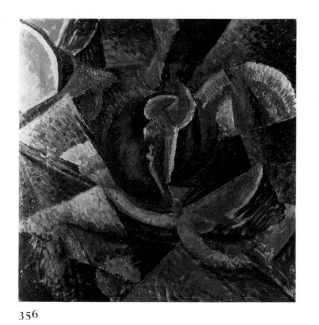

356

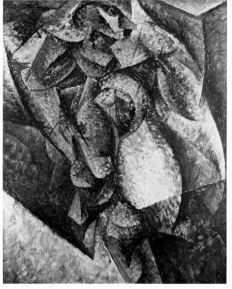

355

361

362

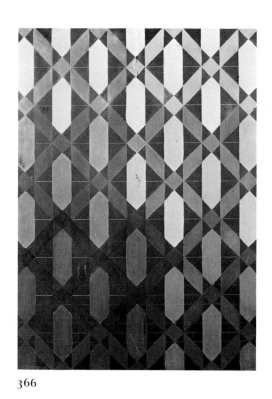

366

364

365

CARLO CARRA 1881–1966

Painted in 1912 after Carrà had returned to Milan from the Futurist exhibition in Paris, 'Rhythms of Objects' both levels against the Cubism of Picasso and Braque acute criticisms and depends on that richly influential style's innovations. Objects, including glasses and a soda syphon, are pulled apart and enmeshed in a web of lines which fragments the entire surface of the canvas much as in the paintings of Picasso and Braque of 1911. Yet, Carrà attempts to develop a rocking rhythm of curves, swivelling in and out of the illusion of shallow space, so as to pull the objects together in perpetual movement, a comment on the static quality that the Futurists found so unacceptable in Cubism – a comment made all the more apt by the classic Cubist subject, still life.

361 **Rhythms of Objects** 1912
Oil on canvas, $20\frac{3}{4} \times 26\frac{1}{4}(52.5 \times 66.5)$
Pinacoteca di Brera, Milan,
Donazione Emilio e Maria Jesi

GINO SEVERINI 1883–1966

Severini came close to abstraction at the turn of 1912–13, but these two paintings (nos. 362 and 363) represent his most extreme efforts. 'Centrifugal Expansion of Light' (no. 362) is one of a group of paintings whose rotating compositions and directly contrasted primary and secondary colours were designed to create a dynamic effect expressive of the expansion of light from a central source. 'Dancer + Sea = Vase of Flowers' (no. 363) has the same luminous brilliance, but, implicitly through its suggestive formal combinations, and directly through its title it creates not only a perpetually fluctuating sensation of colours changing in relation to one another, but also a variable, interpenetrating set of associations (marine, figurative and floral). The eye is stimulated to move and so is the mind, and on both levels Severini uses highly abstracted means, the culmination of an exploration of pictorial dynamism whose origins lay in far more explicit interpretations of dance and dancers. The parents of the present owner once recalled that Severini said of no. 363 that he was sitting on the sand when a troupe of dancers arrived for practice, dancing on the packed sand with many coloured chiffon scarves. The idea struck him of the waves and the movements of dancers and scarves as making a flower life composition . . . hence the title.

362 **Centrifugal Expansion of Light** 1914
Oil on canvas, $27\frac{1}{2} \times 19\frac{3}{4}(70 \times 50)$
E. Nahmad, Davlyn Gallery, London

363 **Dancer + Sea = Vase of Flowers** 1914
Oil on canvas with aluminium replacing original tin,
$36\frac{1}{4} \times 23\frac{5}{8}(92 \times 60)$
Private Collection, New York

GIACOMO BALLA 1871–1958

Late in 1912 (probably in November) Balla wrote to his family from Dusseldorf, where he had been engaged in painting murals on commission, sending them a tiny colour study related in kind to the two watercolours

(nos. 364 and 365) and asking them to 'enjoy a little bit of iridescence'. Through 1913 and 1914 he continued to make such studies, including those on exhibition, and a whole series of paintings, of which 'Iridescent Interpenetration No. 13' (no. 366) is one. The murals for the Lowenstein family in Düsseldorf were not abstract, but the fact that the first such experiments were made while Balla was working on decorations have suggested an initial decorative intention, and there are obvious connections between the repeated geometric shapes of the 'Iridescent Interpenetrations' and the ornamental abstract devices used by the designers of the Viennese Secession in the first decade of the century. It is, at the least, unlikely that these compositions were conceived of as self-sufficient easel-paintings for exhibition. Yet, at the same time, they evolved directly from Balla's earlier Neo-Impressionist painting, and in particular from his attempt to express by means of abstract chevrons of colour the light of one of the first electric street-lamps to be installed in Rome, his 'Street-Lamp' (The Museum of Modern Art, New York), dated by himself 1909–10, but possibly not painted until early 1912. Again, the quantity of such studies and paintings indicated how important they were to Balla, and they remain among the most remarkable fore-runners of modern geometric abstract art.

364 **Study for Iridescent Interpenetration No. 12** 1914
Watercolour, $6\frac{1}{2} \times 5\frac{1}{4}(16.5 \times 13.5)$
Museo Civico, Turin

365 **Study for Iridescent Interpenetration No. 14** 1914
Watercolour, $8\frac{5}{8} \times 7\frac{1}{8}(22 \times 18)$
Museo Civico, Turin

366 **Iridescent Interpenetration No. 13** 1914
Oil on canvas, $37 \times 28\frac{3}{8}(94 \times 72)$
Museo Civico, Turin

Since the beginning of his active commitment as a painter to Futurist aims (strictly speaking 1912 rather than 1910), Balla had been engaged in the expression of high-speed physical movement. In 1913 he began his most fruitful series on this theme, taking as his starting-point matter-of-fact pencil drawings of the Fiat Type-1. These were quickly developed through many studies where the repeated, recognisable form of car and driver were fused with abstract angular configurations, expressive of the penetration of space, and serpentine curving rhythms elaborated from the wheels (nos. 367, 368). Here Balla's earlier cinematic experiments (of a kind rejected by Boccioni) were allied to a search for abstract dynamic forms attuned to Boccioni's 'unique forms of continuity in space'. Ultimately, however, Balla purged his investigations of the cinematic representational factor, arriving by way of near abstractions like 'Dynamic Expansion + Speed' at the thorough-going purity of 'Abstract Speed' (no. 369) and 'Line of Speed' (no. 370). Still related to the earlier drawings (nos. 367, 368) these paintings and studies come of Balla's conviction (very close to Boccioni's) that simple formal configurations express speed most effectively.

367 **Dynamism of a Car**
Pencil, $15 \times 20\frac{1}{2}(38 \times 52)$
Luce Balla, Rome

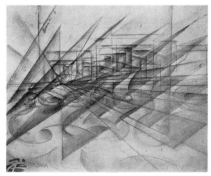

367

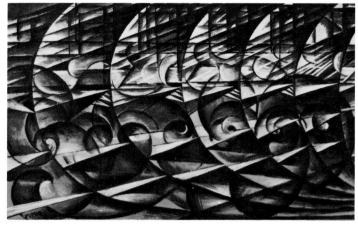

368

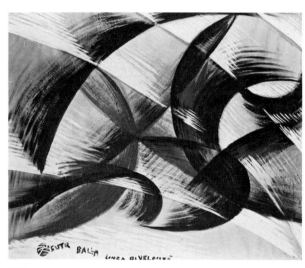

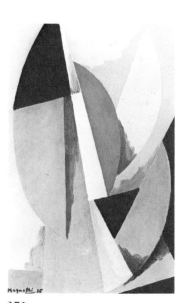

369

370

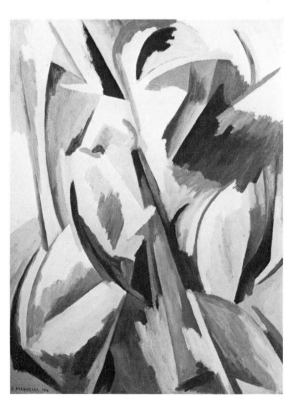

371

372

368 **Dynamic Expansion and Speed** 1913
Oil on paper, $26\frac{3}{4} \times 43\frac{1}{4}$ (68 × 110)
Luce Balla, Rome

369 **Abstract Speed The Car has Passed** 1913
Oil on canvas, $19\frac{3}{4} \times 25\frac{3}{4}$ (50 × 65.3)
Tate Gallery, London (T.1222)

370 **Line of Speed** 1914
Distemper on paper, $26\frac{1}{8} \times 33$ (67 × 84)
Luce Balla, Rome

ALBERTO MAGNELLI 1888–1971

In 1914 Magnelli visited Paris and there met Apollinaire, Picasso, Matisse, Gris and Archipenko. That year he produced his own strident and highly personal variant on Cubism, paintings which are built up of flat, forcefully coloured shapes (made possible by *papier collé*), whose structures tend to the stable and which still directly refer to subject-matter, often still life. Magnelli planned to stay in Paris, but was trapped on a visit to his native Florence by the outbreak of war. It was there, in the winter of 1914–15, that he painted his first series of subjectless pictures, including no.371. In 1960 he wrote to Jacques Lassaigne that these were arrived at by a process of 'elimination and synthesis', and certain of the series still carry associations with figures, though in the most successful these have been totally erased. The second series of abstract pictures came in 1918, the 'Lyrical Explosions' (no.372). They are looser of handling, sweeter of colour and obviously figurative in inspiration.

371 **Composition No.0522** 1915
Oil on canvas, $19\frac{3}{4} \times 12\frac{3}{4}$ (50 × 32.5)
Musée National d'Art Moderne, Centre Georges Pompidou, Paris (AM.1972.24)

372 **Lyrical Explosion No.8** 1918
Oil on canvas, $39\frac{3}{4} \times 30\frac{1}{8}$ (101 × 76.5)
Musée National d'Art Moderne, Centre Georges Pompidou, Paris (AM.1972.26)

Early Abstract Art in Britain
David Brown

In the first decade of the twentieth century much of the most advanced painting in Britain derived from Whistler and the Impressionists. A series of exhibitions in London between 1910 and 1914 made many artists and others aware of some of the more recent developments in Europe. Roger Fry's two Post-Impressionist exhibitions in 1910 and 1912 featured work by Cézanne, Van Gogh, Gauguin, Matisse, Picasso and others and included some Cubist paintings. Futurist exhibitions took place in 1912, 1913 and 1914 and Kandinsky contributed to the Allied Artists Association Salons between 1909 and 1914. Visits by the Russian Ballet from 1909 onwards contributed colour, gaiety and vitality to London. There was a feeling of accelerating change as the number of taxi cabs and motor buses rapidly multiplied; machines spilled out of factories onto the streets.

The response of some of the more adventurous painters to exposure to new ideas was a heightening of colour, simplification of forms, emphasis on surface design and a reduction of pictorial space.

The difficulties of many young artists in earning a living prompted Roger Fry to found the Omega Workshops in 1913 assisted by Duncan Grant and Vanessa Bell. Artists were guaranteed a wage of thirty shillings a week decorating furniture and making designs for textiles, much of this involving completely abstract idioms. Among those working at the Omega were the future Vorticists Wyndham Lewis and Edward Wadsworth who, with others, were to leave in October 1913 after accusing Fry of stealing, for the Omega, a commission by the *Daily Mail* for a 'Post Impressionist Room' at the *Ideal Home Exhibition*, intended for Fry, Lewis and Spencer Gore. Early in 1914 Lewis executed an abstract decorative scheme in the drawing room of the Countess of Drogheda.

Fry was speculating on the possibilities of abstract art in 1913 when he wrote to Lewes Dickinson on 18 February 'I want to find out what the function of content is, and am developing a theory which you will hate very much, *viz.*, that it is merely directive of form and that all the essential aesthetic quality has to do with pure form.' Somewhat similar views were to be elaborated on 'significant form' by Clive Bell in his book *Art*, published in 1914. T.E. Hulme, philosopher and poet, who had been greatly impressed by Wilhelm Worringer's book *Abstraction and Empathy*, in a lecture given in January 1914 in London, declared that 'the new "tendency towards abstraction" will culminate not so much in the simple geometrical forms found in archaic art but in the more complicated ones associated in our minds with the idea of machinery' and that 'Pure geometrical regularity gives a certain pleasure to men troubled by the obscurity of outside appearance. The geometrical line is something absolutely distinct from the messiness, the confusion, and the accidental details of existing things'. However Hulme's attitude to total abstraction was ambivalent as was also Roger Fry's.

Art strikingly like that extolled by Hulme was produced by the painters who signed the Vorticist manifesto printed in the first number of *Blast* published on 2 July 1914. They were Lawrence Atkinson, Jessica Dismoor, Cuthbert Hamilton, William Roberts, Helen Saunders, Wadsworth and Wyndham Lewis as well as the sculptor Henri Gaudier-Brzeska. The Vorticists denounced Futurism as being romantic and sentimental and the cubist paintings of Picasso for being restricted to studio models and objects such as musical instruments. However, Wyndham Lewis in the first issue of *Blast* declared 'the finest art is not pure abstraction, nor is it unorganized life'. The Vorticist artists aimed at a synthesis of Futurism and Cubism. Many of their drawings and the few paintings that have survived have sharp, angular, fragmented linear designs, often diagonally orientated, in strong contrasting colours, reflecting, but not imitating machine forms. Often there is a suggestion of a threatened clash of opposing forces, a stillness with immense potential energy barely under control. More often than not there are hints of machines, figures or architecture and few Vorticist works are completely abstract.

Most of David Bomberg's work of about 1912–14 was concerned with the human figure, usually in movement, frequently of a strenuous nature. Figures were reduced to simplified geometrical shapes, but were still recognisably figures. Only a few of Bomberg's drawings appear totally abstract. A few, of *c.*1914–15, entitled 'Dancer', suggest movement, but not a figure, and have much in common with some of Rodchenko's drawings of about 1915. An untitled gouache of *c.*1915 and three studies for it hint at architecture. Perhaps his most abstract works, (it cannot be known for sure as they have disappeared), were the three paintings and three drawings shown with the Vorticists in 1915, which included 'Design in White' and 'Decorative Experiment'.

Only one Vorticist exhibition was held in London; it was in June 1915. Exhibitors were Dismoor,

Etchells, Gaudier-Brzeska, Lewis, Roberts, Saunders and Wadsworth. In a section 'Works by Those Invited to Show' were Atkinson, Bomberg, Grant and Nevinson. Roger Fry was invited to exhibit but could not be contacted in time as he was engaged in relief work in France. The invitations to Fry and Grant (it is not known whether Vanessa Bell was also invited) may have resulted from two factors. Firstly the Vorticists may have felt there was a need for the avant garde to form a united front in difficult times, and, secondly, have realised that Grant, Bell and Fry were working in idioms at least as advanced as their own. Grant had made the abstract kinetic collage scroll in 1914 and was painting pictures consisting of rectilinear elements in very shallow pictorial space as was Vanessa Bell, both probably owing something to Kupka. Fry made at least one work no less radical in idiom, one exhibited in November 1915 which included two collaged bus tickets among its components. Some idea of the nature of the two 'Paintings' exhibited by Grant in the Vorticist exhibition was given in a review in the *Glasgow Herald*, 11 June 1915: 'Among non-members invited to show . . . is that gifted colourist Mr Duncan Grant. Is it intended that we take seriously Mr Grant's two "paintings" composed of pieces of firewood stuck on the canvas and left uncoloured together with smears of paint upright in shape, put on all haphazard so far as can be judged. Even the Vorticists seem puzzled by these inexplicable exploits'.

Unlike much of the work of the Vorticists, that of Grant, Bell and Fry had an unaggressive tone and had no allusions to machines. The Bloomsbury painters aimed at arranging colour and form to produce an effect of harmony so concentrated as to arouse intense emotion in the viewer.

Most of the early abstract art in Britain in the form of drawings and easel paintings was produced before 1916 and during the war many of the artists working in abstract idioms were in the forces or on war work. Abstract decoration became widespread in the form of dazzle camouflage of ships which was seen by many who did not visit art galleries.

By about 1920 in Britain little or no abstract or near-abstract painting was being produced. Bomberg, Lewis, Roberts and Wadsworth painted large figurative compositions for the British and Canadian War Memorials schemes, using relatively conservative styles which could easily be 'read'. Lewis's attempt to revitalise Vorticism as 'Group X' failed. With the exception of a small number of paintings by Ben Nicholson, including '1924 (painting. trout)' in the mid 1920s, painting in abstract idioms did not occur in Britain again until the 1930s.

BIBLIOGRAPHY

Richard Cork, *Vorticism and Abstract Art in the First Machine Age*, 2 volumes, London, 1976.

Anthony d'Offay, *Abstract Art in England, 1913–15* (Catalogue of exhibition at the d'Offay Couper Gallery, November–December, 1969).

Richard Cork, *Vorticism and its Allies* (Catalogue of exhibition, London, Hayward Gallery, March–June, 1974).

William Lipke, *David Bomberg*, London, 1967.

Walter Michel, *Wyndham Lewis: Paintings and Drawings* with an introductory essay by Hugh Kenner, London, 1971.

Richard Shone, *Bloomsbury Portraits, Vanessa Bell, Duncan Grant and their circle*, London, 1976.

WYNDHAM LEWIS 1882–1957

373 **Abstract Design** 1912
Ink and wash, $9\frac{1}{2} \times 15\frac{3}{8}(24 \times 39)$
British Council

This is the earliest non-representational composition in British twentieth-century art, though there is, perhaps, a hint of warring figures set in illusory pictorial space. It may relate to a commission for Madame Strindberg's night club, 'The Cave of the Golden Calf.'

374 **Composition** 1912
Coloured reproduction, $15\frac{1}{4} \times 10\frac{1}{4}(38.5 \times 26)$
One of sixteen designs from the portfolio *Timon of Athens* published late in 1913
Anthony d'Offay

375 **Composition** 1913
Pencil, ink and watercolour,
$13\frac{5}{8} \times 10\frac{1}{2}(34.5 \times 26.5)$
Tate Gallery (5886)

376 **Timon of Athens** 1913–14
Pencil, ink and wash, $13\frac{1}{2} \times 10\frac{1}{2}(34.5 \times 26.5)$
Anthony d'Offay

377 **Planners: Happy Day** c.1913
Pencil, ink and gouache, $12\frac{1}{4} \times 15(31 \times 38)$
Tate Gallery (T.106)

378 **Red Duet** 1914
Chalk and gouache, $15\frac{1}{4} \times 22(38.5 \times 56)$
Anthony d'Offay

379 **New York** 1914
Ink and watercolour, $12\frac{1}{2} \times 10\frac{1}{4}(31.7 \times 26)$
Private Collection

380 **Abstract Composition** 1915
Ink, crayon and watercolour, $18\frac{1}{2} \times 12(47 \times 30.5)$
Anthony d'Offay

381 **Workshop** 1914–15
Oil on canvas, $30\frac{1}{8} \times 24(76.5 \times 61)$
Tate Gallery (T.1931)

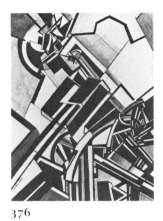

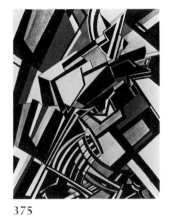

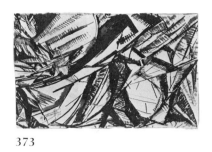

373

376

375

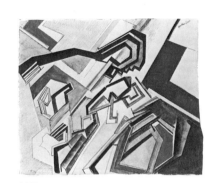

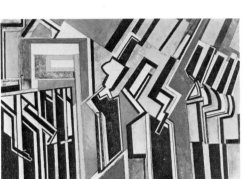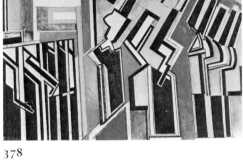

377

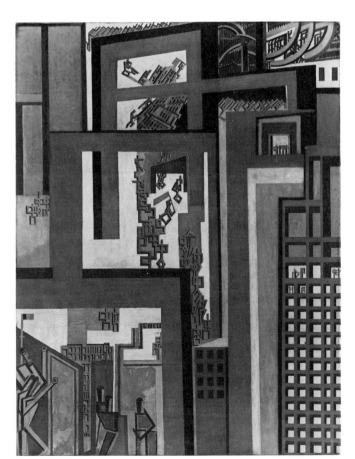

378

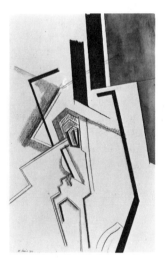

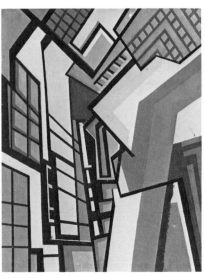

380

382

381

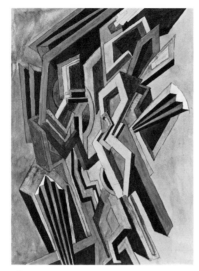

383

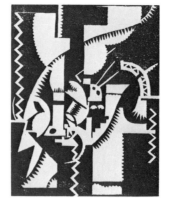

385

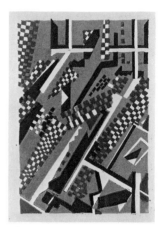

387

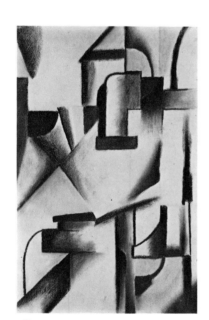

384

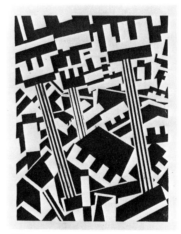

388

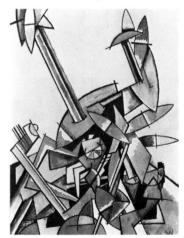

391

393

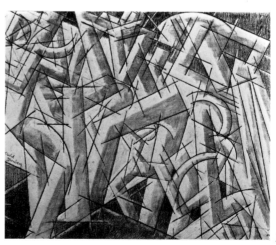

395

382 The Crowd 1914–15
Oil on canvas, 79 × 60½(200.5 × 153.5)
Tate Gallery (T.689)

WILLIAM ROBERTS 1895–1980

383 Study for Two Step II c.1915
Pencil, watercolour and gouache, 11¼ × 9(30 × 23)
Anthony d'Offay

HENRY GAUDIER-BRZESKA 1891–1915

384 Vorticist Composition c.1914
Pastel, 18¾ × 12⅝(47.5 × 32)
Anthony d'Offay

EDWARD WADSWORTH 1889–1949

385 Newcastle 1913
Black woodcut on off-white paper, 5½ × 4(14 × 10)
Anthony d'Offay

In 1914 and 1915 Wadsworth made a number of wood-cuts of varying degrees of abstraction based mainly on views of towns and ports seen from above.

386 Bradford: View of a Town c.1914
Lilac and black woodcut on beige-grey paper,
9⅞ × 4(15 × 10)
Private Collection

387 The Open Window c.1914
Dark and light grey and black woodcut on white paper, 6¼ × 4⅜(16 × 11)
Anthony d'Offay

388 Rotterdam 1914
Black woodcut on white paper, 10¼ × 7⅞(26 × 20)
Anthony d'Offay

389 Untitled: Vorticist Composition c.1914–15
Yellow and purple woodcut on white paper,
5⅛ × 4(13 × 10)
Victoria and Albert Museum, London
(Circ.252-1972)

390 New Delight c.1914–15
Aubergine and black woodcut on linen type paper,
7⅞ × 6⅛(20 × 15.5)
Private Collection

391 Study for Cape of Good Hope 1914
Ink, chalk, watercolour and gouache,
13 × 9⅞(33 × 25)
Anthony d'Offay

This composition, with suggestions of boats in harbour seen from above, probably relates to a large lost painting.

392 Enclosure 1915
Pencil, gouache and collage, 20½ × 18(52 × 45.5)
Museum of Fine Arts, Houston, Museum purchase,
Brown Foundation

DAVID BOMBERG 1890–1957

393 Lyons Cafe 1912
Oil on plywood, 15⅝ × 12⅞(39.7 × 32.7)
Anthony d'Offay

394 Chinnereth 1913–14
Chalk, 18 × 31(45.5 × 53.5)
The Warden and Fellows of Nuffield College, Oxford

395 Acrobats 1913–14
Chalk, 18¼ × 22½(46.5 × 57)
Victoria and Albert Museum, London
(Circ.238-1963)

396 Composition (Green) c.1914–15
Gouache and varnish, 11⅛ × 12⅜(28.3 × 31.4)
Anthony d'Offay

397 Three studies for Composition (Green) 1913–15
Pen and ink on newspaper, 3¼ × 4½(8.2 × 11.2)
Pencil, 4 × 5⅜(10 × 13.5)
Pencil, 4 × 6(10 × 15.3)
Anthony d'Offay

There exist several studies for 'In the Hold' but the painting (no.400) relates most closely to the squared up drawing (no.399). The squaring up, normally used as a means of enlarging a composition has been incorporated into the design so that the colours are interchanged every time they cross one of the lines. In this way the simplified but originally recognisable figures are reduced to a flat pattern of coloured rectangles, hard to decipher.

398 Study for 'In the Hold' 1913
Crayon, 22⅞ × 20(58 × 51)
Anthony d'Offay

399 Study for 'In the Hold' 1913–14
Chalk and watercolour, 21⅞ × 26(55.5 × 66)
Tate Gallery (T.914)

400 In the Hold 1913–14
Oil on canvas, 77¼ × 91(196 × 231)
Tate Gallery (T.913)

401 The Dancer 1913
Crayon, watercolour and gouache,
23⅝ × 21⅞(60 × 55.5)
Anthony d'Offay

402 The Dancer 1913–14
Watercolour and charcoal, 15 × 11(38 × 28)
Trustees of the Cecil Higgins Art Gallery, Bedford

403 Drawing: Zin (?) c.1916
Chalk, 22 × 25(56 × 63.5)
Anthony d'Offay

404 Abstract Design c.1914
Chalk and watercolour, 10¾ × 10¼(27.3 × 26)
Anthony d'Offay

VANESSA BELL 1879–1961

405 Abstract Painting c.1914
Gouache on canvas, 17¾ × 15¼(44 × 39)
Tate Gallery (T.1935)

396

397

400

399

397

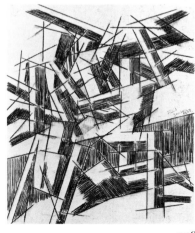

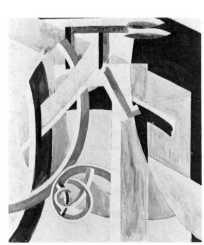

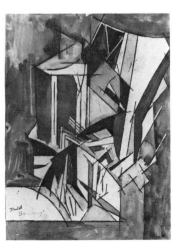

398

401

402

404

403

406

405

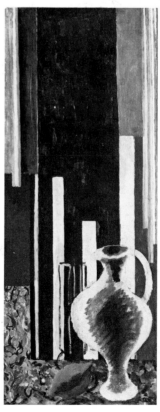

408

409

410

ROGER FRY 1866–1934

Of a very small number of abstract works executed by Fry in about 1914–15, no.406 is the only known one to have survived. This work is probably the first instance of collaged bus tickets being used in painting. For a fuller account of this work see *The Tate Galllery 1974–6: Illustrated Catalogue of Acquisitions*, London, 1978, p.97.

406 Essay in Abstract Design 1914 or 1915
 Oil, oil on paper and bus tickets on veneer board, $14\frac{1}{4} \times 10\frac{9}{16}(36 \times 27)$
 Tate Gallery (T.1957)

DUNCAN GRANT 1885–1978

No.407 was executed in about August and September 1914. Grant intended that it should be viewed through a rectangular aperture 24 inches (61 cm) wide and of the same height – 11 inches (28 cm) – as the painting, mounted on twin spools, moving slowly from left to right by mechanical means. At the same time the spectator should hear slow music by J.S. Bach. In 1914–15, Grant was unable to set up the necessary mechanism.

The basic scheme of the design is seventeen clusters each made up of six rectangles of six colours. On the right hand side of the work all the rectangles are of collage but towards the left all are painted. In 1974, Grant's original intention was realised in cinematographic form using the slow movement of Bach's First Brandenburg Concerto as the soundtrack. Grant made the work as a result of reading in a newspaper of experiments being made in London concerned with the interaction of music and colour. This probably related to the work of A. Wallace Rimington and of Scriabin. Under the heading 'Colour Organ at Queen's Hall', *The Times*, of 21 March 1914, p.10 reported 'Sir Henry Wood has made arrangements with Professor Wallace Rimington to give a performance of Scriabin's 'Prometheus' with the "Colour organ" at a Queen's Hall Orchestra Symphony Concert early next season. The "colour organ" was described in *The Times* yesterday'.

For a fuller account of this work see *The Tate Gallery 1972–4: Biennial Report*, London 1975, pp160–163.

407 Abstract Kinetic Collage Painting with Sound 1914
 Gouache, watercolour and collage of painted and cut papers, on continuous sheets of paper with overall dimensions (irregular) $11 \times 177\frac{1}{4}(28 \times 450)$ laid on unpainted canvas support $14\frac{1}{8} \times 219\frac{1}{4}(28 \times 450)$
 Tate Gallery (T.1744)

408 Interior at Gordon Square c.1915
 Oil on panel, $15\frac{3}{4} \times 12\frac{5}{8}(40 \times 32)$
 Tate Gallery (T.1143)

409 In Memory of Rupert Brooke 1915
 Oil on panel, $21\frac{3}{4} \times 12(55.2 \times 30.5)$
 Painted soon after the artist heard of the death of the poet in April, 1915
 Private Collection

410 The White Jug c.1914–19
 Oil on panel, $42 \times 17\frac{1}{2}(106.5 \times 44.5)$
 When originally painted this work was entirely non-representational, consisting only of rectilinear elements. About five years later, when Grant could see no future for himself in abstract painting, he added the jug, lemon and decorative passages at the bottom left.
 Private Collection

The first American experiments with Abstract Art
Gail Levin

In the decade preceding the start of the First World War, young American artists flocked to Paris to study. More than their compatriots of previous generations, they soon began to emulate artists of the French avant-garde, some of whom they met at the home of Gertrude and Leo Stein. Even those who entered the traditional institutions upon their arrival tended to rebel, turning for guidance to the leaders among the French moderns who were also developing a following among artists in Germany, Russia, and elsewhere in Europe. Several Americans studied with Matisse, some followed the Cubists, while others, like Joseph Stella, were influenced by the Futurists' presence in Paris.

When the Americans returned home, they found a receptive if very limited milieu for their work in people like Alfred Stieglitz whose gallery was a centre for the avant-garde. They were, on the whole, crusaders with a fervent message to convey, who extended themselves and battled the reticence they found among the conservative art establishment and the public.

Synchromism, the first American avant-garde painting to attract attention in Europe, made its debut in Munich at *Der Neue Kunstsalon* in June 1913, in Paris at the Bernheim-Jeune Gallery the following October and in New York in March 1914. It was conceived by Morgan Russell, a twenty-seven-year-old American expatriate, who had attended the Académie Matisse. He was joined in his efforts to change the course of Western painting by Stanton Macdonald-Wright, a fellow American four years his junior. Synchromism, meaning according to Russell 'with colour', was a term he chose for its analogy with 'symphony' to indicate his own emphasis on colour rhythms. It denoted one of the earliest attempts to create paintings composed of abstract shapes and colours.

Russell and Macdonald-Wright presented their ideas in essays written for three Synchromist exhibition catalogues of 1913 and 1914. While they claimed to have pursued the use of colour beyond that in Impressionism, Cubism and Futurism and they boldly attacked Orphism:

> A superficial resemblance between the works of this school and a Synchromist canvas exhibited at the last Salon des Indépendants of [1913] has led certain critics to confuse them: this was to take a tiger for a zebra, on the pretext that both have a striped skin. [1]

By the spring following the *Bernheim-Jeune* exhibition, at the *Salon des Indépendants* of 1914, critics grouped the artists working with pure abstract colour either around Robert Delaunay as the Simultaneists or around Morgan Russell as the Synchromists. [2]

While certain Americans such as Thomas Hart Benton and Andrew Dasburg actually responded to the impact of Synchromism, others like Patrick Henry Bruce and Marsden Hartley, were directly influenced by the French artists Robert and Sonia Delaunay. Still other Americans, such as Georgia O'Keeffe, Arthur Dove, and Max Weber, experimented independently with colour abstraction, often working from nature or their imagination rather than any theory.

The idea behind Synchromism was Russell's intention to create paintings based upon sculptural forms interpreted two-dimensionally through a knowledge of colour properties. Benton briefly experimented by painting Synchromist abstractions which he soon abandoned for figurative representational art. Yet even his later, more characteristic paintings owe a debt to his early discovery of Michelangelesque rhythms in Synchromist painting. In the end, though, he said he ran into 'impossible contradictions', and 'quit Synchromism because I just couldn't paint George Washington as a rainbow.' [3]

By 1913, Bruce, who had settled in Paris in January 1904, was considered an adherent of Delaunay's *école orphique*. In March 1913, he demonstrated his solidarity with his French mentor by insisting that his works be removed from the New York *Armory Show*, the landmark exhibition which shook the conservative art world. Delaunay had withdrawn his entries to protest against the organisers' decision not to hang his monumental canvas 'City of Paris'. The organisers refused and artist Samuel Halpert told the press that Bruce was the 'only American painter at all considered by French artists.' [4] The same article quoted Delaunay who must have been referring to the rival Synchromists when he insisted that the incident was 'unfortunate' because his Orphism was 'already successful and celebrated in Europe, and has influenced American painters here more than any other modern movements.'

In his development as an artist Bruce had progressed from traditional portraits in the manner taught by Robert Henri in New York to a series of still lifes inspired by Impressionism, his study with Matisse, and Cézanne's work which he admired most. [5] In his boldly abstract 'Compositions' of about 1916, Bruce moved beyond his earlier adaptations of

the Delaunays' forms to a more original style with an individualistic use of extremely thick bright paint applied with a palette knife. Bruce was apparently still closely involved with the simultaneous colour theories espoused by Delaunay, but he freely improvised beyond any set of rules.

When Marsden Hartley arrived in Paris in the spring of 1912, he brought with him a letter of introduction to Delaunay from Halpert; he also came to know the Delaunays while visiting Gertrude Stein. Writing to Alfred Stieglitz on 20 June 1912, Hartley mentioned his visit to Robert Delaunay's studio but lamented that the artist's latest work was 'like a demonstration for chemistry on the technical relations of colour and sound.'[6] Writing to Stieglitz that July, Hartley noted Sonia Delaunay's 'Orphistic' dress which he again remarked upon when he exhibited in the *Erster Deutscher Herbstsalon* in Berlin in September, 1913.[7]

Delaunay's influence is revealed in Hartley's 'Composition' of 1914, one of the most abstract pictures he ever painted. The colourful hard-edged disks and stripes may refer to Delaunay's 'The First Disk' (no.30) of 1912 which Hartley could have seen when he visited the French artist's studio that year or to Delaunay's 'Homage to Blériot' which Hartley saw in the Salon des Indépendents in the spring of 1914. Hartley's 'Abstraction Blue, Yellow and Green' (no.434) can only reflect his knowledge of Wassily Kandinsky's paintings, with which he first became acquainted when he met the artist on his initial visit to Germany in January 1913.[8]

Kandinsky's *On the Spiritual in Art* was highly regarded by many American artists, particularly those of the Stieglitz circle.[9] Kandinsky's stress on the link of art and music and of colours and emotions had widespread appeal. His treatise was read by many artists including Arthur Dove, Marsden Hartley, Georgia O'Keeffe, and Konrad Cramer. The impact of Kandinsky's ideas is perhaps best seen in Hartley's more mystical paintings of 1912–13, like 'Painting No.6' (no.431). While Max Weber's fluid abstractions of 1912 may also owe to his reading of Kandinsky, Manniere Dawson's 'Prognostic' (no.452) of 1910 apparently developed independently of any such influence.

Henry Fitch Taylor, a colour theorist, was a painter of Impressionist landscapes when, in 1911, he became a founding member of the group that organised the *Armory Show*. After the impact of that exhibition in 1913, he began to paint abstractly. He invented 'The Taylor System of Color Harmony' including a 'ready reference chart of Color Harmony' which purported to be superior to the colour wheel.[10] Taylor, like several other theorists of his day, attempted to link a chromatic scale in music to one in colour and stressed major and minor triads or chords.

Interest in the visual expression of musical ideas is also present in the work of many other American artists of this period including Max Weber, Georgia O'Keeffe, Arthur Dove, Man Ray, and Morgan Russell, who even composed music. This direction often provided a point of departure leading to a purely abstract painting. O'Keeffe, like Weber, had been taught by Arthur Wesley Dow (1857–1922) who was somewhat more open to abstract principles than most art teachers of his day because of his training with the American Orientalist Ernest Fenollosa. Dow, who reportedly claimed that 'seeing visual relations was like hearing music,' encouraged his students to concern themselves with the spiritual quality in art.[11]

Morton Schamberg shared a studio with Charles Sheeler in Philadelphia before he left on his trip to Paris in 1908. Sheeler joined him there for January and February 1909, and they became acquainted with the work of Cézanne, Matisse, and Picasso. When Schamberg returned to Philadelphia in 1910, he began to develop his own style initially inspired by his knowledge of Fauvist colour. In 1913 and 1914, Schamberg created his own colour abstractions using a figural motif expressed through abstract shapes of colour similar to the Synchromists' art, but there is no evidence that he could have known their work before their New York exhibition at the Carroll Gallery in 1914. His first-hand knowledge of Fauvism and Cubism in Paris, undoubtedly reinforced by the *Armory Show* in which he exhibited in 1913, must be credited with leading him to develop independently his own colourful abstractions. Schamberg's development and the Synchromists' New York exhibition in 1914 may have prompted Charles Sheeler, still a close friend, to paint his own precise representational style.

Modernist trends among American artists were affected by the outbreak of war which caused most to return home from Europe. Marcel Duchamp's arrival in New York in 1915 encouraged the development of the Dada movement involving Man Ray, Picabia, Katherine Dreier and others. In 1920, Dreier and Duchamp founded the Société Anonyme to collect the new Modernist art and to educate the public about it. Despite their efforts, there was a growing reaction against abstraction and by the 1920s, many artists, including Hartley, Sheeler, Benton, Cramer, Dasburg, Russell, Macdonald-Wright, Stella, and Weber, had returned to representational modes of painting. Their reasons were complex, yet the emerging nationalism in the face of America's growing isolationist policies was paramount. The epoch when American artists first produced pioneering experiments with pure abstraction had drawn to a close.

NOTES

1. Stanton Macdonald-Wright and Morgan Russell, General Introduction to *Les Synchromistes*, Bernheim-Jeune & Cie., Paris, 27 October–9 November 1913. Translated text quoted in full in Gail Levin, *Synchromism and American Color Abstraction, 1910–1925* (New York: George Braziller, 1978).

2. See for example André Salmon, 'Le Salon', *Montjoie!* March
1914. pp.21–28; March Vromant, 'A propos du Salon des
Indépendants. Du Cubisme et autres syntheses', *Comoedia*,
April 15 1915, pp.1–2; Louis Vauxcelles, 'Les Arts', *Gil Blas*,
May 7 1914, p.4; Maurice-Verne, in *L'Arc d'Argent*, 28 June
1914.

3. For an account of Benton's relationship to the Synchromists,
see Levin, *Synchromism*, pp.31–33.

4. 'French Artist at Odds with New York Exhibitors: Robert de
Launay Asks That His Pictures Be Withdrawn, But Gets No
Satisfaction', New York Tribune, 2 March, 1913, p.4.

5. See Gail Levin, 'Patrick Henry Bruce and Arthur Burdett
Frost, Jr.: From the Henri Class to the Avant-Garde', *Arts
Magazine*, April 1979, pp.102–106.

6. Quoted in Levin, *Synchromism*, p.43, which reproduces other
examples of Hartley's abstractions. See also Gail Levin,
'Marsden Hartley and the European Avant-Garde', *Arts
Magazine*, September 1979, pp.158–163.

7. The four Americans included in this important exhibition
were Marsden Hartley, Patrick Henry Bruce, Albert Bloch,
and Lyonel Feininger.

8. See Gail Levin, 'Marsden Hartley, Kandinsky and Der Blaue
Reiter', *Arts Magazine*, November 1977, pp.156–160.

9. For a detailed analysis of Americans' interest in Kandinsky,
See Sandra Gail Levin, 'Wassily Kandinsky and the American
Avant-Garde, 1912–1950', doctoral dissertation, Rutgers
University, New Brunswick, New Jersey, 1976.

10. 'The Taylor System of Color Harmony', *Color Trade Journal*,
XII, February 1923, pp.56–58.

11. Lawrence W. Chilsholm, Fenollosa: The Far East and
American Culture, (New Haven: Yale University Press,
1963), p.231 and Frederick C. Moffatt, Arthur Wesley Dow
(1857–1922), (Washington, D.C.: The Smithsonian Insti-
tution Press, 1977).

Morgan Russell and the Synchromists

Russell was born in New York. He visited Paris in 1906
and 1908 and finally settled in France in 1909. He and
Macdonald Wright met in Paris in 1911 and exhibited
together in the first Synchromist exhibitions in 1913 and
1914 presenting their ideas in essays written for the
catalogues. The germ of Synchromism lay in Russell's idea
that he might create paintings based on sculptural forms
interpreted two-dimensionally through a knowledge of
colour properties.

Included in the Bernheim-Jeune Synchromism exhi-
bition Paris 1913 was one very large – 10'4" by 7'6" –
purely abstract painting by Russell 'Synchromy in Deep
Blue-Violet' ('Synchromie en bleu violacé'). The painting
was lost to sight for many years and only survives in a
much restored form, but the study exhibited with it, as well
as various intermediate stages, and even the earliest
notebook sketches have survived.

In his notebook dated May 1912, nearly a year and a
half before 'Synchromie en bleu violacé' was first exhi-
bited, Russell drew a tiny pencil sketch, no bigger than a
postage stamp, for this work. The adjacent notes confirm
that it is a study for his first fully abstract painting which
he subtitled 'Synchromie to light'. Next to a large, rough
unidentifiable sketch on this same page Russell noted,
'light pushing back the dark', and around the sketch for
the 'Synchromie en bleu violacé' he wrote: 'This felt as
profondeur not surface seen – more and more as you
develop it spectrally and as idea – have it mean depth,
projection and movement and thus all form.'

In this painting Russell has actually relied on indicating
form in space by the use of colour principles. For example,
warm colours (such as orange-red) appear to advance, and
cool colours (such as blue-violet) appear to recede. He has,
by now, also understood that he could heighten the value
or luminosity of the yellow, reds and oranges, and thereby
increase the illusion of the projection of these warmer
colours. By surrounding the central yellow shape with its
complement, blue-violet, as two of his 'four points of
support', Russell has applied Michel-Eugène Chevreul's
law that when two complementary colours are placed side
by side, the effect of contrast harmony is increased. Thus,
Russell described 'Synchromie en bleu violacé' as 'only a

composition of colour and light, the form being but a
simple order of projections and hollows.'

Russell had sketched Michelangelo's 'Dying Slave'
many times, concentrating on the figure's contraposto,
fascinated by the imaginary spiral running through the
entire figure. It is this spiral that Russell borrowed as a
means of organising his 'Synchromie en bleu violacé'
around a principal rhythm. In the two crayon sketches
(from his notebook dated July 1912) leading to this work,
the curves were slight and tentative, but in an early oil
sketch for his 'Synchromie en bleu violacé', Russell
exaggerated the curve and countercurve into a form
resembling a question mark. He admitted: 'I have always
felt the need of imposing on colour the same violent twist
and spirals that Rubens and Michelangelo etc. imposed on
form . . .' He did not intend to convey the figure in actual
movement, but rather expected to realise 'a rhythmic basis
of colour'.

MORGAN RUSSELL 1886–1953

411 Sketch After Michelangelo's Dying Slave
*c.*1910–12
Pencil on paper, 12¼ × 8¼ (31 × 21)
Whitney Museum of American Art, New York, Gift of
Henry Reed (78.131.34)

**412 Study for Synchromie en Bleu Violacé
(Synchromie to Light)** 1913
Oil on canvas, 13 × 9½ (33 × 24)
Los Angeles County Museum of Art,
Gift of Mr and Mrs David E. Bright (59.63)

413 Study for Synchromie en Bleu Violacé 1913
Oil on paper, 9¾ × 7 (24.7 × 17.7)
Mr and Mrs Henry M. Reed

414 Sketch for Synchromie en Bleu Violacé May 1912
Pencil on paper in notebook, 12¼ × 8¼ (31 × 21)
Whitney Museum of American Art, New York,
Gift of Henry Reed (78.131.54)

415 **Sketch for Synchromie en Bleu Violacé** July 1912
From artist's notebook
Crayon on paper, $6\frac{1}{2} \times 4 (16.5 \times 10)$
Whitney Museum of American Art, New York,
Gift of Henry Reed (78.131.23)

416 **Sketch for Synchromie en Bleu Violacé** July 1912
From artist's notebook
Crayon on paper, $5\frac{3}{4} \times 3\frac{5}{8} (14.5 \times 9)$
Mr and Mrs Henry M. Reed

417 **Creavit Deus Hominem (Synchromy No.3: Colour Counterpoint** 1914
Oil on canvas mounted on cardboard,
$11\frac{7}{8} \times 10\frac{1}{4} (30.2 \times 26)$
Museum of Modern Art, New York, given
anonymously 1951

STANTON MACDONALD-WRIGHT 1890–1973

418 **Conception Synchromy** 1915
Oil on canvas, $30 \times 24 (76 \times 61)$
Whitney Museum of American Art, New York,
Gift of George F. Of (52.40)

419 **Synchromy in Blue** 1916
Oil on canvas, $29\frac{7}{8} \times 23\frac{7}{8} (76 \times 60.7)$
Weyhe Gallery, New York

420 **Synchromy in Green and Orange** 1916
Oil on canvas, $34\frac{1}{2} \times 30\frac{1}{2} (87.5 \times 77.5)$
Walker Art Center, Minneapolis, Gift of the
T.B. Walker Foundation

421 **Synchromy** 1917
Oil on canvas, $31 \times 24 (78.7 \times 61)$
Museum of Modern Art, New York, given
anonymously 1949

ANDREW DASBURG b.1887

422 **Improvisation** c.1915–16
Oil on canvas, $35\frac{1}{2} \times 29\frac{1}{2} (89 \times 75)$
Mr and Mrs Henry M. Reed

THOMAS HART BENTON 1889–1975

423 **Bubbles** c.1914–17
Oil on canvas, $21\frac{3}{4} \times 16\frac{1}{2} (55.2 \times 42)$
Baltimore Museum of Art, Gift of H.L. Mencken

The Stieglitz Circle

Many leading avant-garde artists were launched or helped
by Alfred Stieglitz from his gallery '291' in New York. It
was the one gallery that consistently showed avant-garde
and controversial work.

Amongst these artists were Arthur Dove, Marsden
Hartley, Georgia O'Keeffe and Max Weber, all of whom
were interested in colour abstraction. They were parti-
cularly influenced by Kandinsky's ideas as described in *On
the Spiritual in Art* and by his emphasis on the link between
art and music.

An interest in colour abstraction was not the monopoly
of the Synchromists or of Delaunay or the Simultaneists.
Many artists subscribed to the colour theories of Chevreul
amongst others. Some followed their own theoretical
inventions and some like Georgia O'Keeffe and Arthur
Dove were more intuitive and worked either from nature
or from the imagination.

ARTHUR DOVE 1880–1946

424 **Abstraction No.1** 1910
Oil on canvas, $10\frac{1}{2} \times 8\frac{1}{2} (26.7 \times 21.5)$
Private Collection

425 **Abstraction No.2** 1910
Oil on canvas, $10\frac{1}{2} \times 8\frac{1}{2} (26.7 \times 21.5)$
Private Collection

426 **Abstraction No.4** 1910
Oil on canvas, $10\frac{1}{2} \times 8\frac{1}{2} (26.7 \times 21.5)$
Private Collection

427 **Abstraction No.5** 1910
Oil on canvas, $10\frac{1}{2} \times 8\frac{1}{2} (26.7 \times 21.5)$
Private Collection

428 **Nature Symbolised** c.1911–12
Pastel, $18 \times 21\frac{1}{2} (57 \times 40.5)$
Private Collection by courtesy of Andrew J. Crispo
Collection, New York

429 **Nature Symbolised** c.1911–1915
Charcoal on paper, $20\frac{1}{2} \times 17 (52 \times 43)$
Mr and Mrs Sidney Sass

430 **Abstraction** 1914
Oil on canvas, $18 \times 22 (45.7 \times 56)$
Ertegun Collection Group

MARSDEN HARTLEY 1877–1943

431 **Painting No.6** 1913
Oil on canvas, $39\frac{3}{4} \times 32 (101 \times 81.2)$
Weyhe Gallery, New York

432 **Composition** 1913
Oil on panel, $19\frac{1}{2} \times 15\frac{1}{2} (49.5 \times 39.5)$
Mr and Mrs Henry M. Reed

433 **Abstraction** c.1913
Oil on paperboard mounted on panel,
$24 \times 20 (61 \times 50.7)$
Mr and Mrs Ralph S. O'Connor

434 **Abstraction Blue, Yellow and Green** c.1913
Oil on canvas, $24\frac{3}{8} \times 18\frac{3}{4} (62 \times 47.5)$
Los Angeles County Museum of Art,
Gift of Morton D. May (53.25.4)

GEORGIA O'KEEFFE b.1887

435 **Blue No.II** 1916
Watercolour on paper, $15\frac{3}{8} \times 11 (40.2 \times 28)$
Brooklyn Museum, New York
Bequest of Miss Mary T. Cockcroft

411

415

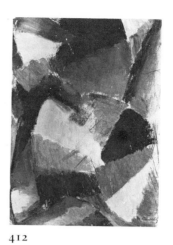

412

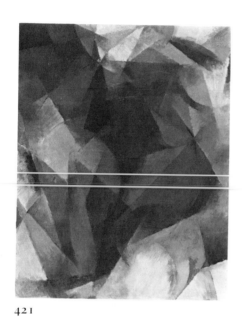

421

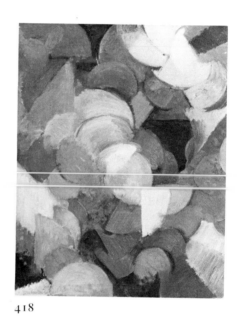

418

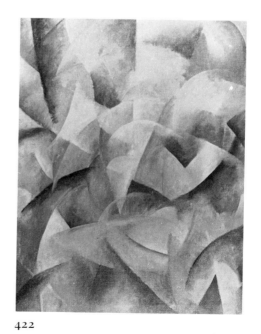

423

422

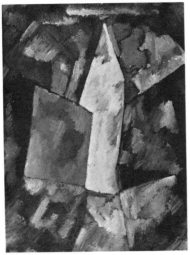

434

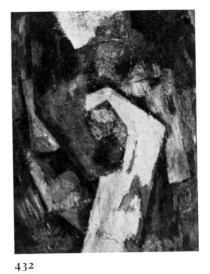

432

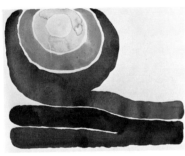

436

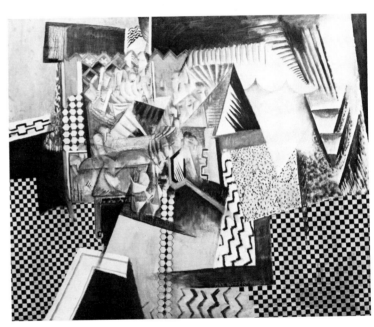

441

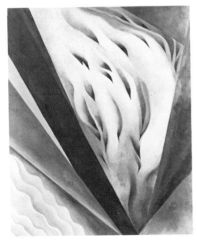

438

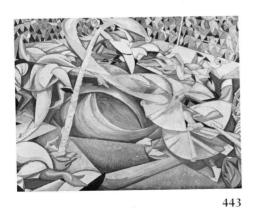

443

442

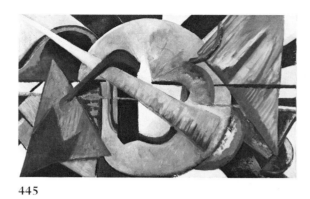

445

448

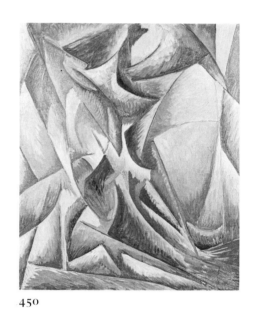

450

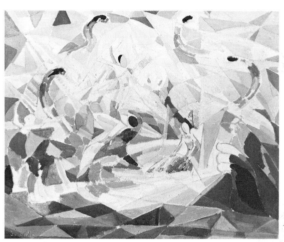

453

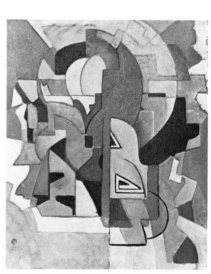

455

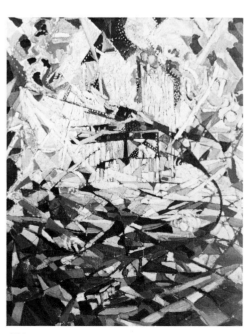

454

436 **Evening Star III** 1917
Watercolour on paper, $9 \times 11\frac{7}{8}(22.7 \times 30.2)$
Museum of Modern Art, New York, Mr and Mrs
Donald B. Strauss Fund

437 **From the Plains I** 1919
Oil on canvas, $27\frac{5}{8} \times 23\frac{5}{8}(70.2 \times 60)$
Andrew J. Crispo Collection, New York

438 **Blue and Green Music** 1919
Oil on canvas, $23 \times 19(58.5 \times 48.2)$
Art Institute of Chicago, Gift of Georgia O'Keeffe to
the Alfred Stieglitz Collection

MAX WEBER 1881–1961

439 **Music** 1915
Oil on canvas, $39\frac{1}{2} \times 38(100.3 \times 96.5)$
Dr and Mrs Frederic M. Chacker

440 **Interior with Music** 1915
Oil on canvas, $60 \times 40(152.5 \times 101.5)$
Ertegun Collection Group

441 **Chinese Restaurant** 1915
Oil on canvas, $40 \times 48(101.5 \times 122)$
Whitney Museum of American Art, New York
(31.382)

Simultaneism

PATRICK HENRY BRUCE 1881–1936

442 **Still Life with Tapestry** 1911–12
Oil on canvas, $19\frac{1}{4} \times 27(49 \times 68.5)$
Mr and Mrs Henry M. Reed

JAMES HENRY DAUGHERTY 1887–1974

443 **Three Base Hit (Opening Game)** 1914
Gouache and ink, $12\frac{1}{2} \times 17\frac{1}{2}(31.7 \times 44.5)$
Whitney Museum of American Art, New York
(77.40)

444 **Abstract Composition** 1918
Oil on canvas, $21 \times 17(53.2 \times 43)$
Mr and Mrs Henry M. Reed

Dada

KATHERINE DREIER 1877–1952

445 **Abstract Portrait of Marcel Duchamp** 1918
Oil on canvas, $18 \times 22(45.7 \times 56)$
Museum of Modern Art, New York,
Abby Aldrich Rockefeller Fund 1949

MAN RAY 1890–1976

446 **Jazz** 1919
Aerograph, $31 \times 25(78.7 \times 63.5)$
Columbus Gallery of Fine Arts,
Gift of Ferdinand Howald

MORTON SCHAMBERG 1881–1918

447 **Geometrical Patterns** 1914
Oil on canvas, $28 \times 16(71 \times 40.7)$
Ira Leo Schamberg M.D.

CHARLES SHEELER 1883–1965

448 **Abstraction: Tree Form** 1914
Oil on panel, $13\frac{3}{4} \times 10\frac{1}{2}(35 \times 26.5)$
Mr and Mrs Henry M. Reed

449 **Flower Forms** 1917
Oil on canvas, $23\frac{1}{4} \times 19\frac{1}{4}(59 \times 49)$
Mrs Earl Horter

KONRAD CRAMER 1888–1963

450 **Improvisation** 1912
Oil on canvas, $30 \times 26(76.2 \times 66)$
San Diego Museum of Art

STUART DAVIS 1894–1964

451 **The Breakfast Table** c.1917
Oil on canvas, $48 \times 34(122 \times 86.3)$
Kennedy Galleries, Inc, New York

MANNIERE DAWSON 1887–1969

452 **Prognostic** 1910
Oil on canvas, $33\frac{3}{4} \times 35\frac{3}{4}(85.2 \times 89.7)$
Milwaukee Art Center, Wisconsin

JOSEPH STELLA 1877–1946

453 **Der Rosenkavalier** 1913–14
Oil on canvas, $24 \times 30(61 \times 76)$
Whitney Museum of American Art, New York,
Gift of George F. Of (52.39)

454 **Battle of Lights (Coney Island)** c.1913–14
Oil on canvas, $39 \times 29\frac{1}{2}(99 \times 75)$
University of Nebraska Art Galleries, Lincoln,
I.M. Hall Collection

HENRY FITCH TAYLOR 1853–1925

455 **Untitled Abstraction** 1915
Oil on board, $30 \times 25(76.2 \times 63.5)$
Weatherspoon Art Gallery, University of North
Carolina at Greensboro, Gift of Burlington Industries

Appendices

Appendix I

	PARIS	NETHERLANDS	ZURICH SWITZERLAND	KANDINSKY GERMANY AUSTRIA
				Hoelzel 1853–1934
1860		Plasschaert 1866–1941		Jawlensky 1864–1941 Kandinsky 1866–1944
1870	Kupka 1871–1957	Mondrian 1872–1944		
1875	Villon 1875–1963 Birot 1876–1967 Picabia 1879–1953	Van der Leck 1876–1958 A. van Rees 1876–1959 Van Heemskerk 1876–1921		Muenter 1877–1962 Schmithals 1878–1964 Klee 1879–1940
1880	Léger 1881–1955 Picasso 1881–1963 Braque 1882–1963 Herbin 1882–1960	Sluyters 1881–1957 De Winter 1882–1951 Van Doesburg 1883–1931 Huszar 1884–1960 O. van Rees 1884–1957	Eggeling 1880–1925	
1885	R. Delaunay 1885–1941 S. Delaunay 1885–1979 Duchamp 1887–1968	Van Deene 1886–1978 Beekman 1887–1964	Arp 1887–1966 Richter 1888–1976 Taeuber-Arp 1889–1943	Marc 1880–1916 Macke 1887–1914 Itten 1888–1967
1890		Wichman 1890–1929 Bendien 1890–1933 Saalborn 1891–1957	Janco b. 1895	Kölschbach 1892–1947 Müche b. 1895

RUSSIA	ITALY	GREAT BRITAIN	U.S.A.	
			Taylor 1853–1925	
Matyushin 1861–1934		Fry 1866–1934		**1860**
	Balla 1871–1958			**1870**
Guro 1877–1913 Malevich 1878–1935		Bell 1879–1961	Hartley 1877–1943 Dreier 1877–1952 Stella 1877–1946	**1875**
Larionov 1881–1964 Goncharova 1881–1962 Exter 1882–1949	Carrà 1881–1966 Boccioni 1882–1916 Severini 1883–1966	Wyndham Lewis 1882–1957	Dove 1880–1946 Weber 1881–1961 Bruce 1881–1936 Schamberg 1881–1918 Sheeler 1883–1965	**1880**
Burlyuk 1886–1917 Rozanova 1886–1918 Popova 1889–1924	Magnelli 1888–1971	Grant 1885–1978 Wadsworth 1889–1924	Russell 1886–1953 Daugherty 1887–1974 Dawson 1887–1969 O'Keeffe b. 1887 Dasburg b. 1887 Cramer 1888–1963 Benton 1889–1975	**1885**
Rodchenko 1891–1956		Bomberg 1890–1957 Gaudier-Brzeska 1891–1915 Roberts 1895–1980	Macdonald Wright 1890–1973 Man Ray 1890–1976 Davis 1894–1964	**1890**

Appendix 2

PARIS

1908
Première of Diaghilev's production of Mussorgsky's *Boris Godunov*

1909
Marinetti's founding manifesto of Futurism published in *Le Figaro*

First season of Diaghilev's *Ballets Russes*

Delaunay starts 'Eiffel Tower' paintings

Salon d'Automne includes works by Balla, Boccioni, Dove, Kandinsky, Léger, Severini

1910
Salon d'Automne includes works by Bruce, Kandinsky, Kupka, Léger, Picabia

1911
'Cubist Room' at *Salon des Indépendants*

1912
Futurist exhibition

Delaunay paints 'Windows' series

Kupka exhibits 'Amorpha' at *Salon d'Automne*

Braque's first 'papier collé'

1913
Delaunay and Apollinaire visit Berlin for Delaunay's exhibition

Delaunay's 'Cardiff Team' shown at *Salon des Indépendants*

Synchromist exhibition

Picabia visits New York to see *Armory Show*

Cendrar's 'Prose du Transsibérien' with illustrations by Sonia Delaunay

Kupka exhibits 'Vertical Planes III' at *Salon des Indépendants*

1914
Salon des Indépendants included Delaunay and Simultaneists as well as Russell and Synchromists

1915
Duchamp goes to New York

NETHERLANDS

1908
Mondrian's first visit to Domburg

O. and V. van Rees in Paris

1910
Amsterdam: Kunstkring founded to introduce modern European paintings to Netherlands

1911
Amsterdam: first *Moderne Kunstkring* exhibition includes paintings by Cézanne, Braque, Picasso

Mondrian leaves Amsterdam to live in Paris.

1912
Futurist exhibitions, The Hague, Amsterdam, Rotterdam

Rotterdam: retrospective exhibition of works by Kandinsky

Amsterdam: *Moderne Kunstkring* exhibition includes works by Braque, Léger, Mondrian, Bendien, Van Rees

1913
Amsterdam: *Moderne Kunstkring* includes works by Kandinsky, Marc, Mondrian, Sluyters, Van Rees

1914
April: Van der Leck visits Algiers and Spain

Van der Leck commissioned to do stained glass by Muller & Co.

Mondrian returns to Holland in the summer

Van Doesburg and Van Rees called up

1915
O. van Rees moves to Zurich

Mondrian meets Dr M. Schoenmaekers

Publication of *Het Nieuwe Wereldbeeld* by Schoenmaekers

1916
Mondrian and Van Doesburg meet

Van der Leck moves to Laren and meets Mondrian

The Hague: Expressionists and Cubists exhibition includes works by Ernst, Kandinsky, Marc, Van Heemskerk

1917
Mondrian and Van der Leck agree to collaborate with Van Doesburg on new periodical

First issue *De Stijl* published in October

First group manifesto of De Stijl

1918
Oud and Van Doesburg collaborate at holiday residence De Vonk Noordwijkerhout

Van der Leck leaves De Stijl

1919
Mondrian returns to Paris

ZURICH AND SWITZERLAND

1911
Moderne Bund founded by Arp, Helbig, Lüthy, holds first exhibition in Lucerne

1912
Moderne Bund artists make contact with Blaue Reiter artists

1913
Kandinsky 'Reminiscences' and 'Compositions 6 and 7'

1914
Arp in Paris meets Delaunay and Eggeling, Picasso and Apollinaire

1915
Arp returns to Zurich

Arp's first 'essential' picture

Arp meets S. Taeuber whom he later marries

Frescoes in Pestalozzi School by Arp and Van Rees

Galerie Tanner exhibition included works by Arp, A. and O. van Rees

1916
Dada begins at Cabaret Voltaire founded by Hugo Ball

First issue of periodical *Cabaret Voltaire*

1917
Arp visits Ascona

Richter, Arp, O. and A. van Rees exhibit at Gallery Corray (*Zurich Cubists*)

1918
Eggeling moves to Zurich and meets Richter. Works on scroll drawings which are to form basis of abstract films

1919
Richter's 'Praeludium'

1920
Richter's: 'Rhythms 21'

1921
Eggeling's film 'Horizontal – Vertical Orchestra'

KANDINSKY GERMANY & AUSTRIA

1908
Vienna: First *Kunstschau* exhibition

1909
Vienna: second *Kunstschau* exhibition

Munich: founding and first exhibition of *New Artists' Association*

1910
Munich: exhibition of Mohammedan Art

Munich: second exhibition of *New Artists' Association*

1911
Munich: first *Blaue Reiter* exhibition

Kandinsky *On the Spiritual in Art*

1912
Cologne *Sonderbund* exhibition includes works by Munch and Van Gogh

Kandinsky and Marc publish *Der Blaue Reiter*

Macke and Marc visit Delaunay in Paris

Munich: second *Blaue Reiter* exhibition

1913
Berlin: Delaunay One Man Exhibition

Munich: *Synchromist* exhibition

Berlin: Walden's *Erster Deutschen Herbstsalon* opens. Includes works by Balla, Bruce, R. and S. Delaunay, Hartley, Kandinsky, Klee, Larionov, Léger, Macke, Sluyters, Severini, O. & A. van Rees, Mondrian

1914
Klee, Macke and Moilliet visit North Africa

Kandinsky goes to Russia

Macke killed in action

1916
Marc killed in action

1919
Weimar: Bauhaus established under Gropius

1920
Gropius invites Klee to join staff of Bauhaus

1921
Gropius invites Kandinsky to join staff of Bauhaus

RUSSIA

1909
Union of Youth founded to develop non-objective art

1910
Larionov graduates from Moscow School of Painting

Popova visits Paris

Exter visits Paris (and each subsequent year until 1914)

1912
Moscow: *Donkey's Tail* exhibition

1913
Larionov's 'Rayism' (manifesto)

Tatlin visits Paris

St Petersburg: Performance of *Victory over the Sun*

Target exhibition includes works by Malevich and Larionov

Union of Youth exhibition included works by Malevich and Matyushin

1914
Goncharova's designs for Diaghilev's production of *Le Coq d'Or*

1915
St Petersburg: *Tramway V* exhibition

St Petersburg: *Zero-Ten* exhibition

Malevich: 'From Cubism and Futurism to Suprematism'

Larionov and Goncharova leave Russia to join Diaghilev in Switzerland

1916
Moscow: *Shop* exhibition

First showing of Rodchenko's work sponsored by Tatlin

1917
Knave of Diamonds exhibition

Russian Revolution

Moscow: Rodchenko helps organise Museum of Artistic Culture

1918
Moscow: establishment of Free State Art Studios

1919
Moscow: Rodchenko's 'Black on Black' shown at Tenth State Exhibition *Non-Objective Creation and Suprematism*

1920
Moscow: establishment of Institute of Artistic Culture

End of Civil War

1921
Establishment of Russian Academy of Art Sciences

Moscow: 5 + 5 = 25 exhibition includes works by Rodchenko, Exter, Popova

ITALY

1910
Manifesto of Futurist Painters and Technical Manifesto of Futurist paintings

1912
Late in year Balla starts on 'Iridescent Interpenetrations'

1913
Magnelli visits Paris and meets Picasso and Léger

1914
Marinetti visits Russia

1915
Third International Exhibition *Secessione*

1916
Boccioni killed in action

GREAT BRITAIN

1910
London: Roger Fry's first Post-Impressionist exhibition

Duncan Grant visits Paris and meets Matisse

Gordon Craig in Moscow – sets and costumes for Stanislavsky's production of *Hamlet*

Roger Fry visits Mohammedan exhibition in Munich

1911
Gaudier arrives in London with Sophie Brzeska

London: *Ballets Russes* at Covent Garden directed by Diaghilev

London: Cézanne, Gauguin exhibtion at Stafford Gallery

1912
London: *Futurist* exhibition

London: Roger Fry's second Post-Impressionist exhibition

London: Royal Albert Hall Allied Artists Association includes works by Kandinsky, Lewis

1913
Bergson: *Introduction to Metaphysics* translated by T. E. Hulme

Diaghilev's *Ballets Russes* at Covent Garden

Founding of Omega Workshop in July

London: Severini exhibition in Marlborough Gallery, April

Exhibition of works by Kandinsky bought in Germany by Michael Sadler

1914
Vorticist Manifesto published in first issue of *Blast*

Grant's 'Abstract Kinetic Collage Painting with Sound'

1915
London: *Vorticist* exhibition

Second issue of *Blast*

London: Mixed exhibition at Alpine Club Gallery includes Fry *Essay in Abstract Design*

Gaudier-Brzeska killed in action

U.S.A.

1904
Bruce settles in Paris

1908
Schamberg visits Paris

1909
Sheeler joins Schamberg in Paris for short stay

1910
Schamberg returns to Philadelphia

1912
Marsden Hartley visits Paris and meets Delaunay

1913
New York: *Armory* exhibition

Marsden Hartley visits Germany and meets Kandinsky

1914
New York: Synchromist exhibition

1915
Duchamp arrives in New York

San Francisco: Exhibition includes works by Balla, Boccioni, Carrà, Davis, Severini, Henry, Sluyters

SOME RELATED CULTURAL AND HISTORICAL EVENTS

1908
Worringer: *Abstraction and Empathy*

Jules Romains: *La Vie Unanime*

Matisse: 'Notes of a Painter'

Austria – Hungary annexes Bosnia and Herzogovina

1909
Compilation of Bergson's writings published in Italian

Dresden première of *Electra* (Strauss/Hofmannsthal)

Schoenberg *Erwartung*

Vienna Première of Kokoschka's play *Murderer, Hope of Women*

1910
Paris première of Stravinsky's *Firebird*

Death of Henri Rousseau

Bruno Corra and Arnaldo Ginna experiment with the first abstract, hand-painted films

Munich première of Mahler's 'Symphony of a Thousand'

Rilke: *Melte Laurid's Brigge*

Death of Tolstoy

Herwath Walden publishes first issue of *Der Sturm*

Death of King Edward VII

1911
Anton Giulio Bragaglia *Fotodinamismo futurista*

Dresden Première of *Der Rosenkavalier* Strauss/Hofmannsthal

Paris première of Stravinsky's *Petruska*

Death of Mahler

Agadir crisis

Assassination of Russian Première Stolypin

1912
Gleizes and Metzinger: 'Cubism'

Vienna première of Mahler's 9th Symphony

Berlin première of Schoenberg's *Pierrot Lunaire*

Apollinaire: *Windows* and *Zones*

Shaw: *Pygmalion*

Death of Strindberg

1913
Klee's translation of Delaunay's 'On Light' published in *Der Sturm*

First issue of *Lacerba*

E.L. Kirchner *Chronicle of the Brücke*

Paris première of Stravinsky's *Rite of Spring*

Apollinaire *Alcools* and *The Cubist Painters: Aesthetic Meditations*

Kafka *Judgement*

Thomas Mann *Death in Venice*

Poincaré President of the French Republic

1914
Apollinaire: 'It's Raining'

Clive Bell: *Art*

June: assassination of Archduke Franz Ferdinand at Sarajevo

August: outbreak of First World War

1915
Italy declares war on Austria

1916
First completed futurist films: *Vita Futurista, Il Perfido Incanto* and *Thais*

Death of Redon

Death of Emperor Franz Joseph I

Lloyd George succeeds Asquith as British Prime Minister

1917
Death of Degas

Establishment of Salzburg Festival

U.S.A. declares war on Germany

Russian Revolution

1918
Death of Klimt

Death of Schiele

Stravinsky's *The Soldier's Tale*

Death of Debussy

Death of Apollinaire

Treaty of Brest-Litovsk ends war between Russia and Germany

November: Armistice in Europe

1919
Death of Renoir

Strauss/Hofmannsthal *Die Frau ohne Schatten*

1920
End of Civil War in Russia

Appendix 3

PUBLIC COLLECTIONS